THE LANGUAGE OF VISION

SOUTHERN LITERARY STUDIES

Scott Romine, Series Editor

THE LANGUAGE OF VISION

Photography and Southern Literature in the 1930s and After

JOSEPH R. MILLICHAP

Louisiana State University
Baton Rouge

Published with the assistance of the V. Ray Cardozier Fund

Published by Louisiana State University Press
Copyright © 2016 by Louisiana State University Press
All rights reserved
Manufactured in the United States of America
First printing

Designer: Barbara Neely Bourgoyne
Typeface: Whitman
Printer and binder: Maple Press (*digital*)

Library of Congress Cataloging-in-Publication Data
Names: Millichap, Joseph R., author.
Title: The language of vision : photography and southern literature in the 1930s and after / Joseph R. Millichap.
Description: Baton Rouge : Louisiana State University Press, 2016. | Series: Southern literary studies | Includes bibliographical references and index.
Identifiers: LCCN 2015040420| ISBN 978-0-8071-6277-4 (cloth : alk. paper) | ISBN 978-0-8071-6278-1 (pdf) | ISBN 978-0-8071-6279-8 (epub) | ISBN 978-0-8071-6280-4 (mobi)
Subjects: LCSH: American literature—Southern states—History and criticism. | American literature—20th century—History and criticism. | Photography in literature. | Literature and photography—Southern states.
Classification: LCC PS261 .M46 2016 | DDC 810.9/97509043—dc23 LC record available at http://lccn.loc.gov/2015040420

For Pat, as always

The meaning of quality in photography's best pictures
lies written in the language of vision.

—WALKER EVANS, "PHOTOGRAPHY" (1969)

CONTENTS

Preface xi

ONE The Language of Vision in Photography and Southern Literature 1

TWO James Agee, Photography, and *Let Us Now Praise Famous Men* 28

THREE William Faulkner, Photography, and the Dialectic of the 1930s 45

FOUR Robert Penn Warren, Photography, and Southern Letters 67

FIVE Eudora Welty, Photography, and Southern Narratives 84

SIX Ralph Ellison, Photography, and *Invisible Man* 100

SEVEN Photography and Southern Literature in a New Century 114

Notes 133

Works Cited 149

Index 153

PREFACE

As with most studies like this one, *The Language of Vision: Photography and Southern Literature in the 1930s and After* emerged from the confluence of long-term personal interests with more recent professional projects. The complex relations of the literary and the visual arts have always intrigued me, and a chance to teach literature and film provided a focus on photographic images. The significance of narrative film as both a visual and a verbal art form provided subjects for several publications, including two books on American film and literature. The scholarly aspects of my research first centered on the Depression decade, because those years prove significant to the histories of southern literature and photography. I was fascinated by the great archives of documentary photographs created by government programs during the 1930s and 1940s, as well as with the simultaneous emergence of hybrid photo books utilizing many of these documentary images as icons of this transitional era.

As I became more involved with academic administration, however, my scholarly work returned to more traditional studies of modern southern literature. While head of the English Department at Western Kentucky University, I helped found its Center for Robert Penn Warren Studies, and my ensuing engagement with Warren's life and work later produced two books and a number of articles on aspects of his extended career and extensive canon. In my most recent book, a close reading of Warren's later poetry as the work of aging, I noticed the poet's intertextual

use of photos as keys to memory in a review of his life. The Warren centennial conference in 2005 provided the opportunity to write an essay reflecting on photography in his work. Although I began with Warren's later poems, they led me back to his early fiction from the 1930s, work that I soon discovered was influenced by Depression-era photographs in general and in particular by the most representative and influential American photographer of that decade and long after, Walker Evans.

Reconsidering Warren from this new perspective provided by photography suggested different critical approaches, which in turn pointed me toward other southern writers who had diverse connections with that burgeoning visual art form during the Depression years. For example, Warren is connected with James Agee by way of their personal and artistic relations with their mutual friend and colleague Evans. A 1936 documentary project by Agee and Evans in the rural South produced the most fascinating of the Depression photo-books, *Let Us Now Praise Famous Men* (1941). Although I was familiar with Evans and his images, careful consideration of his work convinced me that his graphic art evolved from his literary interests. In turn, his artistic vision influenced many American writers during the Depression and after. Although he wrote and published extensively, Evans became a pivotal figure as a photographer. In his own formulation photography is "a language of vision," one that engages in a creative dialogue with the visionary language of the finest writers, especially in the modern South.

After my retirement from teaching, I decided to combine my personal and professional interests in photography and southern literature as the matter of a new book. Warren, Evans, and Agee would become essential figures in this study, of course, and I began to consider other southern writers in terms of their involvement with photography, particularly ones that I had written about in other contexts, such as William Faulkner, Eudora Welty, and Ralph Ellison. All of these writers have connections to photography in their lives and works, and some of these relations also have elicited critical and scholarly attention. Unlike the other writers, who were only beginning to publish during the Depression, Faulkner was an established author by the mid-1930s. His remarkable fictions

in the modernist mode affected not only southern men of letters, such as Warren and Agee, but regional writers different in gender and race, such as Welty and Ellison. Even the photographs of the South by Evans were influenced by Faulkner's literary descriptions of Yoknapatawpha. Many aspects of these diverse visions were extended well past the Depression years and on through the latter half of the twentieth century. In the rapidly growing and changing South, more recent artists in photography and in literature continue to evolve under the lengthening shadow of the earlier artistic generation grounded in the 1930s. In the following chapters, I discuss these continuing developments, concluding with a consideration of Natasha Trethewey, whose life and work demonstrates on into our new century these tensions between the visual and verbal in her use of photographic images and tropes.

This brief narrative of my new scholarly project suggests that this effort evolved slowly and that my research for it involved an eclectic collection of sources both literary and photographic. However, my project is not intended to be comprehensive, much less definitive, in regard to the extensive and complicated subjects of photography and southern literature. Many other writers and texts, or photographers and pictures, could be considered from the perspectives proposed here, as I often suggest in the chapters that follow. Unlike my most recent book on Warren's later poetry, which developed inductively from my recognition of these poems as his life review, this study proceeded more deductively, moving from one figure or text, one image or trope to another. Therefore, my project is not determined by any particular theoretical program or critical approach in regard to either photography or literature. Instead, I have employed a variety of critical theories and practices drawn from traditional and more recent criticism and scholarship of literature and photography. Thus, my purpose here is defined by my title—to analyze and interpret the complementary languages and visions of photography and literature in the South, proceeding in rough chronological order from the 1930s forward and centering on a half dozen major writers and their finest texts through close readings both verbal and visual.

Given this purpose, let me explain my use of visual images in *The Language of Vision*. It might seem strange that my study of photography and southern literature reproduces no photographic illustrations within the text itself. This strategy is deliberate. Some of the journal articles that form the bases of my central chapters did include photographs, but my editors and I encountered myriad problems with the use of only a very few examples. Reproduction of photographs in print proves ever more difficult and expensive, not just in terms of editing and printing, but even more so in the time-consuming and expensive pre-publication work of securing permissions and transferring high-resolution images. Moreover, these complications of production, along with the inherent limitations of space in journal formats, meant that only a very few photographs could be reproduced when many might be discussed in the text.

Contemporary electronic technologies, although beset with their own limitations, do provide some solutions to the problems of print reproductions. When I began to shape my materials into a book-length study, I resolved to extend the visual range of the text through electronic, as well as print references. While any edition of Agee's *Let Us Now Praise Famous Men* includes Walker Evans's photographs arranged as the volume's Book I, the Library of Congress website of Farm Security Administration photography presents three times their number from his 1936 Alabama notebook alone. Other sites, notably those of the New York Metropolitan Museum and the Museum of Modern Art, contain many more. Thus, I hope readers will follow my references not just to Evans's iconic images from the 1930s on these sites but to visual and literary texts he created before and after.

As I assembled the manuscript for this book I systematically made specific and general references to print and electronic sources. I trust that these citations will make reading my book more focused, as well as more rewarding. As we all know by now, much of electronic media's power of association exists in the instant cross-referencing of sources and materials. So an online search for a specific photograph, whether by its visual format or its verbal description, will generate dozens like it in an instant. Indeed, no better way exists to grasp the vision of a visual

artist than to appreciate the many pages of thumbnail images that present themselves. Therefore, the very limitations of print reproduction of photographs may suggest other, better methodologies for understanding the complex relations of visual images and literary texts.

I want to recognize those individuals who provided encouragement and assistance during this book's extended development. In the long view, such acknowledgement would include a great number of students, colleagues, and administrators at several educational institutions—notably, at Tulsa University, where I taught film and literature classes, as well as at Western Kentucky University, where I presented courses in American and southern letters. Scholars and critics, both theoretical and practical, who have directly influenced this project, are acknowledged more formally in the text. More recently, however, I have read the central chapters as papers at conferences and have published them in academic journals. I recognize the reactions of panels and audiences at gatherings of the Robert Penn Warren Circle, the Center for Faulkner Studies, the Society for the Study of Southern Literature, the South Atlantic Modern Language Association, and the American Literature Association. Readers and editors at several journals provided assistance with earlier versions of the chapters. They include Douglas Chambers at *Southern Quarterly* for Chapter Two, Mark Miller at *rWp: An Annual of Robert Penn Warren Studies* for Chapter Four; Wayne Chapman at *South Carolina Review* for Chapter Five, Matthew Roudane at *South Atlantic Review* for Chapter Six, and Joan Wylie Hall at *Southern Quarterly* for Chapter Seven. The final version of the book has been influenced most recently by readers and editors associated with the Louisiana State University Press. They include Acquisitions Editor Margaret Lovecraft, Director MaryKatherine Callaway, Southern Literary Studies Editor Scott Romine, Managing Editor Lee Sioles, Copy Coordinator Jennifer Keegan, and Copyeditor Julia Smith, among several others. In particular, I am most grateful for the thoughtful, informed, and helpful reactions and suggestions made by my anonymous first reader; they have done much to improve my efforts here.

THE LANGUAGE OF VISION

ONE

*The Language of Vision in Photography
and Southern Literature*

Most significantly in the 1930s, but well before and long after, photography
and southern literature affected each other as intertextual languages and
influential visions creating personal insights and cultural meanings in
the manifold convergences of documentary realism and subjective mod-
ernism. This chapter provides the historical and cultural backgrounds,
as well as the critical contexts and theoretical sources for my readings
of photographic images and tropes from representative southern writers
and their salient texts. The histories of southern literature and pho-
tography highlight their important intersections before and after the
Depression decade, in the Civil War years, and in the Civil Rights era.
My introductory remarks consider theoretical technique and critical
practice in photography and literature, particularly in regard to their
mutual influences and intertextualities. These shaping contexts are dis-
covered in the several tensions among cultural developments informing
the 1930s, particularly in those between an evolving modernism and
a renascent naturalism during that decade. In the second half of the
twentieth century, liberating movements of gender, race, and class—
especially in the era of Civil Rights during the 1960s—facilitated new
approaches to photography, literature, and their corresponding visions
that continue to develop even today.

Photography as a southern artifact and document has a history almost
as extended and contested as that of the regional literature. For example,
literary critic Richard Gray recently projected the southern past by way

of a striking visual metaphor. "The South has customarily defined itself against a kind of photographic negative, a reverse image of itself with which it has existed in a mutually determining, reciprocally defining relationship" (xv–xvii). Gray's visual trope suggests not just regional tensions but racial ones, at least in terms of the traditional black-and-white negatives most often employed during the 1930s. Visual and psychological binaries of region and race also are reinforced by many other cultural mediums in addition to literature and photography, but these paired art forms prove most important in the Depression decade. Historical considerations of the years between the two world wars as the period of the Southern Renaissance in literature has been extended by a recent recognition of photography's importance to internal as well as external perceptions of the region during that era and, by extension, the years before and after.

For example, southern novelist and critic David Madden posits three crucial periods—the Civil War years, the Depression decade, and the Civil Rights era—as the primary sources of southern anxieties regarding the region's photographic recreation. Madden begins his analysis by noting that, "from the start, many southerners feel photographs exposed the South, at its most vulnerable, to staring, sometimes gloating, northern eyes," a reaction that would prove especially true for white patriarchs anxious about traditional privilege (13). Madden also suggests that the photographic heritage deriving from the nineteenth-century watershed of American and southern history that was the Civil War both anticipates and affects the graphic record and visual reading of later regional changes in the 1930s and in the 1960s. Much as in literature, the special significance of photography to southern culture during the Depression is determined by the historical convergence of an immediate social crisis with an ongoing cultural renaissance. The symbolic import of the photographic image as a record of regional change had been established earlier by that internecine conflict and its aftermath in the nineteenth century. Struggles against racism and segregation and for desegregation and civil rights in the second half of the twentieth century would recall not just the social transformations of the New Deal era but the cultural

dislocations several generations before. In fact, the effects of cultural changes in the 1960s often have been likened to a second Civil War and Reconstruction. The South's photographic heritage, though, finds its focal moment in the 1930s, when modern literary texts at once refigured images from the photography of the past and projected photographic images of the present to influence future developments of southern life and art, both literary and visual.

The histories of literature and photography in the South are more extensive and complicated than I can develop fully here. I believe readers interested in a study like this one will have basic familiarity with the general outlines of southern literature, and I assume these readers' willingness to consider a few sources on the history of regional photography. Perhaps the best place to start is with Madden's seminal essay, "The Cruel Radiance of What Is" (1982), with its title borrowed from James Agee's prose describing Walker Evans's photography in *Let Us Now Praise Famous Men* (1941). In my view, the best historical collection and description of southern photography can be found in *Picturing the South: 1860 to the Present* (1996), edited by Ellen Dugan. Her book includes a diverse selection of pictures and prose from photographers and writers that derived from a major exhibit under the same title at the High Museum of Art in Atlanta during the Olympic year of 1996, providing both a graphic and a critical introduction to southern photography. Katherine Henninger presents a recent, thorough, and well-illustrated consideration of regional photography in *Ordering the Façade: Photography and Contemporary Southern Women's Writing* (2007), in which she essays "A Short and Selected History of Photography in the South" as part of her introduction (26–84). Henninger's subject is the transfiguration of photography by women writers of the contemporary South, who visually deconstruct the cultural façade of the region's male hegemony. Her study also proves the best overall discussion as yet of photography's utility to southern literature in terms of critical theory and practice, and thus it has considerably influenced my thinking about these subjects here.

Henninger's formulations, like those of most recent critics concerned with the relation of photography and literature, are focused by a handful

of theoretical works about both art forms. Two short books within the photographic literature, Susan Sontag's *On Photography* (1977) and Roland Barthes's *Camera Lucida* (1980), are crucial for Henninger, as they are for most literary critics considering photography in any context. Sontag and Barthes approach their subjects by way of Freudian psychology and existential philosophy, so that their discussions of human concerns such as time, death, and memory remain more abstract than actual, more theoretical than practical. In particular, the ontological relationship of the still photograph as a spatial artifact to the flowing passage of time fascinates Sontag as well as Barthes. Both use literary devices to express this ineffable relation of time and space, however. Barthes is more abstract and classical in his theoretical position: "In the photograph, Time's immobilization assumes only an excessive, monstrous mode: Time is engorged" (91). Sontag frames the photograph's location in the space-time continuum more concretely in terms of camera work: "Precisely by slicing out this moment and freezing it, all photographs testify to time's relentless melt" (15).

Implications of death are inherent in the consideration of fleeting time, and Sontag and Barthes powerfully phrase their formulations about this complex relation. "Photography is an elegiac art," according to Sontag, and she locates the truth of her proposition in the concrete imagery suggestive of a death's head: "All photographs are *memento mori*" (15). Again, Barthes inscribes his theory with greater abstraction: "Ultimately what I am seeking in the photograph . . . is Death: Death is the *eidos* of that Photograph," with *eidos* here understood as in classical philosophy to define a mental image of an ideal essence or form (15). Sontag considers this association of photography with death personally, in regard to her own physical infirmities, while death haunts Barthes's study, which was written as a memorial of his dead mother through remembered photographs. Time and death impinge on individual memories, though a collective memory persists in the visual images of photography and the verbal ones of literature.

Barthes's theoretical formulations may be more abstracted than Sontag's, but his critical practice proves more concrete. This practical

turn is concealed to some extent by his Latinate constructions. These scholarly allusions begin with his title, *Camera Lucida*, or "bright room," which plays on the early definition of photographic apparatus as a "*camera obscura*," or "dark room," illuminated only by the beam of light admitted through the camera's aperture to record the truth of its vision beyond the dark chamber where visual transformation takes place. Other important figurations are what he names the "studium" and the "punctum" of the photograph, terms that I roughly translate from the Latin as the general "study" and the particular "point" revealed within its visual imagery, or the "context" and "text," as he also calls them. Barthes's association with literary theories of reader response should be recalled here; for the *studium* seems the general matter all observers can see in a photograph, while the *punctum* seems the visual point within it discovered by the individual viewer. "A photographer's *punctum* is that accident which pricks me (but also bruises me, is poignant to me)," as Barthes plays with language in his theoretical considerations (27).

Because such emotional reactions must remain subjective, they may be problematic in the criticism of real or recreated photography. In a literary photograph (a fictional photograph described in a literary work), the writer creates both *studium* and *punctum* for the reader, as Henninger correctly observes: "Fictional photographs . . . can only be seen as acts of representation" (9). By demonstrating how recent women's writing about the South uses photographic tropes to rewrite the region's prevailing masculine narrative in cultural and literary terms, Henninger also outlines a valuable theoretical and practical discussion of the differences between the photograph as visual text and as verbal trope. She also develops her own theoretical and critical vocabulary in support of her analysis and interpretation, which simultaneously emphasizes the mediation often overlooked in real photos but necessitated in their literary recreations. As in Henninger's reading of fictive texts by her contemporary southern subjects, some of these visual references may appear inadvertent and/or inconsequential, much like real photographs. The literary critic must remember that within written texts a visual image remains at one more remove from reality. Literary

photographs are intentional, and they call attention to their inherent mediations of reality (9). Actual photographs may disguise that mediation by creating deceptive reflections of reality, such as the bright facades of southern traditions that Henninger exposes in her readings of feminine texts.

In more traditional terms, both the fictional photographs created by Henninger's subjects and her readings of this visual imagery also are examples of literary ekphrasis. As its Greek etymology implies, the rhetorical device of ekphrasis is an "out-speaking" of a nonverbal image. The trope was developed as an expressive mode by ancient orators to vary narration with description or to include an order of space within one of time. The classic example is found in Homer's *Iliad*, when the poet describes the "Shield of Achilles" in order to posit the cosmology of the culture that created the narrative. Ekphrasis slowly evolved as a literary trope that could complement narrative progression with a spatial metaphor. More modern examples range from John Keats's "Ode on a Grecian Urn," to Robert Browning's "My Last Duchess," to W. H. Auden's "Musee de Beaux Arts." The cultural explosion of photography, film, television, and other visual arts has increased the frequency of ekphrasis in modern and contemporary literature, if not so formally as in these traditional examples. The use of ekphrasis in southern literature has a long, significant history.

It also must be said that just as narrative appropriates the spatial features of graphics, visual art aspires to the narrative sequences of time. Visual orderings of space range from triptychs in traditional painting to books of photographs. Photography also supplements its imagistic connotations with denotative language. Examples include titles attached to pictures, elements of language juxtaposed with them, or even words located in them. From their beginnings, the visual arts in the South accommodated their visions to verbal creations, either by illuminating literary texts with visual images or by introducing verbal texts directly into visual ones. The hybrid photo books of the 1930s, which often involved the decade's finest writers and photographers, serve as obvious examples of intertextual references. Comparable volumes, however, il-

lustrated the Civil War, even as it was fought, and the struggles for Civil Rights were revealed in similar publications. Language itself became the direct subject of photography, in the naturalistic record of southern life (such as photographs showing the signage of segregation), as well as in the artful juxtaposition of visual and verbal texts in exhibitions and publications. For a recent example, see African American photographer Carrie Mae Weems's "Ebo Landing" from her *Sea Island Series* (1992). Its composition forms a vertical triptych in which her two pictures of St. Simons Island bracket a poem invoking the mass suicides by Ibo slaves there (Dugan 189).

In all these considerations, we are dealing with variations on "the language of vision." Walker Evans used this phrase to frame the creative character of the photograph by comparison to the literary text in his own essay defining the "meaning of quality in photography's best pictures," ones that he characterizes as "written" in this "most literary of the graphic arts" ("Photography" 169, 171). Evans is an important, influential figure in American photography, of course, yet he is connected to American literature for the most part through his collaboration with southern writer James Agee on their documentary volume *Let Us Now Praise Famous Men* (1941). Although literary critics recognize Evans's creative influence on Agee and several other writers, the evolving photographer also found inspiration in literature. Born in 1903, Evans came of age during the 1920s, not so much as an apprentice graphic artist but as an aspiring writer deeply influenced by international literary modernism. He studied modern French literature at the Sorbonne and worked with American modernists such as Hart Crane in New York City. He published his own fiction and poetry in English and in French before he found his true calling in photography. The subjects of his initial photographic projects included American architecture, African sculpture, and the Cuban revolution. Then his work with New Deal programs during the 1930s put him at the axis of the documentary arts, and Evans's work became the finest representative of intertextuality in the literary and graphic arts. First in practice and later in theory, Evans achieved the "lyric documentary"—a balancing of word and image, de-

notation and connotation, and time and space in his own terms ("Lyric Documentary" 38). Although not a southerner, Evans loved the South, and his best-known and finest images were created there in response to southern subjects. His visual influence was widespread but most enduring in southern literature. Evans thus becomes the pivotal figure for my readings of several southern writers and their own intertextual relations with photography during the 1930s and for long after.

The relations of photography and southern literature have a long, significant history that extends from the early nineteenth century down to the present. Even before the appearance of photography in the South, new literary efforts punctuated the burgeoning culture of the region and firmly established a viable southern tradition in letters during the seventeenth and eighteenth centuries.[1] These earlier developments often were intertextual with the traditional graphic arts. During the antebellum era, southern romanticism came into its own at the same moment that the daguerreotype established itself. This initial photographic technique captured an image by exposing a silvered plate to sunlight for several moments. Because of technological and economic limitations, daguerreotypes were mostly confined to portraits, a focus that almost immediately raises cultural questions. Daguerreian images could be viewed as advances of democracy in capturing individuality, yet the process was difficult and expensive, and thus limited and limiting, much like portrait painting. By the 1840s, southern literary centers such as Charleston, Richmond, and Baltimore supported resident daguerreotypists, so that the initial writers of regional significance, such as Edgar Allan Poe, Henry Timrod, and William Gilmore Simms, were also the first to be portrayed in the fledgling visual medium. In New Orleans, proponents of the new art form included a black practitioner, the painter Jules Lion (Henninger 33–34).

The moments of individual lives and social histories frozen by daguerreotypes also raised philosophical questions of life and death, as well as of memories and memorials. America in the nineteenth century was acutely aware of mutability and mortality, so much so that it created a veritable culture of death. Photography quickly became a prominent

aspect of this process by portraying individuals before and after their passing, often posed among living survivors. Cultural historian David E. Stannard considers gender, race, and class in relation to the elegiac aspects of the daguerreotype, and he provides a revealing assessment of the contribution of nascent photography to the antebellum culture of death in America and in the South. Stannard's theoretical discussion opens with a passage from Sontag, and his formulations also parallel those that Barthes advances on the metaphysical relation of photography to time, death, and memory.[2] All these cultural and artistic tendencies would be extended and exaggerated by the mortal toll of the Civil War, though for the most part photography had moved beyond the daguerreotype by the 1860s.

In the decade immediately preceding the Civil War, the rapid evolution of photographic techniques included the wet-plate process, which used first iron, then tin, and finally glass negative plates to produce multiple prints on several mediums. These advances enabled southern picture takers to move beyond studio portraits and poses into direct records of regional culture in its many other aspects, favorable and not. Early southern photo images strove to mirror the rest of the nation—representing a promising natural setting, a thriving commerce, and a prospering population—at least for the white subjects shown. The sinister aspect of this reversed negative image that Richard Gray uses to portray the South was revealed in the dark shadow of chattel slavery. Often racism was portrayed in deferential scenes of contented "darkies," but realistic images of misused blacks showed their identifying scars from the iron or the whip. Also disconcerting are the frequent attempts to use photographic images to demonstrate the racial inferiority of African Americans. For an example of this dehumanizing practice, Henninger points to the image of a bare-breasted slave woman taken in Charleston circa 1850 by daguerreotypist J. T. Zealy to support the hypotheses of Harvard naturalist Louis Agassiz, who posited the separate creation of the races, an ontological position applauded by southern racists (34).[3] Definition of race by photography prefigures contested images of black Americans from the nineteenth into the twentieth century that are

traced in the works of southern writers, particularly of black authors such as Ralph Ellison and Natasha Trethewey considered later.

These darker shades of southern life that seem the negative image of America at large were created by slavery, and they were fixed by the Civil War and its aftermath. The 1860s would provide the first images of the South to command regional, national, and even international attention; they became the initial examples of war photography on a substantial scale. As the sesquicentennial celebrations of the Civil War have reiterated, the significance of this awful conflict to American history generally and to southern history in particular is prodigious. The war's destruction, as measured in any material or human statistics, was unprecedented. The Civil War dead numbered at three-quarters of a million, about 3 percent of the nation's population. (Today, 3 percent of our population would total 7 million people.) The proportions of these casualties were even more dreadful in the South, where one-fifth of white men of military age perished in half a decade. Other statistical measures prove as shocking—perhaps a quarter of these dead remain unknown—and the sheer predominance of death still haunts the history and the imagery of the Civil War, especially in the South. Although this epic struggle would shape the development of the region for a century and more, only recently has the photographic record been recognized as central to the war's legacy.[4]

The horrors of the Civil War were related to the development of southern photography in several significant respects, and the most important are tied directly to death and loss. The new photographic techniques made realistic images accessible to soldiers and civilians whether at war or at home. The practice of photography in the 1860s incorporates the period's sentimental imagery in regard to love and loss generally, as well as to mortality and memory specifically. Dying soldiers in both armies were able to gaze on images of their survivors at home, while family and friends both South and North were left with lasting images of their loved ones lost on battle fields or in prison camps. In realistic terms, photography exposed the authentic nature of the first modern war of attrition that profoundly affected combatant and

civilian alike. Those on the home front, for example, were shocked by photographs of the bloated corpses littering blasted landscapes—the grim harvest of war. The complex relations of photography to time, death, and memory so powerfully illustrated by the visual heritage of the Civil War fascinated nineteenth-century writers and critics. The incorporation of photography into their literary efforts attracted theorists such as Sontag and Barthes as well as literary critics such as Edmund Wilson and Lewis Simpson.[5]

Although northerner Mathew Brady remains the best known of the many Civil War photographers, he was only one among dozens from both sides of the Mason-Dixon Line to record the effects of that epic combat, fought for the most part on southern soil. However, as Madden observes, the most noted photographers of the South, such as Brady's best-known colleagues Alexander Gardiner and George Bernard, were not natives of the region. Their southern counterparts remain less regarded, perhaps because in war the victors select the documents later accepted as historical truth. Visual documentation ranges from likenesses of famous and forgotten troops, to pictures of regimental musters and parades, to images of camp tents and supply lines. After battle, their pictures often became powerful artistic statements in their contemplation of the war's destruction, waste, and death. Because their technology still limited the Civil War photographers' abilities to capture action directly, their images project either a foreground of battle, seemingly calm and hopeful, or the stark contrast of a haunting aftermath in scarred landscapes, urban ruins, and wasted corpses. The effects of these remembered horrors, not just on the survivors but on their descendants, must have been substantial in the later nineteenth-century South so haunted by the physical and psychological trauma of America's most destructive conflict.[6]

This powerful language of vision survived the Civil War and its aftermath to affect the future work of photographers, filmmakers, historians, and creative writers. Many of the southern authors considered in this book recreated photographs from the Civil War era not only as the realistic and documentary images that their originals embodied but as the complex, reflexive visual tropes they became in the hands of Brady and

his finest colleagues. As is so often the case in the history of southern literature, William Faulkner provides the most powerful instances, particularly in the novel often judged his finest fiction, *Absalom, Absalom!* (1936). As we see in Chapter Three, many critics of this great novel have noted that it uses photographs of its central characters not merely as descriptive devices but as subjective symbols reflecting the mysteries of personal and social identity in relation to time and death. The most intriguing examples are found in Rosa Coldfield's verbal recreations of Charles Bon's individual portrait and his secreted photograph of his New Orleans mistress with their child, as demonstrated by their central positioning within Faulkner's complex and subjective narration. The writer's modernist language of vision thus recreates photographs like those he could have seen in many southern family albums, including his own. They are reflexive interpretations made by those photographers who took them and by the characters who view them, especially Quentin Compson. Chapter Three views other works by Faulkner less often considered in a visual manner, while other chapters consider texts created by some of my major figures and other southern writers who recreated Civil War photographs in prose and poetry.

The last third of the nineteenth century and the first third of the twentieth century—the period between the Civil War and the Great Depression—brought substantial changes to the nation. These were especially difficult for the defeated and exhausted South. Evolving attempts at engagement and disengagement between the regions during the postbellum period became known as Reconstruction and Redemption in the South. The region's ultimate efforts at recovery are revealed in the economic and social programs of New South industry and Jim Crow law, developments that awkwardly ushered and accompanied the region into the modern world.[7] These many historical confusions affected cultural productions, including literature and photography. During and after the Civil War, southern letters continued to romanticize regional history and culture, and such sentimental visions were also the norm in photography, as the mythology of the Lost Cause was constructed in visual as well as verbal language.

In addition to the pictorial relics preserved from the antebellum era and the war years, southern photographers reconstituted such memories in postbellum images of veterans and reunions, as well as of reinterments and memorials. Through the years of Reconstruction and Redemption, for example, many southern homes were graced by prints of Michael Miley's famous portrait of Robert E. Lee astride his gray warhorse Traveler. (By 1866, when the painting was done, Lee was serving as president of Washington College in his native Virginia.) Poems in the style of Henry Timrod's "Ode" on Magnolia Cemetery in Charleston were complemented by pictures of similar ceremonies, dedications, and celebrations on Confederate Memorial Days. For example, the cultural complexities of such Lost Cause imagery are encapsulated in an anonymous photograph depicting now aging southern belles dressed in angelic costumes and posed around a cenotaph inscribed with the universal sentiment "In Memory of Our Confederate Dead."[8]

The influence of realism and naturalism in continental, British, and American literature began to penetrate southern fiction even before the turn of the twentieth century in the narratives of Mark Twain, George Washington Cable, and Charles W. Chesnutt. The evolving realism of these writers and several others was mirrored in a regional photography that documented the ordinary lives of white and black southerners in black and white images. As the technology continued to improve, these visual records were made not just in the cities and towns that supported photography studios and shops but in the rural areas that were served by itinerant photographers. Much of this vernacular photography remains anonymous, and it rarely rises above recording the people of the region struggling against the forces of Reconstruction and accepting the compromises of Redemption. By the turn of the twentieth century, however, the harsher influences of philosophical and literary naturalism helped shape the later works of Twain, Cable, and Chesnutt, as well as the work of Kate Chopin, Alice Dunbar-Nelson, and Ellen Glasgow.

Visual intertexts with these writers can be found in photographs that focused on the same contested aspects of gender, race, and class within the changing southern scene. Although northerner Arnold Genthe was

attracted to the South by Cable's fiction, his photos of New Orleans at the turn of the new century are influenced by the sentimental traditions of Victorian pictorialism, and his collections are only of local color interest at best. Genthe patronized African Americans when he pictured them working for whites, but popular and press photography recorded stereotypes of blacks ranging from white ideas of "darky" humor to horrifying images of black bodies tortured and lynched. Although some of this photographic imagery of white-on-black violence had documentary purposes at the time, it is clear that these abhorrent images were intended essentially as visual aspects of a social program supporting racist terrorism during the Jim Crow era. In order to ensure their chilling effect, these horrifying depictions of inhuman brutality were publically and widely distributed, incredibly enough even as picture postcards exchanged in the U.S. mail.[9]

In contrast with the northerner Genthe, native son E. J. Bellocq quietly attempted to record all aspects of his New Orleans, notably its brothels and prostitutes, seemingly in a manner intertextual with roughly contemporary French photographer Eugene Atget's visual documentation of his Paris. Atget's oeuvre, unappreciated in France, was championed by later American photographers such as Berenice Abbott and Walker Evans. In a similar way, Bellocq's forgotten work from the early twentieth century was rediscovered decades later and influenced figures as diverse as photographer Lee Friedlander, filmmaker Louis Malle, and poet Natasha Trethewey. By far the most significant photographer working in the South during the early twentieth century, however, was another northerner, Lewis Hine, who was dispatched into the region by the National Child Labor Committee to document inhumane working conditions. Hine's realistic pictures mirrored the muckraking journalism and literary naturalism of his era by photographing working children posed against the machinery they served in the mines and mills that were key to the changing economic order of the New South. From the turn of the century forward, Hine constructed pictorial sequences he called "human documents," accompanied by prose descriptions,

anticipating and influencing the documentary photographs, films, and photo books showing the South in the Depression decade.

The South's emergence into twentieth-century America and its initial entrance into modernity most often are connected to the First World War. The national unity required for a military effort on a global scale certainly changed the historical view of the Civil War, a struggle then more than a half-century past. The two world wars also bracket a contrasting pair of decades, the "Roaring Twenties" and "Dirty Thirties," in the slang of their times. The social and cultural changes wrought by World War I over these two decades prove so many and so profound that is difficult even to summarize them. In economic and military terms, America was confirmed as a major world power, and the South participated in the prosperity and prestige that accrued, if to a lesser extent the rest of the nation (especially for black southerners). The industrialization and urbanization begun in the New South years were increased by the war effort and then were extended even further by the postwar boom of the 1920s. The resulting expansion of social opportunities and cultural prospects would change the nation and the region considerably. In particular, the social divisions of gender, race, and class would be assessed and addressed in new ways that prompted revolutionary and reactionary movements in the South during the two decades that separated the world wars.

In cultural terms, America and the South engaged fully with modern ideas, literature, and art for the first time. The resulting tensions between past and future would prove most significant for letters, creating a national expansion sometimes compared to the American Renaissance preceding the Civil War. A related regional burgeoning in the twentieth-century South would come to be known as the Southern Renaissance. Some southern critics would call the movement a Renascence, as in the classically educated Allen Tate's formulation of it: "With the war of 1914–1918, the South reentered the world—but gave a backward glance as it stepped over the border: that backward glance gave us the Southern Renascence, a literature conscious of the past in the present"

(535). Many literary historians see this Renascence as concluding along with the Second World War. New Critics of Tate's generation, such as Cleanth Brooks, and the southern scholars who succeeded them, such as Louis Rubin, and recent literary historians, such as Richard Gray, all posit something like a new birth in southern literature between the two world wars. They all reason inductively from the appearance during that time of major writers and texts (including several I examine in this book). The concept of a Southern Renaissance has become contested in recent years, however, with revisionist critics such as Michael Kreyling and Patricia Yeager questioning not just its paternity but its very existence. For my purposes in this study, a general recognition that a new flourishing of southern literature occurred between the world wars works nicely, for the same sort of development was happening simultaneously with photography in the South. Indeed, the existence of reciprocal creative relations between the visions of the two art forms in the 1930s and after is my subject and my argument here.[10]

Like the epic conflict of 1861–1865, the First World War also was marked by rapid developments in the technology of camera work and its reproduction in other media. In war, the photographer became a primary agent of military reconnaissance, especially in combination with recently enhanced aerial capabilities. At home, news photographs now were able to capture and transmit the action of battle, so that images of the trench warfare of the front lines were quickly available to the public. At the same time, the personal dislocations and separations of warfare spurred a human interest in memorial photography, much as in the Civil War years a half-century earlier. All of these developments enhanced the documentary power and prestige of photography in terms of both social experience and subjective memory. It is not surprising then, that postwar American consumers demanded usable and inexpensive cameras and film, though they were willing to pay for more expensive technologies, particularly if capable of the color reproduction just beginning to flourish. The economic good times of the 1920s facilitated the use of the photograph as documentation, as entertainment, and as art. In art photography, the pictorial style of Alfred Stieglitz and Edward

Steichen still persisted from before the war, but it was supplemented by modernist tendencies, demonstrated in a straightforward and realistic manner by Paul Strand, a surrealistic and subjective mode by Man Ray, or a combination of both styles by Edward Weston.[11]

Most historians locate the Great Depression between the collapse of the world economy in October 1929 and the outbreak of the Second World War in September 1939. These dates bracket a decade in sharp contrast to the booming 1920s and 1940s. While the Twenties had offered new economic, social, and cultural promise to the nation at large and to the South in particular, the 1930s seemed to close these possibilities for the country and for the region. The southern states would bear an even heavier burden of financial privation with the collapse of agricultural prices, most notably those of cash crops like cotton. The region's inadequate social institutions faltered, as they had after the Civil War, thus creating the extreme plight of the southern tenant farmer. President Franklin D. Roosevelt even proclaimed the South to be America's number-one problem in the depths of the nation-wide depression. Still the social and cultural breakthroughs in the South that followed the First World War persisted, even in the midst of the adverse economic climate that pervaded the region during the Depression. As the most notable example of this flowering, the Southern Renaissance, born in the 1920s, blossomed and realized its finest achievements in the 1930s. Once again, photographic developments mirrored literary ones, as their intertextual languages of vision influenced each other ever more directly and profoundly.[12]

Despite the economic downturn and in testimony to its power as a means of personal realization as well as social documentation, photography continued to expand as popular pastime and cultural practice during the 1930s to become a major influence on the creation and interpretation of social research and modern art. By the decade's end, as photographic historian John Raeburn notes, "More than 50 percent of American families owned a camera and made some six hundred million pictures yearly, spending $100 million doing so" (9). As Raeburn goes on to explain, "Snapshots marking family and social occasions accounted

for much of this, but many who wielded cameras had more artistic goals" (9). Raeburn's important study, *A Staggering Revolution: A Cultural History of Thirties Photography* (2006), focuses on those photographic artists most influenced by modernism during the era—individuals as different in their art as Ansel Adams, Berenice Abbott, and Edward Weston—as well as on the social realists usually associated with the photography of the 1930s—especially those government-sponsored documentarians such as Dorothea Lange, Russell Lee, and Arnold Rothstein. Raeburn also lends support to my view of Evans as the focal figure combining these seemingly dichotomous modes of photography during the Depression.

Like Lange, Lee, Rothstein, and most other documentarians of the period, Evans worked under Roy Stryker of the photographic program of the Farm Security Administration, a New Deal agency charged with planning, effecting, and documenting agricultural, economic, and social progress in rural America. The Farm Security Administration (FSA) photographic program (1935–1944) is analogous to other New Deal efforts in the graphic, literary, and dramatic arts, for the most part under the aegis of the Works Progress Administration (WPA). The FSA has left the greatest legacy, however, in the some 164,000 of its photographs collected by the Library of Congress and now available at their Web site. Although the FSA photographers roamed the entire country, they focused on agricultural trouble spots, so they produced a disproportionate number of southern images despite that none of the important figures were southerners themselves. FSA images have become icons of the Depression decade, forming our responses to the economic, social, and human crisis in public policy and in subjective art.[13] Eschewing photojournalism as well as propaganda in favor of his own "lyric documentary," Evans set his own course within the agency until Stryker finally let him go his own way. As I have formulated, Evans bridges photography and literature in the Depression years. His photography is shaped not just by documentary impulses but by literary modernism, and his pictures are influential on and intertextual with the efforts of many writers.[14]

In his "Preamble" to *Let Us Now Praise Famous Men*, the photo book he created in collaboration with Evans, James Agee would state categorically that "the camera seems to me . . . the central instrument of our time" (26). Like most Americans during the 1930s, including a surprising number of his colleagues in southern letters, Agee was fascinated with photography, even if he rarely took pictures himself. William Faulkner, Katherine Anne Porter, Erskine Caldwell, and Robert Penn Warren also created more photographic tropes and images in literature than actual photographs. However, Zora Neale Hurston, Eudora Welty, Richard Wright, and Ralph Ellison wrote about photographs, and they were all practiced photographers themselves. Indeed, Ellison even supported himself as a professional photographer while he was writing *Invisible Man* in the 1940s. In 1936, Agee's documentary project with Evans in rural Alabama confirmed the writer's fascination with this now pervasive form of visual art, and the compelling product of their languages of vision became the best of the photo books in 1941.

Other southern writers—as different in their efforts as Hurston and Caldwell, or Wright and Welty—were involved with similar hybrid texts, so much so that this newly developed genre provides a convenient lens for considering the close connection of photography and literature in the 1930s. Although intriguing examples such as Welty's unpublished *Black Saturday* (circa 1935), Hurston's *Tell My Horse* (1937), and Wright's *12 Million Black Voices* (1941) all languished, a similar collaboration by the then better-known Caldwell and the equally famous Margaret Bourke-White, *You Have Seen Their Faces* (1937), remained on the best-seller lists despite the economic hard times.[15] *Let Us Now Praise Famous Men*, released shortly before the nation entered World War II, also made little impression then, though it has evolved to become the best regarded among all these hybrid efforts from the period. The book has become so esteemed, in my view, because its dialectic of visual and verbal art exemplifies the larger issues of cultural representation during the Depression that recent criticism has rediscovered in the efforts of the decade's finest artists and writers. In *Dancing in the Dark: A Cultural History of the Great Depression* (2009), for example, Morris Dickstein

traces through many examples in fine art and popular fare what he formulates as "the tension in the 1930s between a resurgent naturalism and a subterranean modernism, between a desire to bear witness to the social fact and an insistence on the individual character of all witness, all perception" (41).[16]

The major writers considered in this book fit this formulation nicely, as do many of their works, as all of them are related to the 1930s directly or indirectly, in one sense or another. My initial, defining example is the artistic tension between Agee and Evans that created *Let Us Now Praise Famous Men*, in which the photographer's poignant images made in 1936 evoked the writer's powerful prose. Faulkner, the leading figure of the Southern Renaissance, produced his finest work during the years bracketed by *The Sound and the Fury* (1929) and *Go Down, Moses* (1942). His modernist use of photographic tropes in *Sanctuary* (1931) and *Absalom, Absalom!* (1936) stands in interesting juxtaposition to a more documentary sense of photography in his Depression-era works, such as *Pylon* (1935) and *The Wild Palms* (1939). However, a similar dialectic between subjective and documentary languages of vision may be found in Warren's works focused on the decade, especially *All the King's Men* (1946), which was inspired by Huey Long's Louisiana. Welty came of age as an artist working for the WPA as a writer and photographer, and her stories and novels are often set in Depression Mississippi. Ellison discovered photography and fiction for himself after leaving the Deep South in the 1930s for Harlem, which provided the place and time of his great novel *Invisible Man* (1952). Even contemporary poet laureate Trethewey's work is influenced by the dialectic of southern literature and photography in the 1930s, both by the culture at large and more specifically by Robert Penn Warren.

As a concluding example of such historical and artistic tensions at work in the 1930s, we can mention a continuing effort in American art and entertainment to relate the Depression to the Civil War, especially in the South. The most notable instance remains Margaret Mitchell's *Gone with the Wind*, both as bestselling novel (1936) and as blockbuster movie (1939). Critics then and now have explained the nationwide

adulation of book and big-screen versions of Scarlett O'Hara's story by way of nostalgia for another era of struggle and privation, one safely resolved in the receding past.[17] During the Depression years, the Civil War and its aftermath provided a vision of nation and region focused first by ruin and then by rebirth, dramatic imagery appealing to both artists and their audiences South and North. For example, Faulkner produced two books of Civil War fiction in this period, *Absalom, Absalom!* (1936) and *The Unvanquished* (1938); the first is a dense modernist novel, while the second collects his more accessible stories from popular magazines. Both books insist on their author's famous stance that the past is not dead but lives in the present.[18] Southern authors would add other examples in fiction and poetry, showing their concern for a usable past linking the Civil War years and the Depression decade.

The popular and artistic interests of the 1930s in the 1860s also anticipate the Civil Rights era of the 1960s, when the next important nexus of literature and photography occurred in the South. Many leaders, writers, and artists of the struggle against segregation in the Civil Rights years came of age during the Depression, so they quite naturally looked back to those earlier cultural upheavals for inspiration. Of course, two decades of momentous history separated the 1930s and the 1960s. In the 1940s, World War II effectively altered modern history, while the fragile peace that followed soon collapsed into the Cold War during the 1950s. National efforts required during these two eventful decades effected major changes in all aspects of American culture, including literature and photography. The neglected South became ever more a part of the national prosperity that followed the war in the 1950s, and the region experienced economic, social, and political transformation. Simultaneously, the incorporation of the South into national purposes and developments necessitated changes to social and cultural traditions, especially to regional compromises regarding gender, class, and race.

The changes wrought by World War II were reflected in all aspects of southern life, including letters, so that the Southern Renaissance, at least in its first iteration, generally is considered to end in the postwar period with the creation of a postmodern letters in the South, or

perhaps what has been called a post-southern literature. Although most writers of the initial Southern Renaissance were excused from service because of their age, health, or gender, they were all affected by the war. A new generation of southern writers came of age during that time, however, and several experienced combat, including James Dickey, William Styron, and Randall Jarrell. These veterans came back in the 1950s to a changing South also delineated by a new generation of women writers such as Carson McCullers, Flannery O'Connor, and Elizabeth Spencer. World War II accelerated the technological advances in photography, as was the case with earlier conflicts, resulting in easier access to improved photographic techniques in the postwar years and an increasing cultural acceptance of photographic production as both historical documentation and artistic creation. Many of the principal photographers from the FSA and other government agencies documented the war effort at home and abroad, but others, like Walker Evans, continued to explore the artistic possibilities of the medium, leading at last to a postmodern photography in the work of a younger generation of practitioners.

If World War I began the work of cultural change within the South of the twentieth century, then World War II accelerated that process exponentially. During the 1917–1918 war, many southerners left their home region, temporarily or permanently, while many Americans from different regions came south to sojourn or to stay. Further movement, though mostly northward, was generated by the prosperity of the 1920s and the poverty of the 1930s. In the 1940s and 1950s, these movements would become an ongoing exchange in many directions that would alter social and racial relations within the South and the nation, as well as the literary and graphic works inspired by these changes. Although the underlying reasons for these several developments can be traced back to the nineteenth century, their immediate causes could be found in the war effort and the new prosperity it engendered. The politically solid South controlled much wartime spending, thus ensuring that the region had more than its share of training bases and defense plants. So southerners achieved the infrastructure necessary for modern industry almost

a century after the Civil War. During those years, millions of Americans from other parts of the country spent time in the South and recognized its postwar possibilities. In the 1950s, technological advances developed during the war, most notably effective air-conditioning, created greater southern opportunities than before. By the end of the twentieth century, once-isolated Dixieland, with all its regional and racial peculiarities, had evolved as a major component of the burgeoning Sun Belt, which in turn set a new standard for regional development in the rest of the nation.[19]

While the South became a different place after World War II, it also remained southern in a very real sense, a region determined as much by its history as by its geography. In particular, the racial dilemmas of the nineteenth century now demanded resolution in the twentieth century. Integration and civil rights were national as well as southern causes, but, as was the case in the Civil War, the major engagements took place on southern soil. Although many aspects of this social revolution existed earlier and persisted later, the 1960s saw its salient events. The social changes effected at home and abroad by the two world wars inevitably coalesced into a compelling pressure to end segregation, particularly the vestiges of southern Jim Crow laws, and to extend full citizenship to all Americans, especially to southern blacks. Growing racial pride and activism began to appear after the war, in which millions of African Americans served, though they were still separate and unequal on the home front and the front lines.

The armed forces were integrated in 1948, school desegregation began in 1954, and integration slowly came to public facilities, such as the public transportation system of Montgomery, Alabama, in 1956. It was not until the early 1960s, however, that the tide turned, with waves of protest demonstrations, marches, and sit-ins that culminated with the March on Washington in 1963. Encapsulated by Dr. Martin Luther King Jr.'s "I Have a Dream" speech, the powerful promises of these movements were manifested in a succession of legislative victories: the Civil Rights Act of 1964, the Voting Rights Act of 1965, and the Fair Housing Act of 1968. These sweeping changes often were met

by violent resistance in the South and the rest of the nation, such as the Birmingham church bombing in 1963, the Mississippi Freedom Summer murders in 1964, or the Memphis death of Dr. King in 1968. Furious counter measures also began in the 1960s and continued into the 1970s, alongside the positive developments.[20]

 These crucial events were reflected immediately in written and graphic texts, by northerners as well as by southerners, intended for regional, national, and international audiences. Even more than in the Civil War or the Depression, the verbal and visual documentation of the civil rights movement proved critical to its very evolution. Regional and national news organizations, including the black press, sent writers and photographers by the score into the action, and their reportage in print and pictures had an immediate and lasting effect on regional and national audiences. Civil rights groups quickly became conscious of the need to control the narrative of their engagement with the southern establishment, and to a large extent they did so quite effectively. This clarity of purpose was matched by the expanding scope and means of reportage, especially in terms of the new medium of television. For the first time, audiences everywhere could experience almost firsthand the harrowing confrontations on the southern front. Considering this broad panorama of mass media is beyond my purposes here, but literature and photography remained at the center of all documentation and persuasion in regard to these developments.[21] As the new media were more elaborate in their technology and thus more difficult and expensive to deploy, they remained under white control, though open to black influence. Impressive literature and photography emerged from the civil rights groups themselves, to meet the needs of their struggles, and these iconic texts were recognized both then and now as determining forces of the decade.

 The revolutionary decade's photographic icons were especially powerful. This transformative imagery seemed to appear out of nowhere, especially to white observers, but it had a considerable background in the photographic traditions of and by black southerners. On a smaller scale than white establishments but no less significantly, African Ameri-

can communities in the South supported their own photography studios and news outlets that countered the negative depictions and narratives that persisted in the majority culture even after the Second World War. On the one hand, this counteractive work in words and images evoked black humanity, dignity, and innocence, while on the other hand it condemned white racism, dishonor and injustice. Black photographers such as Moneta J. Sleet Jr. from Kentucky, Louise Martin from Texas, and Gordon Parks from Kansas would extend these thoughtful practices into the 1960s.[22] Their visions were often in contrast to the violent scenes recorded even by sympathetic white cameramen such as Charles Moore, Danny Lyons, and Bill Hudson. However, these action shots were the most galvanizing then and the most haunting now—images in black and white and in color of fire hoses and police dogs loosed on teenagers in Birmingham, mounted troopers clubbing freedom marchers near Selma, or Dr. King gunned down at Memphis. Like the great treasury of Civil War photographs or the documentary collections of the Depression, the legacy of Civil Rights photography would define both the way the movement saw itself then as well as the way we remember or visualize it now, even into our new century.[23]

A similar enlargement can be observed in national and regional photography during the post-1960s period, and it is often regarded as a movement away from both documentary realism and subjective modernism. Much of this development may be traced back to the 1930s, with its many photographic movements and artist-photographers, for the most part not southern but often engaged with the South. Walker Evans is the most notable of these figures of continuity in photography after the 1930s, much as his friend and colleague Robert Penn Warren was in literature. Continuing to experiment with new techniques and styles himself, Evans's lyric documentary style also was widely influential on the newer photography that tended toward a sort of visual poetry. This influence and intertextuality is most apparent with national figures who sometimes worked in the South, notably northerners Robert Frank and Lee Friedlander, but Evans's legacy also may be seen in the work of many southern photographers, in particular William Christenberry and

William Eggleston. Christenberry had roots in Hale County, Alabama, the scene of Evans's 1936 documentary sojourn with Agee, and he has reworked familiar landscapes and structures many times to reveal the passages of time in images that Evans once called "perfect little poems." Christenberry's visual project influenced Eggleston's, especially in landscapes and colors, with a tendency toward a symbolic vision and narrative suggestion characteristic of then emerging postmodernism. Photography by women such as Sally Mann, Jane Rule Burdine, and Lynn Marshall-Linnemeier is less concerned with a southern past than with an expansive psychology. The twentieth-first century has continued to witness remarkable changes in the culture of the South, many of which are rooted in the 1930s, including aspects of literature and photography.

Similarly, the social and cultural upheavals of the 1960s affected American writing in the late twentieth century, especially fiction and nonfiction and black and southern literatures. Even the news reports of the often-disturbing events in the civil rights struggle became as focused, powerful, and moving as the photographs that illustrated them. The racial struggles in the 1960s South, along with the decade's battles in other places on other issues, such as the Vietnam War, helped to create what came to be called the New Journalism, a development marked by personal, passionate reporting and the construction of a narrative more concerned with subjective truths than documented facts.[24] These are literary characteristics as well, and traditional letters also inclined toward reportage by creating new genres such as the nonfiction novel and new modes such as postmodernism. The social and cultural clashes of the 1960s thus eventuated in new beginnings in postwar American and southern literatures, sometimes recognized as postmodern or postsouthern movements. Postmodernism may be recognized as a new mode that moves beyond binaries such as realism and modernism in literary terms, as well as capitalism and socialism in socioeconomic ones. Postsouthernism subverts the cultural aspect of place-ness also, in the sense that the traditional South in the era of late capitalism may have lost its regional differences within a postmodern nation and even a transnational world.[25]

These theoretical and critical contexts as well as historical and cultural backgrounds are intended to introduce my closer considerations of my several exemplars of photography and southern literature. Again, my initial focus will be the Depression decade, its tensions of graphic and literary art forms, as well as its dialectic of a revived documentary realism and an ongoing subjective modernism. Walker Evans, in terms of both his critical practice and theory, provides my focal point for the chapters that follow, much as he did in these introductory remarks. In Chapter Two, I consider Evans's documentary collaborator James Agee, as his writing in *Let Us Now Praise Famous Men* proves closest to the visual medium. In my third chapter, William Faulkner's fiction represents the major literary and graphic tensions of the period as seen in its cultural dialectic of realism and modernism. Robert Penn Warren occupies a pivotal position as a modern person of letters in the South, so Chapter Four is centered on his fictions and poems, which continue to redefine the cultural tensions of the 1930s through most of the later twentieth century. In my fifth chapter, I consider ways in which gender, race, and class are reinterpreted by Eudora Welty's feminine vision in both her photographs and her narratives from the Depression decade to the Civil Rights era. Ralph Ellison's *Invisible Man* also was influenced directly by photography in its analysis of how race was culturally constructed in segregated America, as demonstrated in my Chapter Six. In my seventh and concluding chapter, I examine how Natasha Trethewey reflects several of these themes and visions in her contemporary poetry and prose—ekphrasis and modernism, as with Agee and Warren, or gender and race, as with Welty and Ellison. Finally, the artistic and historical resonances of these developments are summarized, and then extended through the later part of the past century and on into our new one.

TWO

James Agee, Photography, and Let Us
Now Praise Famous Men

Like many Americans during the 1930s, including several of his colleagues in southern letters, James Agee was intrigued by the photograph as a recently pervasive artifact of modern culture. Despite the economic depression, photography burgeoned as a popular pastime during the decade, while it also became a significant influence on social documentation and modern art. A 1936 documentary assignment in rural Alabama with photographer Walker Evans confirmed Agee's interest and produced some of his best writing. In 1941, a powerful compilation of his literary efforts and Evans's visual ones at last appeared as *Let Us Now Praise Famous Men.* Although largely ignored at the time of its publication, Agee's collaboration with Evans has come to be the most highly regarded of the era's many photo books, as exemplified by its selection as "The Best Work of Southern Nonfiction of All Time" in a poll of southern writers and critics conducted by the *Oxford American* in 2009. In my view, the work has become so recognized because its visual and verbal intertextualities exemplify the dialectic of cultural representation during the Depression that recent criticism has rediscovered in the efforts of the decade's finest artists and writers. The graphic and literary texts comprising *Let Us Now Praise Famous Men* are complementary, yet conflicted. Evans's photographs of rural Alabama reflect the realism and naturalism of New Deal documentary by way of modern art, while Agee's literary effort to document the representative

identities of three tenant-farm families in the Alabama cotton belt is subsumed almost completely by the anxious subjectivity of a persistent American modernism.

The importance of *Let Us Now Praise Famous Men* in recent critical reconsideration of the 1930s derives not just from the formal dialectic of documentary and modernism found in its visual and verbal intertextuality but from the singular characteristics of its subject matter. Agee and Evans gathered their raw material during the summer of 1936 in Hale County, Alabama, while on a three-week sojourn that now appears as unique as their reactions to it. *Let Us Now Praise Famous Men* began as an assignment that Agee readily accepted as one of his duties as a writer at *Fortune*, the glossy business magazine launched by Henry Luce in 1929. The staff included writers like Archibald MacLeish and Dwight Macdonald, and creative perspectives on topical assignments were encouraged. Agee's prescribed subject would be the plight of the southern tenant farmer, yet the writer had considerable latitude on the means to achieve his reporting.

Agee could choose a photographer to illustrate the article, and he contracted with his friend Evans, who was then employed by the photographic section of the Farm Security Administration (FSA). Roy Stryker, director of the FSA documentary unit, eagerly granted Evans a temporary leave in order to have his section's work published in *Fortune*; the only condition was that the rights to all of the photographs would remain with the agency (Rathbone 120–21). The pairing of Agee and Evans on this single documentary project seems extraordinary three quarters of a century later. We must remember, however, that both men were very young and as yet unproven in 1936. Born in 1909, Agee was at the time only four years out of Harvard, a fledgling writer with but a handful of articles at *Fortune* and one book, *Permit Me Voyage* (1934), a slim volume in the Yale Younger Poets Series.[1] Evans was just six years senior to his literary collaborator, and he had only a year of higher education, a few publications of his photographs, and no significant employment until he joined the FSA in 1935.[2] Despite its initial failure,

Let Us Now Praise Famous Men marked the maturation of both artists, and with its later fame, it remains in many ways the high point of both artists' careers and canons.[3]

Agee and Evans knew each other through mutual friends in Manhattan's creative circles, including Hart Crane in the years directly before the poet's untimely death. Evans met Crane when they each lived near the Brooklyn Bridge, a nineteenth-century structure that would become the central symbol in the poet's modernist epic *The Bridge* (1932). Their friendship was strengthened by their interest in each other's art. Evans had first aspired to be a writer, influenced by the examples of Gustave Flaubert, Henry James, and James Joyce (Rathbone 40–42). Crane had experience as a graphic artist, and he emphasized the visual aspects of the symbolic bridge in his epic poem. Their friendship led to the first publication of Evans's photographs, three medium-distance shots of Brooklyn Bridge in the first edition of Crane's great work. Although they also knew each other, Agee's relation to Crane was more literary than personal. The older poet was a major influence on the young writer's work, and the title of *Permit Me Voyage,* derives from a visionary sequence titled "Voyages" in Crane's first collection, *The White Buildings* (1930). Like Crane, Agee emphasized visual imagery in his prose and in his poetry, while sharing with him a keen interest in photos and movies as developing American art forms.

Agee and Evans were very different in their personal and professional identities despite their mutual interests, however. Agee was idealistic, impulsive, and often romantic in his literary vision, while Evans was realistic, reserved, and reticent in his approach to his photographic art. Still, the pair complemented each other almost perfectly in both personality and practice, so much so that each could accept the other's vision and integrate it with his own. Agee and Evans had taken individual documentary journeys through the South on earlier writing assignments for *Fortune* and photographic expeditions for the FSA; now the committed young writer proposed immersion in their new subject matter by living with a tenant family during a summer's cotton picking. The normally detached photographer not only took up this challenge but, after Agee

was frustrated in his initial inquiries, made the actual connection with the tenant families through his FSA experience and contacts. They were soon accepted by three interrelated families who would allow Agee to board with them so that he could observe life on an Alabama tenant farm. The pragmatic Evans gave their project his best efforts during the days but spent his nights in nearby towns (Rathbone 127).

This close and extended contact with each other and with their subjects is one aspect that makes this documentary collaboration unique among so many others undertaken during the Depression. At the same time, these close conditions make the project problematic in many ways. Although Agee was eager to take on this assignment, its inherent difficulties worried him from the outset. Describing the projected journey to Father James Harold Flye, a friend and mentor since prep school, Agee confessed his "considerable doubts of the ability to bring it off" in a way that would satisfy either his editor or himself (*Letters* 92). Self-doubt in these daunting circumstances is understandable, and in Agee's case it seems to have been exacerbated by an unrelenting fear of failure that had haunted him since his father's accidental death when he was boy. Some critics view Agee's plan for an expedition into the southern hinterlands as a quest to reconnect with his roots in eastern Tennessee, and in such a reading the close personal union Agee enjoyed with the tenant farmers becomes an attempt to restore his own fragmented family life.

These tensions involving Agee's professional and personal purposes also affected Evans and the subjects of their documentation. If Evans initially shared Agee's enthusiasm for all the places and people they were sent to record, he seemed to withdraw slowly from them all, even as the writer's commitment continued to intensify. In *Let Us Now Praise Famous Men*, Agee's attitudes toward Evans's work became ever more conflicted. Although the writer believed the photographer's images were infused with something akin to Keatsian truth and beauty, his anxiety about his own literary task may have derived from the immediate appearance of the photos. In his "Preamble," Agee goes so far as to declare that "If I could do it, I'd do no writing at all here. It would be all photographs"

(28).[4] Yet the striking pictures Evans captured also could prove stark and pitiless in their candid revelations of tenant life in the cotton South, as Agee's description toward the conclusion of a final photo shoot with the families demonstrates. "Walker setting up the terrible structure of the tripod crested by the black square heavy head, dangerous as that of a hunchback, of the camera; stooping beneath cloak and cloud of wicked cloth, and twisting buttons; a witchcraft preparing, colder than keenest ice, and incalculably cruel" (311).

No wonder that these tenant farmers—the Burroughs, Fields, and Tengle families of the Mill's Hill community in Hale County, Alabama— were confused by what they perceived as the strange activities of these outsiders. Although the adult tenants may have understood and even supported the public goals of the project in the first place, they too started to draw back instinctively from Agee's personal intensity and Evans's professional reserve. An obvious locus of anxiety all around was the sexual tension created by these handsome young men, at least one of whom was involved in sexual relationships during that stay. Agee, with his usual honesty, confesses his attraction to the single and married tenant women. One father recognized the effect of the pair on his daughters and declined to board the men. Protocols for the use of human subjects did not exist in that era, and questions regarding the subjects' agency in the project haunt *Let Us Now Praise Famous Men,* especially given the outsiders' image as "government men" in the eyes of the tenants (310).

Questions of agency and responsibility become one focus of a much later photo book, *And Their Children After Them* (1989), the collaboration of journalist Dale Maharidge and photographer Michael Williamson. Subtitled *The Legacy of Let Us Now Praise Famous Men,* this documentary volume revisited the same area a half-century after Agee and Evans to trace the effects of their earlier effort. One legacy Maharidge and Williamson discovered was a lingering resentment among the sur- viving tenants and their progeny. Agee's revelations had caused local embarrassment early on and created wider notoriety later as *Let Us Now Praise Famous Men* emerged from obscurity in the 1960s and after. This

antipathy recalls Madden's discussion of southern suspicions regarding photography. The most important findings of the new book concerned ongoing social and economic disparities that determined the lives of tenant farmers long past the end of the cotton culture. In this regard, the later text proves superior to the earlier one, which lacks any real sense of the cotton economy. Like its model, *And Their Children After Them* is a powerful document; it was awarded a Pulitzer Prize in 1989.

One of Agee's attempts at an introduction to *Let Us Now Praise Famous Men* is his untitled poem, dedicated to Walker Evans (21). In the final ordering of the text, the poem follows almost directly after the gathering of thirty-one photographs that became Book One, and these verses make an oblique comment on Evans's images. The first of Agee's four stanzas is worth quoting in full.

> Against time and the damages of the brain
> Sharpen and calibrate. Not yet in full,
> Yet in some arbitrated part
> Order the façade of the listless summer.

Again, the writer's charge to his photographer suggests a conflicted response to the emerging visual art form. If the photo's scientific calibrations are capable of at least initially organizing the inchoate impressions absorbed during their long, hot summer, then its order frozen in time invokes only the "façade" of that experience, like the worn fronts of wooden structures that frame the anxious faces of the tenants. Such is the conflicted nature of that "part" achieved by some sort of arbitration between Agee and Evans in regard to the selection of photographs that serves as the visual introduction to Book Two of *Let Us Now Praise Famous Men.*

Reconstructing the exact nature of the accord the two collaborators reached is impossible, of course. Yet Agee does insist that "the photographs are not illustrative" or connected directly with the texts, as in most published photo books, including those by Erskine Caldwell, Zora Neale Hurston, and Richard Wright (8). In his preface, Agee also asserts

that the visual and verbal texts "are coequal, mutually independent, and fully collaborative" (8). He remarks on the "fewness" of the examples, and later he alludes to "photographs for which there is no room in this volume," implying that their publishers cut the photo selections to contain costs (8, 178). The first edition from 1941 opens with thirty-one photographs; for the 1960 edition, published five years after Agee's death, Evans dropped five and added thirty-six to double the selection to sixty-two examples. Even this larger number includes fewer than half of the pictures still extant.

In both editions of Let Us Now Praise Famous Men, as well as in two early notebooks of the Alabama photographs preserved at the Library of Congress, Evans seems to arrange his materials like family albums (Mellow 331). In turn, he focuses on the Gudger, Ricketts, and Wood families, as they came to be called in an attempt at anonymity. Evans moves from parents to children and other dependents, interspersing their pictures with pictures of their homes and possessions. In the 1941 edition, this arrangement is bracketed by a portrait of the landowner at the opening and three documentary shots, two of a nearby crossroads hamlet and one of the town that was the county seat. Evans retains this general pattern of organization in the 1961 edition, though he adds fourteen pictures to the family albums and seventeen to the contextual images of Alabama's hamlets, towns, and cities. Thus, the overriding principle of Evans's organization in the visual Book One is spatial, while Agee's order in the verbal texts of Book Two is narrative.

Within his spatial ordering, Evans presents sixteen individual portraits and four group pictures, one farmhouse exterior and seven interiors, as well as the three shots of neighboring hamlets and towns. Although the total numbers vary in the 1961 edition, the two extant notebooks, and the FSA files, the ratio of the subjects of shots stays roughly the same. Both Evans and Agee close up on people, especially members of the three families. These persons, whether seen individually or in groups, always are represented in context; even the tightest close-ups are arranged against the naturally weathered board siding of the tenant houses. The group pictures and the interior shots create other

contexts of people and things, of course, while the final three photos
open out into other parts of the Alabama cotton belt. Yet these are for
the most part not the contextual markers of much iconic FSA documen-
tary photography focused on eroded fields, abandoned farmhouses, or
migrant camps.

In these photographs that became Book One of *Let Us Now Praise
Famous Men*, Evans treated the matter of 1930s documentary with a for-
mal regard he derived from modernism in the arts, including literature.
In visual terms, this meant that he rejected a prior aesthetic inherited
from the nineteenth-century pioneers of photography and extended
into the twentieth by traditional practitioners such as Alfred Stieglitz.
This initial phase of photographic art came to be called "pictorialism,"
mostly because of its connections with the serious subject matter and
self-conscious style of traditional graphic arts (Raeburn 34–35). Pictorial
photography becomes analogous to the late romanticism against which
literary modernists reacted at the beginning of the twentieth century.
Several differing movements toward a "pure" photography emerged as
a loosely organized counter-aesthetic emphasizing the autonomy of the
subject and the artistic restraint of the practitioner. In literary terms,
connections with realism and naturalism seem obvious, but analogies
with the modernist aesthetic in American poetry as practiced by Robert
Frost, William Carlos Williams, Marianne Moore, and Hart Crane prove
more salient.

If these modernist poets preserve various continuities with past,
they simultaneously reveal an insistent focus on a very real American
present. Williams famously defined this new poesis in a short, disjunc-
tive poem with a suitably tentative title, "A Sort of a Song": "Compose.
(No ideas / but in things) Invent!" (145). Williams's twentieth-century
ars poetica proves particularly germane to a consideration of Evans's
pictures because the poet wrote an early and enthusiastic review of the
photographer's first book publication, *American Photographs* (1938). The
volume was essentially the accompanying catalogue of a retrospective
exhibition of Evans's work at the Museum of Modern Art, introduced by
his friend Lincoln Kirstein, and some historians of the art form consider

it the most influential single work in the American photographic canon. Williams's review of the collection in the *New Republic* was entitled "Sermon with a Camera," and it traces Evans's vision in the vernacular matter transformed by photographic art. Clearly, Williams recognized a kindred spirit in Evans, another modern artist who demonstrated the pertinence in the American present of Horace's classical dictum *"ut pictura poesis"* ("as is visual art so is poetic art," in my own rough rendering of the Latin). In his later reconsideration of his photographic oeuvre, Evans neatly formulated the essence of his style as "lyric documentary," a balance of subject and form.[5]

Let Us Now Praise Famous Men would not appear for another three years, but in *American Photographs,* Evans's selection from his previous decade's work included almost a third derived from his eighteen months with the FSA, with almost a third of those images taken during his three weeks in Hale County. Although he abandoned the family album arrangement found in his Library of Congress notebooks and in his two versions of Book One, Evans included examples of his three sorts of subjects—individual portraits and group pictures, farmhouse exteriors and interiors, and neighboring places. Evans's friend John Szarkowski, the first director of photography at the Museum of Modern Art, remembers that the photographer intended his work to be "literate, authoritative, transcendent" (13). The iconic images that developed from his documentary project with Agee in Alabama achieved the lofty standard he set for himself.

Just as his collaboration on the documentary project that became *Let Us Now Praise Famous Men* provided the catalyst for the creation of Evans's finest photographs, those iconic images leveraged Agee's artistic achievement during their time together into the best single endeavor of his varied career and canon. Agee had seen Evans's first proofs while they were still in Alabama, and he continued to be impressed by the polished prints and the positive response they received, especially in the Museum of Modern Art retrospective and its catalogue volume. High praise of *American Photographs* began with Kirstein's introduction to the book, in which he compared Evans's work with that of established

literary figures, including Stephen Crane, John Dos Passos, Ernest Hemingway, Hart Crane, William Carlos Williams, and Ezra Pound. Reactions to the show and the book were wide ranging and universally positive; Eleanor Roosevelt praised it highly in her syndicated newspaper column (Raeburn 182). Friends of Evans and Agee joined this chorus of praise, but with more artistic insight. William Carlos Williams penetrated the artistic psychology of Evans's photographs: "It is ourselves we see, ourselves lifted from a parochial setting. We see what we have not heretofore realized, ourselves made worthy in our anonymity" (Szarkowski 16).

All of Evans's critical success set a lofty standard for Agee to contemplate as he labored over several years to turn his finished but unpublished article for *Fortune* into a book.[6] Indeed, Agee's major revisions took place during 1939, the year after Evans's *American Photographs* retrospective. Called "Three Tenant Families" when in progress, the book was published two years later as *Let Us Now Praise Famous Men.* Agee's title derives from the Christian apocrypha, and it represents how his work evolved from a documentary study of tenant farming in the original article to a modernist intertext focused on the subjective recreation of tenant life in visual and verbal art (Bergreen 126). Because Evans's photography challenged Agee's literary imagination, the conflicted responses in these new chapters reveal Agee's creative anxiety. This artistic agon becomes clear even as his references to those photographs emerged as an important focus within the loose organization of *Let Us Now Praise Famous Men.*

Just as Evans's arrangement of his topical matters in Book One roughly approximates the spatial boundaries of their Alabama setting, so Agee's narrative organization generally follows the chronology of his and Evans's stay. Like the modernist novels both men admired, the narration here is far from straightforward. Agee makes several awkward attempts at a start, meanders about his topics in the development of his book, and concludes abruptly without any real resolution. A preface, three epigraphs, and a table of "Persons and Places" precede two pages of contents Agee hopefully names "Design of the Book." It lists some

eighteen additional sections, including another introductory gather-
ing consisting of "Verses," "Preamble," and "All Over Alabama." The
seemingly logical organization of the succeeding parts "One," "Two,"
and "Three" is complicated when Agee parallels other parts he names
"July 1936," "Colon," and "Intermission." He counterpoints the factual
matter in these parts with longer subjective reflections in three con-
trasting sections titled *"(On the Porch: 1,"* *"(On the Porch: 2,"* and *"(On
the Porch: 3"* [sic]. In turn, each of these sections is subdivided into many
subsections: some are titled, some are numbered with both Roman
and Arabic numerals, and some are neither titled nor numbered. The
writer's plan perhaps is intended as a modernist pastiche on the model
of a traditional documentary—one reflexively demonstrating its generic
inability to comprehend a subject of such significance, complexity,
and urgency. In the execution of that plan, however, Agee's Book Two
becomes more an assemblage of individual takes on his subjects and
themes, a gathering that ultimately mirrors the montage principle in
Evans's organization of his family albums in the photographic Book One.

In my reading of *Let Us Now Praise Famous Men,* its thematic ordering
of Agee's multiform reflections on the tenant families is best seen in
three focal patterns of material, religious, and photographic imagery.
The longest of Agee's three epigraphs is titled *"2. Food, Shelter, and Cloth-
ing,"* and it is taken from an introduction in a third-grade geography
text belonging to one of the tenant children. Agee's subchapters here—
"Money," "Shelter," "Clothing," "Education," and "Work"—then docu-
ment the place of these universal human needs in the lives of the three
tenant families. The subtitles recall not just the child's geography but
Thoreau's "Economy" chapter from *Walden,* as in his more documentary
chapters Agee depicts the agricultural poor forced into the involuntary
practice of Thoreauvian economics. Unlike in its nineteenth-century
example, this economic regimen works mostly for the worse; yet, like
Thoreau's experiment, it sometimes operates for the better in spiritual
if not in material terms. Both the earlier account of a rural retreat by
the classical naturalist Thoreau and this sprawling observation by the
Christian humanist Agee are rife with religious imagery. In both books,

the allusions prove for the most part Christian, but in Agee's case they more specifically Anglo-Catholic. Several subsections are titled after elements of the Mass, including "Gradual," "Reversion," and "Introit"; other sacraments and sacramentals are found, and the texts of Christian prayers and scriptures are included. These images prove integral to Agee's narrative, as his experience in Alabama is marked by frequent acts of contrition and communion.[7]

The rich prose in *Let Us Now Praise Famous Men* likewise is permeated by photography—both as subject when Agee discusses its practice, especially by Evans, and as product when Agee verbally recreates actual photographs, most importantly those Evans made in the summer of 1936. Instances of the first sort appear throughout the book, but late in his process of composition Agee added substantial examples near his introduction and conclusion. In the final order of Agee's narration, the subsection "Near a Church" tells how the collaborators interrupted their hunt for white tenants to explore an empty black church. After he "helped get the camera ready," Agee also considered the best angle for Evans's shot, "searching out and registering within myself all its lines, planes, stresses of relationship" (48). The writer's loving focus on the church's rough façade clearly matches the photographer's care in framing, balance, and lighting. Yet the remainder of this interpellation dramatizes their differences as well. While the two white men wait for the sunlight to strike their subject at its best angle, "a young negro couple came past up the road" (49). Agee pursued them in a self-conscious attempt to get their consent for Evans to enter and photograph the sanctuary. The awkward dialogue that ensues is important as one of the book's few references to blacks (though African Americans were the majority in the immediate area) and for Agee's consciousness of their agency as subjects for him and Evans. For example, he "had no doubt that Walker would do what he wanted whether we had 'permission' or not"—exactly what transpired when Evans was left at the church (50).[8]

Like his introductory example, Agee's concluding one also demonstrates his pervasive patterns of material, religious, and photographic images. It becomes even more subtle and ironic in its evocation of this

imagery because it consists of an extensive quotation of several pages. In subsection 3 of Agee's penultimate part, "Notes and Appendices," a substantial article first published in 1937 about the photographer Margaret Bourke-White is reprinted "by courtesy of the New York *Post*," which Agee, in his only editorial comment, notes is "a liberal newspaper" (385). Perhaps his appendix is anticipated in his "Preamble," where he asserts that his belief in the camera's centrality to documentary representation during the 1930s also led him to "rage at its misuse, which has spread so nearly universal a corruption of sight that I know of less than a dozen alive whose eyes I can trust" (26). If by implication Evans was numbered among them, Bourke-White surely was not. Along with the exaggerated details endemic to a feature piece on a "Famous Photographer," Agee replicates those parts of the *Post* article concerning her southern excursion with the writer Erskine Caldwell that was published as their *You Have Seen Their Faces* in 1937 (382). Bourke-White is commended for the guile she used to insert herself among the flock of a "Negro preacher" to photograph him from a dramatic angle that emphasizes his emotional oratory (383). Everything in her account, even allowing for exaggeration by her worshipful interviewer, stands in pointed contrast to the attitudes toward material culture, religious belief, and photographic documentary revealed in Agee's earlier subsection "Near a Church."

Agee's narrative line in Book Two of *Let Us Now Praise Famous Men* is ordered by the products of the actual photographic process as well, for his writing consistently references and recreates real photographs. Most important are the ones Evans made during their Alabama stay, of course, though other products of photographic practice are found throughout. Examples include allusions to efforts by well-known photographers Agee admired, such as Mathew Brady, Henri Cartier-Bresson, and Helen Levitt—as well as those he disparaged, such as Margaret Bourke-White, who is satirized verbally as "maggie berkwitz" (303, 387). Anonymous pictures in publications such as textbooks, popular magazines, and newspapers are mentioned, as are simple snapshots of the sort found in the tenant families' albums and on their walls. These various pho-

tographic productions are seen within Evans's pictures as well, most often as details within the framing of his interior shots—the close-up of family photos and calendars tacked over the Tengles' fireplace, for example. These intertextual references seem documentary, at least on Agee's part, while Evans's instances of them more fully recall the sense of time and death in the critical theory and practice of Roland Barthes and Susan Sontag.

Although some of this intertextuality may be incidental to other documentary or artistic purposes, the very composition of Evans's prose and Agee's photos makes clear that much of this self-reference is consciously intended. Most arresting in Book Two are the imprints of Evans's visual images that are to be traced within Agee's verbal ones. Such traces are not mere illustrations of the written text, as in other examples of the photo book. Again, this was one reason that *Let Us Now Praise Famous Men* was divided into the visual Book One and the verbal Book Two. Yet some documentary patterns of visual allusion support the prose; when Agee describes different types of work clothes in his subchapter on "Clothing," he demonstrates his point by telling his reader that "Ricketts in his photograph here, wears such overalls" (235). Several passages seem to recreate particular photographs, whether consciously or not. In fact, it seems probable that some of Agee's detailed descriptions were written with Evans's pictures as aids to his memory. The photographer's most recent biographer surmises, "Some descriptions in the book read as though Agee had Evans's detailed photographs in hand while writing the text," for example, the passage about the coal-oil lamp in "A Country Letter" (Mellow 33).

The most intriguing correspondences in Book One, however, are those where Agee's written depictions contest directly with Evans's photographic ones in a modern variation on the classical literary trope of ekphrasis.[9] Among Agee's synergies of ekphrasis in *Let Us Now Praise Famous Men,* those passages competing with the individual or group portraits seem the most significant examples, a conclusion that may find support in the writer's frequent agonizing over the inadequacy of his language to capture the full humanity of the Alabama tenants. Evans's

iconic portrait of the youngest farmer, Floyd Burroughs, is presented by means of a head-and-shoulders close-up; his determined, anxious stare is complemented by his worn overalls and work shirt and set against the grainy pine siding of his house.[10] Indeed, the subject's steady reflection of the camera's gaze seems the locus of interchange between life and art, artist and subject, as in Barthes's theory of a photograph's "punctum," or point. The overall contexts of Burroughs's close-up would correspond to Barthes's "studium," while his and Sontag's themes of time, death, and memory are everywhere implied. Evans's image of Burroughs introduces the same paired qualities of privation and perseverance seen in the individual and group portraits that follow, often the images most appreciated by later cultural historians and art critics.[11]

Agee renames the youngest of the tenant farmers George Gudger, picturing him as "a modification of the Leyendecker face, brick red, clean shaven; a medium-height, powerful, football player's body modified into the burlings of oak and into slow square qualities blending those of the lion and the ox" (238). The poetic diction of "burlings" seems especially apt here, as a "burl" or "burr" is the rounded outgrowth of a tree, evocative both of Burroughs's sinewy form and of the knotted grain in the unpainted pine wallboards against which Evans posed his subject. In his images of oak, ox, and lion, Agee recalls archetypal legends of human transformation within the natural world. His allusion to other visual art, ironically in "a modification of the Leyendecker face," suggests modern America's myths of social evolution through economic success. Joseph Christian Leyendecker was also a visual artist dealing in archetypes—not a photographer but a magazine and advertising illustrator whose images probably were among those decorating the interior walls of the tenant houses. His most enduring creation was the "The Arrow-Collar Man," as much an icon of the 1920s—one reflected in F. Scott Fitzgerald's portrait of Jay Gatsby sporting his beautiful shirts—as Evans's iconic portrait of Burroughs became for the 1930s in the decades following the publication of *Let Us Now Praise Famous Men*. Even a glance at Leyendecker's illustrations confirms Agee's analogy, while demonstrating the difference in intention and representation

between a real and a fictive photograph in the way that Katherine Henninger has so ably defined. As seen by Evans, Burroughs is possessed of the physical features that Agee reflects in his description of Gudger; this description was part of the creation of an American archetype often found in Depression-era fiction and film, a natural hero such as Tom Joad in John Steinbeck's *The Grapes of Wrath* (1939).[12]

Agee's descriptions of other tenants—in particular, those he calls Annie Mae and Maggie Louise Gudger, Fred and Sadie Ricketts, and Bud and Ivy Woods—also exist in ekphrastic tension with Evans's pictures of Allie Mae and Lucille Burroughs, Frank and Flora Tengle, and Bud and Lily Fields. Likewise, the visual and verbal texts of *Let Us Now Praise Famous Men* contain literally dozens of additional examples of the sorts of photographic practices and products developed above—of documented photo shoots and reframed magazine pictures, of individual portraits from small-town studios and snapshots from family albums. All of these images, whether verbal or visual, thus become photographic tropes in the sense I have formulated here, reflecting not just the material culture that produced them but each other—like a gallery of mirrors. Each reflection reveals aspects of its own time and place, ones that are then compounded by all of the others to reveal diverse languages and visions before unheard and/or unseen.

The cotton country of Alabama observed by Agee and Evans thus emerges as an artistic microcosm of the human macrocosm, "*The Great Ball on Which We Live,*" to recall the language of the tenant child's geography text (14, emphasis in original). The record of this exceptional collaboration by writer and photographer becomes nothing less than a southern masterpiece, one recognized today as recalling the influence of those great books by Thomas Wolfe or William Faulkner that came before it, while anticipating those by Eudora Welty or Robert Penn Warren which would appear after and reflect its influence.[13] Yet the complementary and conflicting visual and verbal intertexts Agee and Evans created can be appreciated best as providing a focus on the dialectical work of cultural representation in the South of the 1930s and after. Rooted in the new documentary realism of the Depression

decade, the final record of their Alabama project was influenced by the enduring modernism that shaped the writer's and the photographer's artistic programs. In 1936, the initial texts created by Agee and Evans found their beginnings in documentary and realistic representation, but their revision of the work that became *Let Us Now Praise Famous Men* in 1941 concluded as a notable instance of modernist subjectivity and re-flexivity—one that reflected its own problematic times and anticipated difficult years ahead when it was republished in 1960.

THREE

William Faulkner, Photography, and
the Dialectic of the 1930s

Although not as closely or intensely as James Agee, William Faulkner
was personally connected with and artistically engaged by photogra-
phy during the 1930s. This aspect of Faulkner's career and canon has
received extensive scholarly and critical attention already, much like
every other component of the writer's life and work. However, Faulkner
and photography have been considered most often from the perspective
of literary modernism. This critical context remains appropriate, of
course, as Faulkner was the consummate American modernist in fiction.
Moreover, the most celebrated instances of Faulkner's photographic
tropes are marked by the subjective and reflexive matters of modernist
narrative.[1] Recent Faulkner criticism has located the writer and his work
within different contexts during the 1930s, including concerns—such as
realism and naturalism, economics and politics, or popular art and cul-
ture—that affected photography as well as literature.[2] Faulkner's varied
interests in photography also indicate his place within the informing
dialectic of cultural representation presented in Chapter One. Such a
dialectical approach to Faulkner, fiction, and photography illuminates
aspects of his career and elucidates works within his canon during the
Depression era, the years that also are accepted as his most productive.
Criticism on Faulkner and photography has centered on essentially
modernist novels like *Sanctuary* (1930) and *Absalom, Absalom!* (1936),
while my focus is on fictions less often considered: *Pylon* (1935), *The
Wild Palms* (1939), and *Go Down, Moses* (1942), all of which strike a

complicated balance between subjective modernism and documentary realism.

 Born in 1897, Faulkner grew up with the twentieth century and its many innovations, including the technology that enabled anyone who could afford a Kodak and a roll of film to become an amateur in the photographic arts. Like most aspects of his literary consciousness, the young Faulkner's visual sensibility was formed by the legacy of his southern family. In her recent study, *Faulkner and Love: The Women that Shaped His Art* (2009), Judith Sensibar views photography as just one element of Faulkner's artistic sensibility that was influenced by his mother. Maud Butler was an aspiring painter before her marriage into the Falkner family, and after it she tinted photo portraits to subsidize art supplies purchased for herself and her children (Sensibar 137, 165). His mother not only encouraged Faulkner in his drawing and painting, but she helped him obtain his own camera (527, n. 13). Young William was fascinated, and he soon showed an increasing talent in using it, particularly in taking trick photographs. As several scholars have noted, the maturing writer became a habitual poser; he created photographic images of himself as an Ivy League frat boy, a decorated flier in the Great War, and a cosmopolitan dandy—this last pose perhaps the source for his Oxford nickname of "Count No 'Count" (Watson 21, 35). As with his pursuits in the other visual arts, Faulkner's photographic efforts were subsumed in his literary development, but he would return to them later in his life and his work.

 Faulkner's earliest fiction presents surprisingly few photographic tropes, given his use of photos as symbolic elements in his self-definition as a person and an artist. Two interesting but relatively unremarked examples are found in "The Leg," a story of the First World War written during 1925 but not published until 1936, and in *Flags in the Dust*, his first Yoknapatawpha novel, written during 1927 but not published until 1929 in a shortened form as *Sartoris*. Faulkner's initial uses of fictive photographs as symbolic tropes presage his modernist practice later, though both early instances are located within traditional narrative structures. "The Leg" proves a strange mixture of war story and super-

natural tale. An American volunteer in the Royal Flying Corps loses a leg in aerial combat, and he is haunted by phantom pains while he is dying. The American pilot is also pained by memories of an innocent British girl he abandoned who later committed suicide; her brother, also an aviator, finds a photograph of her seducer, which the surviving Englishman uses to seek closure. The picture represents the mystery of the tale, as it was taken in England during the first full summer of the war while the wounded pilot lay dying in a French hospital. Faulkner never explains this difficulty, and he leaves the survivor gazing at the ghostly image, perplexed by its puzzle. In my reading of the tale, Faulkner seems to be pondering the reality of a photograph as a document, much as the protagonist is discovering his own shadowy selfhood within the mysterious picture he contemplates. Thus the ambiguities of time, death, and memory are evoked by this fictive photograph, recalling the formulations of Roland Barthes, Susan Sontag, and other theoretical critics of this graphic art form as a language of vision.

The tensions between the documentary and subjective uses of the photograph that also suggest its complex relations to the movement of time, the enigma of death, and the permutations of memory are evident in a second early example from *Flags in the Dust*. Again, the novel is concerned with the effects of the First World War, though Faulkner considers them here within the setting of Yoknapatawpha. This generational saga of the Sartoris clan is based to some extent on the writer's own family, though with exaggerated genealogical doubling when the generations produce mirrored pairings of doomed men. In the final reiteration, twin brothers John and Bayard Sartoris have served as pilots on the Western Front, where John was killed on a suicidal Armistice Day mission. Just as the surviving flyer in "The Leg" discovers his darker double in that story's inexplicable photo, Bayard encounters his own mirror image in a photo of John, his identical twin and, in some senses, his better self. This photo of John at Princeton before the war is an image of lost innocence for both brothers; Bayard burns this symbolic image, attempting to escape the memories and emotions it evokes. The destruction of John's picture becomes the end of Bayard's

brighter prospects, embodied in his love of family. The novel ends with Bayard's rejection of a future as husband and father, and he dies in a crash during a dangerous test flight, far from his family, on the day his son is born at home.

Several others of Faulkner's fictions involve aviation and photography, ranging from stories written in the early 1920s to his late novel *A Fable* (1954). A pair of short narratives centered on flight and focused by photographs are "Ad Astra" and "All the Dead Pilots"; they were first published in Faulkner's initial story collection *These Thirteen* (1931), though both pieces were written earlier. In the first story, a German pilot, who has deserted to the Allies on November 11, 1918, burns his identity papers and the pictures of his family in an act of self-destruction prefiguring that of the Sartoris brothers. The dead pilots of the second story include those killed on the Western Front and others who die barnstorming in war-surplus aircraft at home. Their juxtaposed pictures become a sort of photomontage that helps to shape this fragmented narrative, the narrator of which was an aerial observer equipped with "a synchronized camera" during the war (*Collected Stories* 512). "That's why this story is a composite," its narrator tells the reader, "a series of brief glares . . . in an instant between dark and dark" (512).

Although *Flags in the Dust* and the aviation stories are rife with the disillusion and anxiety of the Lost Generation that is often associated with American modernism, they are presented in more traditional narrative modes such as the ghost story or the family saga. After his extensive apprentice work in the 1920s, Faulkner revealed his debt to international modernism in both the matter and form of *The Sound and the Fury* (1929), a novel that contains few photographic tropes of thematic consequence. *As I Lay Dying* (1930), which quickly followed, is more profoundly influenced by modernist techniques in the visual arts, Cubism in particular, though again with few photographic examples. This absence is perhaps explained by the material poverty of the Bundrens, a family as deprived as Agee's tenants, people too poor for studio portraits or for cameras and film. This is not to say that the Bundrens' epic quest to bury their matriarch is a Depression book as such. Like

The Sound and the Fury, As I Lay Dying was written and set in the 1920s, and in both books Faulkner is more concerned with projecting the individual psychology and subjective perception of his characters than with documenting the social causes or consequences of their collective behaviors.

Faulkner's next published novel, *Sanctuary* (1931), presents another complicated example of his literary development during the Depression decade. Faulkner claimed that the book was his attempt at popular success, written in sardonic response to the commercial failure of his earlier efforts. Unfortunately, his remarks about *Sanctuary*, coupled with the popularity generated by its sensational matter, limited serious consideration of the novel until quite recently. Yet when Faulkner read the first proofs of *Sanctuary*, he revised the manuscript extensively and paid part of the costs out of his royalties (Blotner 268). The initial version of the novel was an uneasy amalgam of conventional material about the anxious lawyer Horace Benbow, excised from *Flags in the Dust* for its publication as *Sartoris*, combined with new and somewhat explicit matter concerning his niece Temple Drake. Faulkner shortened this ungainly amalgam in an attempt to create a novel that "would not shame *The Sound and the Fury* and *As I Lay Dying* too much" (quoted in Blotner 270). As published, *Sanctuary* is much closer in narrative form to Faulkner's two novels in a modernist mode than to its first version, which is more like his apprentice fictions.

One significant difference between the first and second versions of *Sanctuary* can be discovered in their differing uses of photography. Because the original manuscript was longer, it presented a larger number and greater variety of photographs. Those examples retained in the published novel complement its modernist manner by emphasizing the subjectivity, reflexivity, and ambiguity of both character and plot. These photographic tropes have received much critical attention, however, readings that generally see Horace's complicated reaction to his stepdaughter's picture as symbolic of his incestuous desire for Temple. His psychological reaction thus unites the two major strands of the revised narrative by pairing the ineffective lawyer, husband, and father figure

with the impotent gangster Popeye. These earlier readings are so numerous and accomplished that I need not rehearse them here. Instead, I consider several intriguing photographic tropes from the first version that were excised in the published novel.[3] These examples suggest not just Faulkner's earlier connections with literary realism but his concern for social contexts that would reappear in his fiction as the Depression years unfolded.[4]

The most interesting instances of photographs excised from the published version of *Sanctuary* are seen in a picture gallery that limns the visual history of the Sartoris clan. These pictures have been collected by the family matriarch, Miss Jenny DuPre, and arranged around the walls of her sitting room. Her collection of Sartoris portraits serves as a rough history of southern photography; the modes as well as the subjects change over the generations. "The first was a faded tintype in an oval frame" of the first John Sartoris, Faulkner's recreation of his great-grandfather, called the "Old Colonel" in honor of the rank Faulkner's model and his fictive counterpart held during the Civil War (Langford 25). The generational line of Sartoris males follow in order (again roughly recreating the genealogy of Faulkner's own family) in "light stained, faintly archaic" depictions and later in "conventional" photographs (Langford 25). The recent generation appears in a series showing the lost twin brothers John and Bayard, starting with a studio pose of the young boys in curls and ending with "a hasty snapshot" of Bayard mounted in his pursuit aircraft during the war, seemingly "shouting or laughing" in moments now made into "travesties by dead celluloid" (Langford 26). This passage suggests not just Faulkner's awareness of photographic history but his sense of photos as artifacts evoking the movement of time, the perplexity of death, and the problem of memory. These several graphic texts in the Sartoris family gallery reveal the psychology and individuality of its subjects, as well as their social and cultural contexts, in a realistic, objective mode that will become apparent in Faulkner's fiction in the 1930s.

Faulkner's engagement with the social matters and realistic themes of the Depression decade really begins with *Light in August* (1932). This

substantial, powerful, essentially naturalistic novel nicely balances the writer's experimentation with modernist modes and his evolving sense of the era's economic and social problems, especially in their most extreme manifestations in the South, such as racism and lynching. Its lengthy narrative includes only a few photographic tropes, though these few prove to be interesting and important ones that prefigure Faulkner's dialectical use of these tropes throughout the decade. There are several references to newspaper photos following the suicide of Hightower's wife. Some are of Hightower himself, and he is also a photographer of sorts. The emblematic sign he erects advertising the services available in his decaying house mentions, among others, "Photography Developed," though like his other offerings there are "few enough . . . photograph plates" (50).

In contrast to these telling yet rather ordinary images, a brilliant photographic trope involving Joe Christmas demonstrates Faulkner's modernist complexities. In Chapter 5, Joe is wandering a country road, angry after a midnight confrontation with his housemate Brown, who has called him a "nigger," when a car overtakes him, its headlights' glare revealing Faulkner's modern take on the "tragic mulatto." "He watched his body grow white out of the darkness like a kodak print emerging from the liquid" (94). Faulkner's simple sentence encapsulates Christmas's racial dilemma. The photo print forming in the developing fluid reveals him as white, while in the negative from which it was created he is black. In addition to Faulkner's exposure of the southern construction of race, this trope also suggests the writer's personal familiarity with the entire photographic process.

In several ways then, *Light in August* makes an appropriate conclusion to the initial phase of Faulkner's great achievements. In just over three years, Faulkner had published five significant novels, but it would be another three years before his next novel appeared. This break in his remarkable productivity had several causes, personal and professional. In 1929, Faulkner married his childhood sweetheart, by then divorced with two small children, and in 1930 he assumed the mortgage of the extensive and neglected property he named Rowan Oak. With these

new financial obligations, Faulkner turned his talents to writing that
promised more immediate monetary rewards, such as short fiction for
slick magazines and scripts for movie studios. Over these same years,
however, the writer worked on a long fiction connected in many ways
with his earlier modernist efforts, a book that would ultimately be-
come *Absalom, Absalom!* in 1936. In 1935, Faulkner quickly wrote and
published *Pylon* (1935), a contemporary narrative probably intended to
achieve the same popular success as *Sanctuary*, as well as a break from
the long and difficult genesis of *Absalom, Absalom!*

Pylon has been generally ignored by Faulkner's critics until even more
recently than *Sanctuary*, and for many of the same reasons. Perhaps
Pylon has been obscured by the long shadow of Faulkner's succeeding
novel, *Absalom, Absalom!* Judged by many as his greatest work of fiction,
Faulkner's epic of southern history is also an unmistakable homage to
international modernism. This complex narrative traces not just the life
and times of Thomas Sutpen, a nineteenth-century southern patriarch,
but the reconstruction of his legend and legacy by several narrators
in the twentieth century. Another modernist aspect of the novel is its
brilliant use of photographic tropes. As with those photographs that
persisted into *Sanctuary* as published, those found in *Absalom, Absalom!*
not only reveal character and shape plot but develop intricate questions
regarding representation and perception. This sense of a photograph's
meaning as subjective for the character who views it, its *punctum* in
Barthes's terminology, leads Sensibar to view Faulkner's images here
as "photographs of desire" (226). Her formulation includes the desires
of characters photographed in the past as well as those of the narrators
reading the images in the present. Sensibar's connection proves espe-
cially telling in the case of Rosa Coldfield, who is the only character
who could have seen Judith Sutpen's picture of Charles Bon or Bon's
of his biracial mistress and their child. Such ekphrastic readings have
received close attention from the critics already, much as with those in
Sanctuary, and again I defer to the work of James G. Watson, Katherine
Henninger, and Sensibar regarding gender, race, and class as reconsid-
ered in these photos.

Let me turn instead to *Pylon* and to its more realistic, objective, and documentary manner, including its photographic tropes perhaps created under the influence of documentary examples foregrounded during the Depression decade. In some ways, *Absalom, Absalom!* and *Pylon* could be read as two dissimilar novels by two rather different authors. Some recent Faulkner critics, however, have connected the two novels from the mid-1930s by way of their shaping and reshaping of personal and cultural narratives.[5] In *Absalom, Absalom!*, the reconstructed narratives of the novel's historical characters dramatize the southern myth as centered by the Civil War using photographic portraits typical of that era, while in *Pylon*, the histories of contemporary characters represent the South during the Depression by way of more realistic visual documents. Born but a few years before its emergence, Faulkner grew up with aviation, and from his boyhood on he was fascinated by flight. In 1918, he enlisted in a Canadian reserve unit of the British Royal Flying Corps, but he did not win his commission or his wings. This flying experience is reflected in his early fiction, which is filled with lost, dying, and dead pilots. After his marriage, Faulkner earned his pilot's license and bought his own plane. During Mardi Gras week in 1934, he flew it to an air show celebrating the recently built airport in New Orleans. His hectic days and wild nights there would provide him with the sensational materials for another novel meant to achieve the popular success of *Sanctuary*, which was sold to Hollywood and made into a forgettable movie entitled *The Story of Temple Drake* (1933).

In significant contrast with those in *Absalom, Absalom!*, the photographs seen in *Pylon* are focused more by machines than by people, by planes more than by pilots. Faulkner announces this visual motif on his opening page, where he carefully describes a ubiquitous poster advertising the regional airshow. This initial example is located in the window of a fashionable men's store, juxtaposed to a pair of expensive riding boots evoking the past, "horse and spur . . . the posed country life photographs in the magazine advertisements" (*Complete Novels* 2:779).[6] The airshow ads include contrasting "photographs of the trim vicious fragile aeroplanes and the pilots leaning against them in gargantuan

irrelation." Faulkner develops this modernist image as a full-blown photographic trope: "as if the aeroplanes were a species of esoteric and fatal animals not trained or tamed but only for the instant inert." Although the ultimate purpose of these visuals is to sell tickets to the airshow, they do so by appropriating heroic imagery past and present, from the wild horses of southern tale-telling to the daring machines of modernism. It is interesting that the actual airshow poster that Faulkner saw in New Orleans was a drawing of three sleek aircraft in the style of European futurism rather than the photo-documentary that he recreates for his purposes in *Pylon*.

These iconic images of planes and pilots are reiterated throughout the novel, most significantly on the first page of an "Airport Dedication" special edition of the city's newspaper. The photograph is placed below the fold of the front page, and above it appears a close-up picture of the local politician whose ambition and guile shaped this new cultural construction in his own image. Although the special edition, like the airport, is dedicated to "The Aviators of America," it is really focused on "the photograph of a plump, bland, innocently sensual Levantine face beneath a raked fedora hat," the visage of the city father after whom the airport is named (*Complete Novels* 2:789). As *Pylon* unfolds, the inauguration of the waterfront aerodrome will reconfigure the four ancient elements—earth, air, fire, and water—in a full panoply of ceremonies celebrating the death-defying feats of these lost pilots. The sacrificial aspect of these dedication games is presented visually and verbally in the lobby of the city's most luxurious hotel, which also serves as the headquarters for the inauguration week. Faulkner's imagery is more modernist in its manner and symbolism here; the allusions to Pilate's ironic proclamation nailed to the cross where Christ died suggest the sacrificial aspect of the fiery crash that mars the air races. One of the victims is the pilot in Faulkner's ménage à trois that includes a female wing-walker and a male parachute-jumper. Even this bizarre love triangle could not generate the sensational success of *Sanctuary* for *Pylon*, however, and Faulkner was forced to return to writing for the magazines and the movies.

Roosevelt's second presidential term in 1936 marked the midpoint of the Depression in several senses. The persistence of economic hard times encouraged even more political and social experimentation, which in turn was greeted with increasing skepticism by many. American culture and art, including literature and photography, had absorbed the changes of the 1930s more slowly, however, and they were still evolving in realistic manner and documentary style, often under the influence of programs like those of the Farm Security Association (FSA) or the Works Progress Administration (WPA). Although Faulkner did not have the direct connections with these developments that some of his contemporaries in southern letters did, he sometimes seemed aware of and perhaps was influenced by them. Indeed, the writer's political position during the Depression was ambiguous and often contradictory. He did support several antifascist efforts, and in 1938 he donated the manuscript of *Absalom, Absalom!* to a literary group supporting the Loyalists in the Spanish civil war (Blotner 411). On the domestic front, Faulkner was much less of a liberal, especially after he purchased the country property he named Greenfield Farm in 1938. Like his Mississippi neighbors, Faulkner reacted against New Deal social and agricultural programs, and he expressed his resentment by naming his livestock after President Roosevelt's advisors (Blotner 412). Jests like these would find more thoughtful outlets later in the stories of his last great fictional effort of the Depression era, *Go Down, Moses* (1942).

In addition to stories for magazines and screenplays for Hollywood, Faulkner would complete two books of fiction during this period, *The Unvanquished* (1938) and *The Wild Palms* (1939). The first of these is a short fiction cycle, one comprised of Faulkner's related and sequenced stories of the Civil War and Reconstruction which had appeared earlier in magazines, and it was probably intended to profit from the popularity of *Gone with the Wind* (1936), which had completely eclipsed *Absalom, Absalom!* that year. Even with his movie industry connections, Faulkner was unable to sell the screen rights to his great novel, though he was successful in selling the rights to *The Unvanquished*. Just as the movie sale of *Sanctuary* had enabled the writer to buy Rowan Oak, the then-

substantial sum of $25,000 he received for his new short fiction cycle financed the purchase of Greenfield Farm (Blotner 392). *The Unvanquished* proved a popular failure, however, and it was never adapted as a film. The book's critical reputation has been modest until quite recently, when it has been better received as a real Depression book despite its setting in an earlier period. Several recent critics have noted that viewing the economic collapse through the cultural memory of the Civil War was a popular project of the 1930s.[7]

The Wild Palms perhaps reveals Faulkner's best balance of the dialectic between documentary realism and subjective modernism that informed the Depression years—particularly in its photographic tropes. Under the overall title *If I Forget Thee, Jerusalem,* Faulkner constructed and intercut two parallel narratives, "The Wild Palms" and "Old Man." When he finished this project, his publisher balked at the narrative experiment and the overall title. Faulkner was able to keep his intercalary structure, but he lost his title. The new book was published as *The Wild Palms,* a title that emphasized the more contemporary of the two narratives. Faulkner and his publishers evidently believed that the raw sexuality in this strand of the book might replicate the popular success of *Sanctuary.* In this naturalistic tale of two doomed lovers, the reader encounters adultery, divorce, and abortion. Perhaps aided by generally favorable reviews, *The Wild Palms* did make the *New York Times* bestseller list for its first week, but, as was the case with *Pylon,* total sales proved disappointing, and the book was soon forgotten and out of print.

The intricate parallelism of the dual narratives in *The Wild Palms* escaped even the more favorable reviewers as well as the early Faulkner critics. After Malcolm Cowley published "Old Man" by itself in *The Portable Faulkner,* it was often republished as an entirely separate novella. Although "Old Man" can be read and appreciated on its own, it proves even richer when read as Faulkner intended, in parallel with "The Wild Palms." In a sense, these paired narratives recreate the immense complications of sexuality and procreation as comedy and tragedy, with each of these contrasted modes defined in its broadest sense. "Old Man" refers to the Mississippi River, on which most of the action takes place during

the devastating flood of 1927. Faulkner's protagonist is a relief worker conscripted from a prison farm and called only "the tall convict." Sent in a rowboat to rescue a pregnant woman stranded by the rising flood, the tall convict and his new charge are swept away down the river. A succession of seriocomic adventures ensues: he saves her from the flood, delivers her baby, supports her and the infant by hunting alligators in a swamp, and finally returns woman, baby, and boat to the prison where his odyssey had begun months earlier.

Although photographs play little part in this narrative strand, given the often desperate and always primitive settings along the lower Mississippi, many of the prison farm and flood relief scenes do mirror the documentary pictures and films made during the later flood of 1937. FSA photographers including Evans captured striking images of flood refugees black and white in almost the exact settings of Faulkner's narrative. Footage of similar scenes was included in commercial newsreels as well as documentary films like Pare Lorentz's *The River* (1937), a short feature made to support New Deal flood control projects such as the Tennessee Valley Authority. Literary critics have made similar connections. Henninger compares Faulkner's descriptions of a conscripted chain gang, including the tall convict, with FSA photography (126). "While the two guards talked with the sentry before the tent the convicts sat in a row along the edge of the platform like buzzards on a fence, their shackled feet dangling above the brown motionless flood out of which the railroad embankment rose" (*Complete Novels* 3:539–40).

Faulkner's description of a scene in which the convict returns to the rail junction where he started his sojourn is reminiscent of FSA images. "[T]here was a store at the levee's lip, a few saddled and rope-bridled mules in the sleepy dust, a few dogs, a handful of negroes sitting on the steps beneath the chewing tobacco and malaria medicine signs, and three white men" (*Complete Novels* 3:683). In particular, Evans's fondness for country stores, advertising images, and mule teams is quite comparable. Also notable is the intertextuality of words and images on the signs in both literary and photographic texts. Another intertext favored by Evans and his colleagues in the FSA is a picture of another

photo, or a visual text within a graphic text. Faulkner creates a parallel photographic trope to show that the tall convict and the rescued woman endure as much in a few months as most couples in a lifetime. "[T]he old married, you have seen them, the electroplate reproductions, the thousand identical coupled faces . . . among the packed columns of disaster and alarm and baseless assurance and hope and incredible insensitivity and insulation from tomorrow" (*Complete Novels* 3:667).

Among the multiple reflections of Faulkner's parallel narratives, the photographic trope that represents the struggles of the transitory couple from "Old Man" might also reference the several months of suffering endured by the forlorn pair at the center of "The Wild Palms." The history of this doomed couple also starts on the Mississippi; Harry Wilbourne is a medical intern in New Orleans, and Charlotte Rittenmeyer is a suburban wife and mother. Because both of them have unfocused artistic ambitions, the direction of their relationship becomes even more complex than that traced in "Old Man." The north/south pattern is reversed and then complicated with an east/west sojourn. Swept downriver on the floodtide, the couple in "Old Man" ventures into a harsh natural world, survives in it, and returns back up the river to where they began—tracing a comic curve climbing toward resolution. In the throes of their desires, the second pair flees northward, first to Chicago and then to a borrowed cabin in Wisconsin, but they complicate their travels by turning westward to a remote mining town in Utah and returning eastward. Their story arc develops as the downward curve of tragedy when a catastrophe strikes under the wild palms of the Gulf Coast. Charlotte sickens and dies after Harry botches her late-term abortion, and he is quickly arrested, tried, convicted, and jailed for life.

As in "Old Man," the rural settings in "The Wild Palms" are the sites of grim, naturalistic struggles. Urban locales like New Orleans and Chicago may appear less threatening, but they prove even more menacing during the depths of the Depression. The harsh aftereffects of the economic collapse are addressed by New Deal programs in these cities, but these efforts prove ineffective and pointless. At the same time, these multiple locations in "The Wild Palms" provide many instances of

photographic tropes representing the dialectic of modernism and real-
ism throughout the 1930s. Because of the couple's artistic connections,
many of the photographic references in their narrative consider this
visual medium as art rather than as documentation. In the summer of
1937, Harry and Charlotte meet at an artist's party in the French Quarter.
He is enthralled by the paintings displayed on the walls. "He had seen
photographs and reproductions of such in magazines" but not actual
paint on canvas (*Complete Novels* 3:519). For the more sophisticated
Charlotte, viewing this assemblage is like "trying to put together a jig-
saw puzzle with a rotten switch through the bars of a cage" (3:521).

This initial scene and its visual image of a puzzle reappear through-
out the Harry and Charlotte's ill-fated history together. In Chicago, their
first home is in a converted loft, "a big oblong room with a skylight in
the north wall, possibly the handiwork of a dead or a bankrupt photog-
rapher" (3:552). While Harry finds work in a venereal disease clinic,
Charlotte partners with an art photographer. "She was to make puppets,
marionettes, and he to photograph them for magazine covers and ad-
vertisements" (3:556). This scheme comes to nothing, and her artifacts
fill their loft, significantly, "like parts of a tableau or puzzle, none more
important than another" (3:557). These diminutive creatures and the
photos of them thus represent the couple's earlier lives that they left
in the past, especially Charlotte's two little girls, as well as their future
losses, especially her late-term fetus Harry aborts to effect Faulkner's
tragic conclusion. Faulkner portends their failure, as neither Harry nor
Charlotte ever ponders their future, individually or together.

After Harry loses his job at the clinic, they desert the Chicago loft
for a borrowed summer cabin on a lakeshore in northern Wisconsin,
but their Thoreauvian experiment fails as autumn turns to winter.
Charlotte is able to find holiday season work as a window dresser for a
department store on Chicago's loop, and they settle into the city once
again. Many of these urban scenes, including several WPA projects, are
presented in the style of New Deal art, particularly its documentary
photography. Harry wanders the streets looking for temporary work
and viewing the effects of the Depression on the cityscape. For example,

he imagines the odd picture he makes while sitting "on a sunny bench in a park among the bums and W.P.A. gardeners and nursemaids and children" (*Complete Novels* 3:552). All of the figures in this city scene are symbolically connected with the couple. Charlotte has left her children to the care of her forsaken husband and the nursemaids he hires, while Harry is differentiated from the vagrants only by the hope of "a W.P.A. job of some sort" (3:575). When Charlotte is laid off after the holidays, the couple is reduced to living on their meager savings, handling their few dollars "like pieces in a jigsaw puzzle" in a way that seems "a form of masturbation" (3:559).

Their luck seems to turn when Harry finds a job as the company doctor at a Utah mining camp, but a nightmare version of proletarian struggle ensues, an "Eisenstein Dante" as Faulkner elides filmic and literary allusions (3:621). Travelling backward and downward toward New Orleans, Harry lands a relief job in San Antonio, where he becomes the very picture of the faceless men lost in that era beneath his "cheap white bellows-topped peaked cap with a yellow band—the solitary insignia of a rankless W.P.A. school-crossing guard" (3:642). In San Antonio, Harry agrees to an abortion for Charlotte, which he tries to arrange but then performs himself to fatal results. Following his trial, conviction, and life sentence, Charlotte's husband offers Harry the means of suicide to escape his hard fate, but the tragic lover demurs. *The Wild Palms* then concludes with one of Faulkner's most famous passages: "*between grief and nothing I will take grief*" (*Complete Novels* 3:715, emphasis in original).

Published in 1939, *The Wild Palms* was Faulkner's final book of the Depression decade, but two additional volumes that he began during the 1930s would appear over the next few years: *The Hamlet* (1940) and *Go Down, Moses* (1942). *The Hamlet* was set in the Yoknapatawpha countryside just after the turn of the twentieth century, and Faulkner intended it as the first novel in a projected trilogy that would bring the central Snopes family into Jefferson and follow their evolution up to the present in the 1940s. The Second World War altered his plans, however, so that *The Town* (1957) and *The Mansion* (1959) were finished with altered writing schedules and chronological settings. Faulkner's

picture of rural poverty in *The Hamlet* must have been influenced by his personal experience during the 1930s, as well as by the decade's realistic art, but the novel does not reveal important examples of photography. In this way, *The Hamlet* at the Depression's end recalls *As I Lay Dying* at its beginning. Unlike the earlier novel, *The Hamlet* is not formed as much by formalism, so it seems closer to earlier social chroniclers that Faulkner had long admired, such as Dickens or Balzac.

Go Down, Moses marks the conclusion to the great years of Faulkner's career and canon, a period also informed by the dialectic of Depression-era documentary realism and subjective modernism. Like *The Unvanquished* four years before, Faulkner's new book essentially recycled short stories first published in magazines, and these seven pieces also are unified as a cycle by intertextualities within and among them. Faulkner felt his revisions of the short fictions for *Go Down, Moses* thus made it "a novel indeed," despite his publisher's addition to the title of the phrase "*And Other Stories*" (Blotner 437). Although some critics have agreed with its author's assessment, most have seen the overall narrative of *Go Down, Moses* as a grouping of discrete subsections and have placed interpretive emphasis on those parts that fit their reading of the work as a whole. A major division has developed between the three hunting stories set in the shrinking wilderness—"The Old People," "The Bear," and "Delta Autumn"—and the four others set around the central plantation—"Was," "The Fire and the Hearth," "Pantaloon in Black," and "Go Down, Moses." All seven titles chronicle the history of the McCaslin family, with the wilderness tales revealing the sins of its white members, and the plantation stories showing the costs for its blacks. In chronology, *Go Down, Moses* ranges from the nineteenth century to the present of the early 1940s, and the same years unfold within both sets of fictions.

Photographic tropes are found throughout *Go Down, Moses*, often involving the black branch of the plantation family. The visual and photographic construction of race can be seen as an ongoing concern in the southern literature that develops from the dialectic of the 1930s. As we have seen, Faulkner had explored this dynamic in *Absalom, Absalom!*, though his means were essentially modernist. In "The Fire and the

Hearth," the longest narrative in *Go Down, Moses,* he uses more realistic tropes to explore the biracial identity of Lucas Beauchamp, the patriarch of the plantation family's black branch in the present-day setting. Although Lucas's mixed-race heritage is not acknowledged by his white kin, Faulkner's narrative voice makes a forceful historical connection in describing him as a young man in the late nineteenth century. "It was the face of the generation that had just preceded them: the composite tintype face of ten thousand undefeated Confederate soldiers almost indistinguishably caricatured" (*Complete Novels* 4:83). The final twist of this extended metaphor is seen in the white cousin's misreading of the compounded tintypes' objective evidence of physical and historical realities. Thus, by the present of 1940, Lucas is in his late sixties, and his face is "a composite of a whole generation of fierce and undefeated Confederate soldiers . . . embalmed and slightly mummified" (*Complete Novels* 4:91). Faulkner's final manipulation of the image adds ironic nuances of meaning—suggestive of passing time, eventual death, and racial memory—to the cultural construction of race in the South.

In contrast to these complex turns on photographic images from the past, Faulkner's scenes of the present are created in the realistic style of New Deal art, including its documentary photography. For example, when Lucas searches abandoned buildings and wasted fields for a rumored Confederate treasure, Faulkner's descriptions resemble FSA photographs showing the aftereffects of failed conservation practices as the legacy of harmful plantation agriculture. Thus, Lucas views "a clump of ragged cedars, the ruins of old cementless chimneys, a depression that had once been a well or cistern, the old wornout brier- and sedge-choked fields spreading away, and a few snaggled trees of what had once been an orchard" (*Complete Novels* 4:71). Interesting comparisons of these fallen garden images can be made with the scenes Evans had photographed in Faulkner's Lafayette County on one of his first southern sojourns for the FSA only a few years earlier in 1936. After his purchase of Greenfield Farm it is possible that the environmentally conscious author reflected on these pictures or similar ones illustrating news or agricultural reports in local, state, and national publications.

Just as Lucas is central to the plantation stories concerning the black heritage of the family, his white kinsman Isaac McCaslin focuses the hunting tales. By his rights as the last descendent in the male McCaslin line, Ike should inherit the property, but he relinquishes it to his older cousin, McCaslin Edmunds, in a vain attempt to evade moral responsibility for the sins of the white fathers. Ike was orphaned early on, so his character has been shaped by Sam Fathers, a triracial plantation hand who leads the autumnal hunts into the Delta wilderness. The first hunting story is titled "The Old People" after Sam's Native American ancestors, and in it young Ike is initiated into the old ways of the wilderness now lost to civilization. The central story of the hunting triptych, "The Bear," chronicles the epic chase of a totemic bear, and its death is followed quickly by Sam's, thus marking the end of the wilderness life. Ike's repudiation of his plantation heritage follows when he comes of age. In the last hunting story, "Delta Autumn," he is nearing eighty in 1940 when he finally realizes the failure of his quixotic gesture at twenty-one.

On the long ride into the Delta for his final hunt, Ike views "the land in which neon flashed past them from the countless towns . . . on broad-plumbed highways, yet in which the only mark of man's occupation is the tremendous gins, constructed in sheet iron . . . the land across which there came now no scream of panther but the long hooting of locomotives . . . all that remained of the old time were the Indian names of the little towns" (*Complete Novels* 4:251). Although this extended Faulknerian sentence reveals the writer's balancing of documentary and subjective elements, it also reflects the photo-illustrated directions for automobile tours in *Mississippi: The WPA Guide to the Magnolia State* (1938) (315, 406–7, 411). In contrast, Faulkner dramatizes Ike's subjective vision of what this changing landscape means. "No wonder that the woods I used to know don't cry out for retribution! he thought: the people that accomplished it will accomplish its revenge" (*Complete Novels* 4:251). *Go Down, Moses* does not end with "Delta Autumn," however, but with the title story, in which the darker themes of racial crime and punishment are projected from past to present, into northern ghettos as well as southern plantations.

In 1941, the Pearl Harbor attack began America's direct involvement in the Second World War and signaled the end of the Depression. Following his failed attempts to enlist, Faulkner played no personal part in the war, but the cultural changes during these years made them a watershed in his life. The writer would produce little fiction of importance during the war, and by its conclusion he was nearly forgotten, with all of his novels out of print save for *Sanctuary*. In 1946, Malcolm Cowley's edition of *The Portable Faulkner*, along with Robert Penn Warren's influential review in the *New Republic*, began a critical reconsideration that saw the Yoknapatawpha saga as the principal achievement of modern American fiction. This conclusion was corroborated by Faulkner's Nobel Prize for Literature in 1950 and by the publication of his self-intended masterpiece *A Fable* (1954), an impressive if puzzling allegorical tale of the First World War. Faulkner continued to write and publish to both critical and popular acclaim until his untimely death in 1962, the same year that saw his final Yoknapatawpha fiction in *The Reivers*. In several senses, these late literary efforts seem like the writer's age work, looking back on his life and reworking his earlier narratives. In his final years, Faulkner seemed somehow lost in the contemporary South, especially in his conflicted personal response and his lack of a literary response to the civil rights struggle. His later work after the Second World War has received increasing scholarly attention recently, yet the critical consensus still locates the great works of his career in the Depression years, from *The Sound and the Fury* (1929) to *Go Down, Moses* (1942).

Faulkner's use of photographic tropes in his fiction waned, though his other connections with photography flourished. In a circumstance that must have pleased the aging artist, who at the beginning of his career posed for self-portraits, Faulkner, as postwar America's most revered writer, became a subject for well-known photographers, including Carl Van Vechten and Henri Cartier-Bresson.[8] Perhaps their attentions also revived the writer's personal interest in photography, now that he had the means and leisure to indulge in this pursuit. Like Faulkner himself, other photographers were fascinated by the visual aspects of Faulkner's "own little postage stamp of native soil," as he called the home place

that he recreated as Yoknapatawpha (*Interview* 57). The first and the most interesting of these photo-texts is Evans's "Faulkner's Mississippi," which was created on an assignment for *Vogue* in 1948. Evans had been interested in Faulkner since the early 1930s, and he visited Oxford, Mississippi, in 1936, shortly before his Alabama sojourn with James Agee. Evans's 1948 photo-essay of six magazine pages was comprised of a dozen quotations from the writer's fiction accompanied by thirteen pictures.

In one sense, this effort would be the first of many to visually recreate the writer's settings; later, photographers Martin Dain, Jack Cofield, William Eggleston, Alain Desvergnes, and George Stewart would also do it.[9] After Evans, Cofield is perhaps the most important, as he was a local photographer in Oxford, a personal friend of Faulkner's, and an adviser to the writer on his own photography. Dain and Desvergnes also began their photographic records while the author was still alive, so they are in some sense biographical sources on the writer as well as imaginative interpreters of his works. Eggleston is an important southern photographer who was influenced by Evans as well as by southern writers; his work is characterized by the imaginative use of color, and his photographic homage is the only one in these efforts to go beyond the symbolism of the black and white format. Stewart is also a fine photographer, though his sensitive visual interpretations of Faulkner's texts were created much closer to the present. These other visual readings are more extended, focused, and developed than Evans's magazine piece, but none capture Yoknapatawpha any better. Like Faulkner, Evans was a true artist, one who shared the 1930s dialectic of realism and modernism during the same era when the writer's work flourished.

Evans's image of nineteenth-century sculpture in a southern grave-yard directly inspired the writer's late fictionalized memoir "Sepulture South: Gaslight" (1955). Evans's picture was taken a decade earlier during yet another photo expedition through the South. In Mayfield, Kentucky, he encountered a bizarre cemetery gathering of fifteen statues depicting a local man, Col. Wooldridge, his family members, and even his pets. Writer and editor Anthony West, a friend of both Evans and

Faulkner, sent a copy of the photo to the author, perhaps recognizing similarities to the funeral monument of Faulkner's great-grandfather in Ripley, Mississippi, depicted in the final photo of Evan's 1948 *Vogue* piece. In 1954, West challenged Faulkner to use the Mayfield image as the basis for a story. In response, Faulkner wrote a piece recalling the funeral of his own grandfather that deftly balances between memoir and fiction. Evans's image shows the statuary from behind, with the figures seemingly moving away from the viewer toward the distant sky and eternity. Faulkner's now aging narrator describes the monuments: "all of them looming . . . stained now, a little darkened by time and weather and endurance but still serene, impervious, remote, gazing at nothing" (*Uncollected Stories* 455). Faulkner's ekphrastic response to these monuments of the southern patriarchy is more than realistic report or subjective vision; it is an ineffable conjunction of time, death, and memory that confirms the power of photography as the language of vision formulated in the theoretical work of Evans himself, as well as that of Barthes and Sontag.

This remarkable confluence between the creative works of the modern South's best writer and its foremost photographer provides an appropriate place to conclude this chapter. Faulkner's complex relations with photography already have been the subject of considerable scholarly and critical attention. Most of this consideration has been within the contexts of literary modernism, though some recent efforts have located the heart of the writer's career and canon within the Depression decade of the 1930s. Like Evans, Faulkner shared not just the formal tension between verbal and visual languages and visions that shaped the art of this era but the cultural dialectic of documentary realism and subjective modernism that informed it. In this sense, Faulkner and Evans remain not just the most important but the most influential figures in their respective art forms, from the past of the Southern Renaissance into the present of our postsouthern century.

FOUR

Robert Penn Warren, Photography,
and Southern Letters

Much like those of his colleagues in southern letters James Agee and William Faulkner, Robert Penn Warren's career and canon demonstrate a more than casual interest in photography. If not so directly as Eudora Welty and Ralph Ellison, both accomplished photographers in personal and professional terms, Warren became creatively engaged with photographic art in the 1930s and 1940s, along with many other southern writers. Several of these figures were directly involved with photo books during these crucial decades, and while Warren like Faulkner never created a text illustrated by actual photographs, his later remarks about Evans recall how documentary visual art in the Depression era opened the emerging writer's imagination to the power of the real inherent in the photograph to revise subjective perceptions of personal, social, and cultural realities. Evans and others thus influenced Warren in his use of photographic tropes to creatively transform the language of vision within several literary genres. All these developments prove most significant because Warren became the South's leading person of letters during the second half of the twentieth century, to some extent by extending the 1930s dialectic of reflexive modernism and documentary realism to new generations of southern writers down to the present.

Warren's fiction, poetry, and nonfiction have been more readily identified with the history and literature of the Civil War and Civil Rights eras, yet he came of age as a writer during the Depression and was shaped by its legacies. So the interest in photography Warren shared with

other southern authors in the 1930s and the 1940s may be attributed to the pervasive power of photography and film as graphic and popular art during these decades. As a contributor to the Agrarian manifesto *I'll Take My Stand* in 1930, Warren would have been intrigued by *Let Us Now Praise Famous Men* in 1941. Warren knew Agee's work as early as 1935, when he solicited a contribution from the younger writer for the inaugural issue of the *Southern Review* (Cutrer 52). Agee's biographer also notes that Warren applauded the younger writer's film criticism during the mid-1940s. "Agee's observations about movies so impressed the Librarian of Congress [Archibald MacLeish] that he showed them to his friend Robert Penn Warren, who felt sufficiently moved by them to wish that this fellow Agee apply his formidable command of film technique and history to the making—not merely the reviewing of movies" (Bergreen 281).

Warren was introduced to Evans's documentary photography by Agee's text of *Let Us Now Praise Famous Men* in the early 1940s and was acquainted personally with the photographer by the early 1950s in New York City. They were introduced by Warren's future wife, the younger novelist Eleanor Clark, who had posed for portraits by Evans. The two men were friends by the 1960s when they were colleagues at Yale, where they were as much visiting artists as teaching professors and surely discussed their creative works as well as their critical ones. Warren provided a laudatory and insightful dedication for a 1971 retrospective of the photographer's canon at the Museum of Modern Art; when the exhibition was reproduced in part as a portfolio of Evans's prints in 1972, Warren's dedicatory speech became its introduction. Evans also photographed the Warren family collectively in group pictures as well as individually, making portraits of Eleanor Clark during the 1950s, snapshots of the Warren children during the 1960s, and photos of the Warrens' celebrated dinner parties at their Connecticut home during the 1970s.

In her biography of Evans, Belinda Rathbone cites Warren as an astute observer of his friend's photographs, but, as is often the case with his incisive literary criticism, the writer's remarks prove as much

or more interesting for what they reveal about his own creative efforts. Recalling the 1930s many years later, Warren locates his initial realization of the photographer as artist in the example of *Let Us Now Praise Famous Men:* "The world that Walker Evans caught so ferociously in his lens thirty years ago was a world I had known all my life" (Rathbone 284). At first, he recalled "pleasure in simple recognition," but then "staring at the pictures, I knew my familiar world was a world I had never known" (284). A "veil of familiarity prevented my seeing it," Warren goes on to say, concluding that "Walker tore aside that veil; he woke me from the torpor of the accustomed" (284). According to Warren, the tensions of documentary realism and formal restraint in the photo images that Evans made during his stay in the Depression South concealed thematic complexity and psychological symbolism akin to literary texts by southern writers like Faulkner (285).

Warren was one of the earliest champions of Faulkner's genius. He first read the older writer's fiction as early as 1929, and he first wrote about it in an omnibus review of recent fiction that finished with his highest praise for Faulkner's short story collection *These Thirteen* (1932). Warren continued to produce insightful, influential criticism of Faulkner's fiction throughout his long career, always acknowledging the effect of that work on his own efforts. Warren's first published fiction, the novella "Prime Leaf" (1931), was written while he was a Rhodes Scholar at Oxford and, as he admitted later, homesick for the tobacco country of his youth. Decades after, Warren recalled first encountering Faulkner's Yoknapatawpha at a time when he "was ready . . . to catch the voice in that book . . . fiction with a Southern setting" ("William Faulkner" 501). In turn, Faulkner probably read and may have been influenced by "Prime Leaf," as it appeared in the same issue of *American Caravan* (1931) as his early story "Ad Astra." "Prime Leaf" chronicles the Tobacco Wars of the early twentieth century, which were marked by the destruction of crops, barns, and houses, the same motif that Faulkner would use in an early story of the Snopes clan, "Barn Burning" (1939). Warren's own fiction from the 1930s continued to reveal the influence of Faulkner's developing canon, while stories and novels by both writers

reflected the dialectic between the modernist impulse and documentary direction of the Depression decade.[1]

In my earlier study of Warren's short fiction, I noted that the description of his agrarian protagonist that opens his story "The Patented Gate and the Mean Hamburger" is "photographic and poetic," especially in regard to its setting on a Saturday afternoon in a southern county seat during the Depression years (*Short Fiction* 42). Scenes of the South's customary "trading day" were common to the work of documentary photographers such as Evans and literary observers such as Faulkner during the 1930s. Although the story was not published until 1947, after the writer reworked his early short pieces for his initial collection *The Circus in the Attic and Other Stories* (1946), his later retelling of its genesis places it among his first fictions, perhaps created not long after its chronological setting in 1935. The opening sentence, "You have seen him a thousand times," seems intertextual with the title of a photo book published by Erskine Caldwell and Margaret Bourke-White, *You Have Seen Their Faces* (1937), and like it suggests that the reader/viewer must look beyond familiar social surfaces to realize real insight into individuality (*Circus* 120). Warren's own critical discussion of "The Patented Gate and the Mean Hamburger" asserts the primacy of the visual aspect of his text: "the force of the story of Jeff York was to be dependent, essentially, on the way it was 'framed'" (Millichap, *Short Fiction* 97).

Recalling 1930s photographic practice, Warren's opening description of Jeff York alternates a long shot of a universalized type, a dirt farmer in faded blue denims and a rusty black coat who "seems to be molded from the clay or hewed from the cedar," with a close-up on the watchful eyes of this particularized example (*Circus* 120). "When you pass, you see that the eyes are alive and are warily and dispassionately estimating you from the ambush of the thorny brows" (121). Warren's literary method here adumbrates Roland Barthes's formulations, especially of what he names the "studium" and the "punctum" of the photograph, the general "study" or subject of the photographer and the particular "point" or image revealed to the viewer. Warren's overall subject is the historical decline of the agrarian tradition, but his specific image of it

is that of Jeff York, a symbolic exemplar whose sad fall is traced in this oddly titled story. The seemingly disparate images in Warren's title represent the yeoman farmer, who adds the mechanical gate as the final improvement on his place, and his young wife, who wheedles him into selling his place to buy a restaurant in town.

The Yorks know "Slick" Hardin's "*Dew Drop Inn Diner*" very well, as the family stops there for hamburgers after Saturday errands (*Circus* 126, emphasis in text). This local "dog wagon" is just the sort of small-town counterfeit that Evans and other FSA photographers liked to record. "The diner was built like a railway coach, but it was set on a concrete foundation . . . painted to show wheels," so that it seems a concrete image of the social and cultural transitions taking place during the 1930s (126). In a sense, Warren's narrative becomes a triangular struggle, as the young wife allies herself with the aspiring city slicker who wants to sell his diner and buy a pool parlor in Nashville. Both of these figures are introduced much as the protagonist is. Mrs. York is a small woman dressed in a dun-colored calico dress and a dark wool coat, but her eyes "were surprisingly bright in that sidewise, secret flicker, like the eyes of a small, cunning bird which surprise you from the brush" (124). Hardin is "a slick-skinned fellow . . . prematurely bald, with his head slick all over"; in addition, "[h]e had big eyes, pale blue and slick looking like agates" (126). An ex-boxer now content with verbal jabs, he likes to joke and "roll his eyes around, slick in his head like marbles, to see who was laughing" (126). York cannot match these much younger and livelier forces of change in his own life, so he sells the farm, refurbishes the diner, and then hangs himself from the patented gate.[2]

At the opposite end of Warren's fictive canon, his final novel *A Place to Come To* (1977), also opens with a scene from the 1930s, one of the first-person narrator's childhood memories of his father's funeral that he quite consciously compares with the documentary photographs of that era. In Jed Tewksbury's memory of it, the earlier scene seems almost unreal to him, as if it were "a picture seen in one of those books of photographs of the South published during the Depression years," perhaps *Let Us Now Praise Famous Men* (*Place* 13). Jed's lengthy, often

pictorial review of his life provides the narrative of *A Place to Come To,* and it concludes near the novel's present at the funeral of his mother's second husband, a sort of down-home surrogate father figure. Yet the fictional setting of Dugton, Alabama, has not changed much in the interim, as he tells us, "The scene was the same as that of one of the more famous photographs by Walker Evans, but a generation of damage later" (391). The younger Jed may have seen some Depression images at that time, but he undoubtedly knows them now from his unhappy marriage to a noted professional photographer. Although the time of the narrative is later, her career parallels Evans's from the first publication of her photographs, which are "both news and art," or documentary and subjective (332). As the marriage with Jed declines, her work progresses from "one-man shows," to prestigious awards, and finally to a prize exhibit at "the Museum in New York" with the publication of its catalogue "enthusiastically received" (336). We also should note that Warren's evocation of Evans here recasts his critical piece on the photographer's exhibit and catalogue that was completed just as he began work on the novel.

Like his faintly autobiographical narrator/protagonist in *A Place to Come To,* Warren also seems to appreciate more fully the mediated image of the South with the passage of time, both in his own and in the cultural consciousness. As if in evidence of this evolving awareness, the novel includes a number of photo and film images that Jed analyzes with a newfound perception as he reviews his life, much as Warren was doing then in his poetry. The life of Jed's graduate mentor also is represented by the pictures and artifacts of his education and career displayed in his study as if in a gallery. Jed tries to read these objects the same way he reads the classical texts he is studying with his mentor. For example, the "photograph of a very young woman," his mentor's long-dead mother, focuses on "the great dark eyes that, even on the faded paper . . . looked out . . . with a most haunting, smoldering glance" (*Place* 65). Later, in picturing the old house outside Nashville where he lived while teaching at Vanderbilt, Jed reenvisions the dirt farmer who lost the place (much like Jeff York), who reminds him, as did Jed's own father also,

of "pictures by Brady, and other such photographers, of Confederate prisoners" (178). Jed sends personal photographs back and forth with his mother, and she reads these pictures much more closely than his words on the pages. Indeed, all of Jed Tewksbury's memories are described as recollections that become "faded and archaic as old photographs found in the attic" (21). Those images resemble the childhood pictures Warren recreated in his later poems, shaping his own personal work of aging, life review, and questioning of his fate that he was beginning about the same time as *A Place to Come To*.

Let me return to Warren's early work, however, to consider his initial treatments of photographic tropes in his first two published novels, *Night Rider* (1939) and *At Heaven's Gate* (1943). The former, like the two unpublished novels that preceded it, presents fewer and less striking photo images than the latter, which offers not only more photos but more carefully organized patterns of them. Warren's engagement with Evans's photography by way of *Let Us Now Praise Famous Men* in the early 1940s, midway between these two novels, perhaps helped to produce these differences. Not that *Night Rider* is without salient instances of photographic tropes. For example, there is an extended comparison of the protagonist Perce Munn's monotonous married life to the twin photos of a stereopticon slide removed from the bifocal viewer that transforms their repetition into three-dimensional life. Interestingly enough, responding to an interviewer's question in 1969 about the South of his youth, Warren provides another striking stereo-optical image of regional history. "A different feeling toward the present event and the past event somehow overlap in what was like a double-exposure photograph almost. . . . The real world was there and the old world was there, one photograph imposed upon the other" (*Talking* 124). His imagery is reminiscent of two other instances of photo-imposition in *Night Rider*. At the opening, Munn's self-analysis after his sudden and puzzling involvement with the night riders is imaged in photographic terms, as if his remembered self and his new self "were nothing more than superimposed exposures on the same film of a camera" (*Night Rider* 114). As the novel ends, Munn, wanted for murder, recognizes

his picture on the reward poster as a "photograph . . . he had had taken, a little while before he was married," and sees that his innocent and fallen selves are one and the same (391).

In *At Heaven's Gate,* Warren arranges fictive photographs into a pattern of public and private views read by the central figures, Jerry Calhoun and Sue Murdock, as they negotiate their conflicted relationship. Jerry meets Sue, the willful daughter of powerful businessman Bogan Murdock, after emerging from rural obscurity during the 1930s as the star quarterback at the local university; he then becomes her father's protégé in the bond business. Early in the novel, Warren describes Sue's frustrated visit to the newspaper files at the public library, where she seeks insight into "Bulls-Eye" Calhoun. "She studied the pictures, but they did not tell her what she had come to find out" (*At Heaven's Gate* 50). The newspaper photos all show the public poses "picture after picture" of a "football hero," in a helmet that oddly reminds her of "an illustration in an old copy of Caesar's *Gallic Wars*" (50). This is not what she desires to know, the real person who "was off the picture . . . or behind the picture" (50). The same opacity is found in more recent pictures of Jerry on the business and social pages of the paper. On the other hand, like Perce in *Night Rider,* Jerry sees all of these images of himself in a sort of superimposition. "It was like there were two Jerry Calhouns. . . . the pictures of what had happened kept going past, and it all kept happening again" (232).

At the same time, Jerry imagines that he understands what is underneath Sue's "smooth, gold-colored, expressionless face" when he views her portrait at "twelve or thirteen" in the Murdock family's "old photograph . . . the face, which was lifted a little, as though in expectation, the eyes wide and candid, the lips parted slightly" (*At Heaven's Gate* 106). Warren later hints at some dark paternal experience that compels Sue into a series of destructive male relationships—with fraternity boys at first, next with the luckless Jerry, later with the fanatical labor organizer Sweetwater, and finally with the unbalanced intellectual Slim Sarrett, who kills her at last. So pictures of her in the local paper successively include dances with fraternity men, engagement pictures with Jerry,

picket lines with Sweetwater, and finally the murder scene in her apartment. *At Heaven's Gate* ends with Bogan Murdock appearing at a news conference to address the bankruptcy of his firm and the tragedy of his family—both of which have combined to destroy his surrogate son Jerry. The surviving Murdocks strike a pose for a new family picture that will erase Sue from the family album, as well as from public documentation and memory. The photographer "stands behind the tripod of a camera, holding aloft the reflector and the flash bulb . . . [that] gave its explosive, blinding, veracious flash" (390). This imagery of the photographic process encapsulates its power to expose, to reveal, and yet to deceive in a fitting conclusion to *At Heaven's Gate*. The image would also make an apt introduction to my visual analysis of *All the King's Men*.

Warren's great novel, *All the King's Men*, is told in first-person narration that employs photographic tropes as points of personal and public reference for another faintly autobiographical protagonist. Jack Burden is a failed academic, unable to complete his doctoral dissertation in history at his state university. His subject is an earlier failure, Cass Mastern, a distant ancestor who freed his own slaves but died serving for the Confederate cause. Jack drifts into journalism and politics, finally becoming a hack for his state's populist governor, who recalls Louisiana's Huey Long. Whether in public prints or private portraits, photography past and present reflects and reinterprets life by both recording it objectively and recreating subjectively. *All the King's Men* opens in medias res during a drive back to Willie Stark's home place in 1936, where he is going to provide the press with domestic images that will bolster his falling popularity among his countrified constituency—what we would now call a photo opportunity. This one results in an amusing scene in which Jack tries to maneuver the family dog for sentimental effect. This "down home" posing is repeated more frequently after the first lady leaves the philandering governor to return to their farm. "Two or three times the papers—the administration papers that is—ran photographs of him standing with his wife and kid in front of a henhouse or an incubator" (156).

On this sojourn, Stark's entourage stops to test the governor's home-

town popularity at the local drugstore, and Jack notes the campaign photograph of him featured above the soda fountain like a secular icon, probably in imitation of the nearly universal pictures of President Roosevelt in public places during that same era. Early on, Jack compares the real Willie with this likeness, "a picture about six times life size. . . . I had seen that picture in a thousand places, pool halls to palaces" (6). The graphic is glossed by Stark's campaign slogan, "*My study is the heart of the people.*" As Jack settles into retelling Willie's story, he recalls by contrast the first time the politician's image appeared in the big-city newspapers. In his initial political role as county treasurer, Willie was a young lawyer exposing bribery in the shoddy construction of a district school that led to student deaths, so the caption on his front-page photo then read, "KEEPS HIS FAITH" (64).

One of the people in this drugstore crowd, described by Jack as having "the kind of face you see in photographs of General Forrest's cavalrymen," is not afraid to tell the governor that his portrait, "don't do you no credit, Willie" (*All the King's Men* 6, 7). "The Boss" then studies his larger-than-life photograph, "cocking his head to one side and squinting at it," and gives a facetious excuse: "I was porely when they took it. It was like I had the cholera morbus" (7). This pseudoscientific title for infectious gastroenteritis amuses Willie's audience for the moment. However, the whole sequence symbolizes Willie's growing distance from any study of the needs of the people that he was elected to serve, even those he has known from his boyhood back home in Mason City. The responsive reader also senses Warren the author somewhere behind Jack, studying newspaper and newsreel images of Huey Long to gain a point of insight into the man he had seen but once in life and from a distance at a faculty luncheon.

Although tripods and cameras, flashbulbs and news photos abound in the present of *All the King's Men,* notably in bright publicity shots of the politician and darker images of him as an assassin's victim, the most arresting instance concerns the single photograph of Cass Mastern that Jack inherits from his own family's past.[3] For Warren, as for Barthes, photographs seem to capture fixed moments in life by freezing the flow

of time; yet they also may be just bits of flotsam in the flood of history. At the beginning of the interpolated fourth chapter, Jack makes the acquaintance of his ancestor by means of a family "history" he intends to use for his dissertation in "History" at the state university. Warren then spends several paragraphs describing an old photograph from Jack's viewpoint. His gaze is focused first on Cass's ill-fitting Confederate infantryman uniform, worn as a badge of his suicidal "self-humiliation," and then on "the pair of dark, wide-set, deep eyes which burned out of the photograph," much like Barthesian punctuation points within Cass's abnegation of his southern heritage (*All the King's Men* 161). Jack cannot complete his doctoral dissertation until he can come to terms with what the photo represents: "He simply sat there at the pine table, night after night, staring at the photograph, and writing nothing" (188).[4] By the end of Chapter Four, Jack explains his writer's block; before he can understand life, he has to learn what Cass knew, "that the world is like an enormous spider web," perhaps both Warren's central theme and dominant image in *All the King's Men* (188).

If notable photographic tropes are found earlier in *At Heaven's Gate*, which is sort of a prologue to *All the King's Men*, then more may be discovered later in the title novella of his only short fiction collection, *The Circus in the Attic and Other Stories* (1947), a work that serves as a coda to the major novel that won Warren the first of his three Pulitzer Prizes. The protagonist, Bolton Lovehart, is another failed academic like Jack Burden. He starts out to write the history of his hometown (ironically named Bardsville) but instead creates a miniature circus that fills his study in the attic of the family home. Photos trace Bolton's inhibited growth, beginning with his childhood self in family poses at the end of the nineteenth century. "As we look back at them, down the sixty years, they scarcely seem to move at all, to be fixed there in a photograph in an album to prove something sweet and sure about the past" (*Circus* 17). The past proves no surer than the present, however, as seen in news pictures taken when he sells his circus to support home-front efforts during the Second World War, leaving him neither history nor fantasy. "The Bardsville *Gazette* ran a photograph of Mr. Lovehart

standing beside the circus: 'Prominent Citizen Has Secret Hobby. Gives Proceeds to Red Cross'" (55). Other stories in *The Circus in the Attic* present photographic tropes, notably "The Patented Gate and the Mean Hamburger" as we have seen above, but none reveal images that focus their narratives like those considered here. Indeed, after the watershed publication of *All the King's Men*, which changed Warren's life and work, photographic imagery appears in his fiction less often, at least until his last novel, *A Place to Come To*. One important reason is Warren's turn toward historical fiction, particularly in his epic novel set in a frontier Kentucky predating photography, *World Enough and Time* (1949). Even in his Civil War fictions, *Band of Angels* (1955) and *Wilderness* (1961), photos were mentioned less frequently, even as they became more significant in his poetry.

Like other aspects of Warren's creative energies, the most meaningful recreations of photography in his later canon are revealed more often in the poems that shaped his new collections, beginning with *Promises* (1957), which earned him the first of two Pulitzer Prizes for poetry; the second was for *Now and Then* (1978). The poetic texts that most interest me begin with the collection that opens Warren's work about aging, *Or Else: Poem/Poems 1968–1974* (1974). It is worth noting that this complex volume was completed at almost the same time as his critical work on Evans. As the book's title indicates, it may be read as one long poem or as a gathering of many smaller poems, much as one might view Evans's collections of photographs. For example, "Forever O'Clock," is a complex poetic triptych centered on a Depression scene that might have been photographed by Evans. The first and the last of Warren's three lyrics comprising "Forever O'Clock" move back and forth between now and then, or perhaps between time and eternity. Warren's persona moves through a disoriented, nightmarish present in the first section. Then he returns to the past in the second section, driving his "1931 Studebaker" past a tenant farm, with its "gray board shack" bleached by "drouth" (recalling those pictured in *Let Us Now Praise Famous Men*), where a little black girl plays with a rusty can in the red dust. In a shorter third section, Warren's vision turns toward

the horizon, while an elongated last line suggests the perpetuity of death—"A clock somewhere is trying to make up its mind to strike forever o'clock" (*Collected Poems* 289). This contrast between visual images and philosophical views recalls Sontag and Barthes, fascinated as they were by the relationship of this spatial art form to the chronological impulses of literature.

Several other private and public photographic tropes discovered in *Or Else* are likewise concerned with the tensions of time and eternity as seen in past, present, and future. A striking example is "I Am Dreaming of a White Christmas: The Natural History of a Vision," which appears before "Forever O'Clock" in the volume. This long poem is comprised of a dozen lyric sections that involve the subconscious imagery of dreams. The poem's settings triangulate a dark December night in the Kentucky of the poet's past in the early twentieth century, a smoggy late summer evening in the New York City of his present in the early 1970s, and his timeless future as implied by a nocturnal autumn snowfall on Western mountain ranges. The first eight of the twelve sections of "White Christmas" seem to be nightmare images from an appalling family photo album, revealing time lost in all its irrevocable finality. Although the poet recalls his long deceased parents as if in a Christmas morning pose, they appear as "Through / Air brown as an old daguerreotype fading," a scene from the past depicted in the chronological present through the mysteries of photography, decades after their physical death and dissolution (*Collected Poems* 275). This obscure imagery then turns to the early evening "smog-glitter" of hazy skies, "yellow as acid," in late summer seen from the New York City streets, which are the locale of the ninth and tenth sections, set in the present of the poet's own aging (279). "Times Square" as seen here is a waste land peopled by lost souls like those in the grotesque images of postwar American photographers such as Robert Frank or Diane Arbus. The poem's concluding snow scene, which takes place in the future on the Nez Perce Pass somewhere in the high ranges of Idaho and Montana, does evoke a Christmas more white than the opening sections in Kentucky, though its visual imagery bears an ambivalent burden of time, death, and ultimate obliteration.

A more public instance of a visual trope is seen in the five-section poem "News Photo," which follows after "I Am Dreaming of a White Christmas" and "Forever O' Clock" in *Or Else*. This poem's extended subtitle is presented in the manner of a news photo caption: "Of Man Coming Down Steps of Court House after Acquittal on Charge of Having Shot to Death an Episcopal Minister Reported to Be Working Up the Niggers" (*Collected Poems* 303). Warren was engaged closely with southern civil rights struggles during the 1960s and 1970s, and he published two nonfiction books on his involvement, *Segregation: The Inner Conflict of the South* (1956) and *Who Speaks for the Negro?* (1965). Both employ imagery reflecting the news footage of the Civil Rights era, as do a number of poems on these topics such as "News Photo." All of these examples recall Madden's comments on the sensitivity of white southerners to such documentation, and the persona of "News Photo" is both proud and ashamed to be forgiven his mindless violence after a mock trial. "Nothing / is like he expected, as now he / moves toward the flash bulbs, his eyes / inward on innocence" (304). Yet this image becomes more than an individual portrait. "It really is a family picture," including his bitter wife and bewildered son (305). This visual document balances against Warren's ekphrastic readings of personal photographs in other poems considered here. It seems especially close to "I Am Dreaming of a White Christmas," in which Robert E. Lee appears not as Miley's famous life portrait but in his decomposed remains a century later as a vivid image of a now dead and decaying southern myth.

In "Reading Late at Night, Thermometer Falling," Warren as son imagines his own father, a southern patriarch, at about the biblical three score and ten he himself has nearly achieved by 1974. His father's later life was made lonely by his wife's early death in 1931 and further diminished by his personal bankruptcy later in the Depression. Warren pictures him, living on as he did to age eighty-five in a dreary "old folks" home. As a contrast against this late image, Warren remembers himself as a boy finding "an old photograph," dated "1890," of his father as a young law student, posed with a hand on his textbooks, "eyes / Lifted into space. // And into the future" (*Collected Poems* 311). That future had

never eventuated, so the senior Warren tore up the rediscovered portrait of his earlier self and cast the pieces "Into the fire" (312). His father's poetic ambitions came to a similar fate: "Later, I found the poems. Not good," in the view of the younger Warren, by then a more accomplished poet himself (312). Yet the writer reminds us in his philosophical conclusion that "Man lives by images," in this case the visual and verbal ones through which the senior Warren lives on decades after his death in his son's reminiscent poems (312). As we have seen, death provides an important aspect of photographic theory, particularly in the work of Barthes and Sontag. In Warren's later poetry, especially in his poems of age work and of life review, a similar spirit of time and mortality hovers above his photo images recreated by ekphrasis.

Although many good examples of his poetic fictional photographs can be found in all four intervening collections, I will take my last example from Warren's final collection, the gathering published with the 1985 *Selected Poems* under the affirmative title *Altitudes and Extensions.* "Old Photograph of the Future" presents what seems to be a picture preserved in the Warren's family album, a formal portrait in which the focus is on what the opening line describes as "That center of attention—an infantile face" (*Collected Poems* 566). Of course, the face belongs to the poet himself, some seventy-five years earlier, as he reveals in his fourth stanza. No wonder that this earlier image, then a countenance tinted "pink and white" in the local studio, has become his visage, "Now faded, and in the photograph only a trace / Of grays, not much expression in sight," much like the face he now sees peering back at him from his mirror (566). The second and third stanzas complete the photographic tableau of himself as an infant "swathed in a sort of white dress" that matches his mother's, while his father stands apart "In black coat, derby at breast" (566, 567). Three-quarters of a century later, "They lie side by side in whatever love survives / Under green turf, or snow" (567). Inspired by the family album, in his imagination "that child, years later, stands there" by the family plot in the local cemetery, "While old landscapes blur" with tears as "he in guilt grieves / Over nameless promises unkept, in undefinable despair" (567). This recreated photograph, which

seems to arrest an instant in real time, also evokes the abstraction of "Time" itself that so intrigues Warren, and his ekphrastic study of an old photograph reviews the narrative of his life and projects not only the certainty of physical death but the possibility of spiritual persistence.

Family pictures also could be a source of joy and even of transcendence in the face of time and death. One of Warren's final unpublished poems bears a run-on title more typical of his earlier efforts, "A Little Girl, Twenty Months Old, Faces the World: (Photograph, in color: mounted plastic oblong 5 inches high, seven inches long)." In fifteen lines, Warren, then dying of cancer, contemplates his first grandchild, the infant daughter of Rosanna Warren, his own once-little girl, who was now a new mother and a poet in her own right. In 2005, Rosanna presented the Robert Penn Warren Library at Western Kentucky University with the gift of her parents' photograph albums, home movies, and other audiovisual materials. The real purpose of the Warren family photography seems to have been to create a visual record of Rosanna and her younger brother Gabriel; Warren must have snapped many in which he did not appear, though it seems that Eleanor Clark took most. The albums also document the famous couple's many friends, including Allen Tate, Cleanth Brooks, Saul Bellow, and William Styron, and some of the pictures may be the work of others more practiced in photography, notably Walker Evans and Ralph Ellison.[5]

Let me also suggest that Warren's interest in photography may be one reason he was so widely photographed, often by important artists in the medium such as Walker Evans, his friend and colleague at Yale; John Szarkowski, long-time photography curator at the Museum of Modern Art; Annie Leibovitz, the photo-portraitist for *Vanity Fair;* and other noted literary photographers such as Jill Krementz, Nancy Crampton, and Dmitri Kasterine. Moreover, Warren generally took an impressive picture, as can be seen in the photos on his book covers and in the many publications about him. I am most taken by the later photographs, especially one of Kasterine's from 1985, when Warren published his final volume of selected poems at the age of eighty. That photograph serves as the cover picture for my recent study of Warren's

later poetry as the work of aging. Like the pose of Cass Mastern that so fascinates Jack Burden in *All the King's Men*, this one compels extended study; the focal point in both pictures is the subject's reflection of the viewer's gaze. In Kasterine's portrait, Warren stoically stares past the photographer and the viewer, far across time into our shared human future.[6]

FIVE

Eudora Welty, Photography, and
Southern Narratives

As much as many of her male contemporaries in southern letters during the 1930s, Eudora Welty was fascinated with photography. This period proved crucial not just to the development of her fiction but to the visual and literary arts in her region as well as in the nation at large. As we have seen, several southern writers were directly involved with photo books, a hybrid genre popular during the Depression decade. Welty's collection of her own snapshots and stories, "Black Saturday" (1935), never found a publisher. Yet her concern with this project over several years indicates its special meaning, and by extension that of photography generally, to her evolution as a female southern fiction writer of major significance. A single woman caring for her mother in suburban Jackson, Mississippi, Welty's emergence as a literary artist was complicated by personal, social, and cultural issues concerning gender. Early on, critics (mostly male) grouped Welty with other women writers of her region as working in the mode of the Southern Gothic or grotesque; feminist scholars, who recognized in her narratives an expansive feminine vision, later questioned this categorization. The nuanced language of her gendered imagination placed Welty among the most significant of the southern women writing in the middle decades of the twentieth century. As appreciation for Welty's literary achievements increased, critical interest in her photography developed as well, particularly regarding the viewpoints and visions common to both art forms.[1]

Looking back much later in her career, Welty admitted that her pictures and stories were related by a personal imaginative inclination, that of "an inquiring nature, and a wish to respond to what I saw, and to what I felt about things, by something I produced or did" (*Photographs* xv). So the links established between her photography and fiction in regard to Welty's own time and place, as well as to the matter and form of her efforts in both arts, do tell us many interesting things about her dual creative legacies. Yet when asked what picture taking taught her about writing, Welty separates the two: "Nothing consciously, I guess, or specifically" (xv). However, she goes on to speculate that "perhaps a kindred impulse made me attempt two unrelated things" (xv). Her photography and her fiction do remain dissimilar in some fundamental sense beyond the obvious differences between the visual and verbal art forms. In my view, this separation derives from the differing ways in which the visual and verbal arts accommodated the dialectic of artistic responses during the 1930s. Her photography mostly derives from traditional realism and naturalism by way of the New Deal's documentary impulse, as seen in most interpretations of American culture in the 1930s; by contrast, her fiction focuses on these same cultural materials largely by means of a persistent American modernism that recent criticism has found in the works of the decade's best artists and writers.

As in many aspects of her life and work, Welty's engagement with photography may be traced to the consistent influence and encouragement of her family. Welty opens her memoir *One Writer's Beginnings* (1971) by recalling her parents' familial regard for "instruments that would instruct and fascinate," including "a folding Kodak that was brought out for Christmas, birthdays, and trips" (*Stories* 839).[2] Her father was an insurance executive and a pioneering camera enthusiast who developed his own prints of family snapshots with the aid of her mother until he helped establish Jackson's first photography shop (*Photographs* xiv). As the first child, Eudora was her father's favorite subject, and she was taking pictures on her own small "Eastman Kodak" during her college years (xiii). Following her return to Mississippi in 1931 and her father's untimely death soon after, Welty secured a series of jobs

that made use of her writing skills, positions that also prompted her toward more meaningful photography.

The most important of these efforts was her employment from 1935 to 1936 by the Works Project Administration (WPA), the largest of the New Deal's public agencies. Welty was in good company at the WPA, for many of America's writers and artists, including its iconic photographers, survived the Depression by joining its ranks. As a junior publicity agent, Welty traveled throughout Mississippi chronicling the agency's efforts in prose, and soon she was bringing along her own camera on these assignments. She often remarked the value of this experience during her twenties in her development as a person, as a writer, and as a photographer—but Welty was quick to say that her work was not a part of the official WPA photographic programs. When her employment with the WPA ended in 1935, she did apply to become an FSA photographer, but her application ultimately was rejected (*Conversations* 154–56). In any case, Welty's stint with the WPA remains at the heart of her engagement with photography, personally and professionally, and her application to become a photographer for the FSA indicates that she must have been aware of the work done for it by male photographers such as Walker Evans, Ben Shahn, and Russell Lee, as well as females such as Dorothea Lange, Esther Bubley, and Marion Post Walker.

Later in life, Welty would distance her earlier efforts in photography from those of the famous documentarians of the Depression era. The importance of the photographic record to southern literature in the 1930s was determined at least in part by its unusual congruence of economic depression and cultural renaissance during this pivotal decade, as we have seen, but such regional documentation had an extended and contested historical significance in the media construction of the South. David Madden's three crucial periods of southern history—the Civil War, the Depression, and the Civil Rights era—as the primary sources of regional anxieties in regard to its photographic representation prove useful here. Welty's general aversion to the Civil War in her writing, as well as her conflicted response to events in Mississippi during the 1960s, may suggest that she also had problems with the depiction of the region

by the FSA photographers listed above, none of whom were southerners. In particular, she repeatedly emphasized the artistic detachment of her own photographs, insisting in her preface to the first collection of them in 1971 that "Neither would a social-worker photographer have taken these same pictures" (*Eye* 351). This figure of a do-gooder documentary photographer recalls the "crusader-novelist" with whom Welty parted company in "Must the Novelist Crusade?" (1965); her essay insists on the importance for serious fictionists of art being detached from social causes, and she uses Faulkner's works as examples—for, like Robert Penn Warren, she was an early champion of her fellow Mississippian's fiction (*Stories* 803).[3]

In the prefatory interview for the 1989 collection of her photography, Welty specifically differentiated her efforts in the visual genre from that of the Depression era documentarians: "*Let Us Now Praise Famous Men*, for instance, was entirely different in motivation from my own photography" (*Photographs* xvi). She goes on to declare that Evans's practice, at least in this instance, was programmed and posed, while her own was subjective and spontaneous. By way of contrasting his work with her own, Welty asserted, "I was taking photographs of human beings because they were real life and they were there in front of me and that was the reality. I was the recorder of it. I wasn't trying to exhort the public" (xvi). We must remember that Welty drew these distinctions a half-century after she and Evans completed their photographic projects of the 1930s. Welty's misapprehensions of FSA photography in general and of Evans in particular derive from some traditional misconceptions that have been amended in more recent scholarship, which reveals that, far from being a New Deal propagandist, Evans was a social conservative and an artistic modernist. In fact, these qualities separate his work from that of most other 1930s photographers, who were often limited by their topical reportage and social advocacy. As an FSA photographer, Evans pursued his own artistic program, one that had more in common with writers like his early friend Agee, his long-term exemplar Faulkner, and his later colleague Warren.

Despite her protests, Welty often seems to be emulating the practice

of the more important FSA camera artists in both the creation and the publication of her own photographs. Welty's earliest work recalls family album snapshots of individuals or small groups, while her photographs taken later in the decade accomplish a broader vision of landscapes and structures as symbolic settings for her human subjects and resemble the efforts of the more skillful and accomplished FSA documentary photographers.[4] The most intriguing of Welty's visual projects was her unpublished photo-text that had the working title "Black Saturday." As she recalls, "I got a composition ring-book and pasted little contact prints in what I fitted up as a sequence to make a kind of story in itself. . . . I submitted along with the pictures a set of stories I had written, unrelated specifically to the photographs" (*Photographs* xvii). Welty goes on to say that the stories all would be published later—in little magazines, in her first two collections, or in both—while most of the pictures would appear some three decades after in her initial photography collection (xviii). It proves a fascinating exercise for Welty's critics to attempt the reconstruction of this lost text, but it is, finally, a frustrating one, as none of the original versions survive. By the end of the 1930s, Welty had mounted two small gallery shows in New York City, placed a handful of pictures in a variety of publications, and sought a publisher for her photography collection—the latter in formats with and without her fiction (xviii). At that point in her professional career, Welty's stories began to be published in literary journals, and her photography became a decreasing part of her artistic endeavors as her creative attention shifted almost completely to her fiction.

As to quantity, the Welty collection of "1063 negatives and 328 prints" now housed in the Mississippi Department of Archives and History seems substantial by any measure (Marrs 78). Assessing the quality of the photographic work, however, is a more complicated issue. Only a few of her photos were published before her literary success and its resulting celebrity, and even now her photographic canon remains only partially available. Welty's several publications of her photography have been well received by most critics, but more for their matter than for their art. Welty herself never made any greater claims for her pictures. In her

preface to the initial collection of photographs in 1971, she compared
the volume to a "family album" of "snapshots," whose "merit lies entirely
in their subject matter" as a "record of a kind—a record of fact putting
together some of the elements of one time and place" (*Eye* 350–51).

Yet, as cultural documents, Welty's photographs inform our vision
of the 1930s in ways that complement the striking accomplishments of
the New Deal photographic programs—for instance, in regard to the
conflicted binaries of gender, race, and class. Unlike most of the subjects
in the overall FSA collection, the majority of Welty's subjects are female
and black. Although women and blacks appear in the government-
sponsored photography, they are not proportionately represented, nor
are they always treated sympathetically as individuals, probably because
most FSA photographers and administrators were white men.[5] That
Welty would have felt empowered to photograph women more than
men seems almost a foregone conclusion, given the gender dynamics
of the Magnolia State during the Depression. It must have been much
easier in actual practice for a shy young woman like Welty to photograph
women, white or black, than men or even boys of either race. Welty
was drawn to images of feminine accommodation, and she captures
female life from childhood to old age with sensitivity. In her 2007
study of photography and contemporary southern fiction by women,
Katherine Henninger affirms how Welty prefigured the transfiguration
of photography and the photograph for southern female fictionists who
then deconstructed the cultural façade erected by a regional hegemony
of white patriarchs (*Ordering* 42–43). The photographic project that
Welty titled "Black Saturday" is not without its own complications of
gender and race in regard to the agency of her mainly female and black
subjects, however. As Henninger concludes, "How much her photo-
graphs are the result of an intuitive or collaborative understanding of
Welty's project, or how much they are the result of a racially prescribed
inability to deny her gaze, is finally unknowable" (43).

In seeming confirmation of these inclinations within Welty's visual
record of her own time and place, *Photographs* opens with twenty pic-
tures from the 1930s, all from locales in Mississippi and all focusing on

individual women, ranging in reverse life order from older to younger. Although these women are presented in her early "snapshot" style, their sympathetic portraits remain among Welty's finest visual work. The first picture, "1. A woman of the 'thirties / Hinds County / 1935," for example, documents the social and personal character of that time and place, especially physical privation and psychological persistence, but as photographic art it also incarnates more subjective concerns. Welty's straightforward vertical composition contrasts the human integrity visible in this aging black woman's erect stance and level gaze with the social vulnerability shown by her weathered features and tattered sweater. Several critics have associated this nameless figure from Hinds County in 1935 with the fictional character Phoenix Jackson, the dedicated grandmother of Welty's "A Worn Path" (1941). In her 1974 essay concerning the creation of this often anthologized story, Welty indicates that her inspiration was initially visual, the sight of an old black woman "at middle distance, in a winter country landscape" (*Stories* 816).

Welty's verbal recreation of this solitary female figure also proves strikingly visual: "I brought her up close enough, by imagination, to describe her face, to make her present to the eyes" (816). Although the close-up description of her character at the story's opening does recall Welty's early snapshot portrait in its initial viewpoint, the protagonist in the story proves different in many respects from the woman in the picture. In the literary text, she is given extensive development in mythological and historical time and space that begins with her name, Phoenix Jackson, and continues with her selfless journey far from home "away back of the Old Natchez Trace" (177).[6] As Welty frames it in her essay about the story, "A narrative line is in its deeper sense, of course, the tracing out of a meaning," a meaning only implied in the captured moment of a photograph (817). The passage old Phoenix traces along the worn path of the title to procure medicine for her grandson conflates an odyssey of archetypal "trial," "maze," and "cave"—replete with ghosts and dreams from fairy tales—that ends with the holiday season in a "paved city" much like those recorded in FSA photographs (172, 173, 174, 176).[7]

"A Worn Path" thus exemplifies Morris Dickstein's formulation of the dialectic in the 1930s between a resurgent naturalism and a persistent modernism. The utility of such articulations in regard to Welty is further illustrated by comparison of the other black subjects in her early photographs with protagonists named in the titles of her three other stories focused on African American characters during this period— "Keela, the Outcast Indian Maiden" (1940), "Powerhouse" (1941), and "Livvie" (1942). The stories are in some ways documentary work, at least in regard to their title characters, as comparisons with Welty's photographs remind us. In literary terms, however, all three narratives prove to be complex modernist texts in terms of their complicated viewpoints, intricate structures, and mythic references. "Livvie" also proves interesting in photographic terms. The narrative contrasts vernacular snapshots of the central couple's families with a symbolic portrait of the aged husband as a young man, one who radiates sexual energy in much the same way as Livvie's young lover.

The dialectic of documentary and modernist propensities found in these and other early stories is manifested in Welty's photography, as it does in her fiction, by means of a complex language of vision. Many of the plates in her *Photographs* reveal intriguing correspondences with the documentary photographers of the 1930s, for example, in their intertextual use of verbal and visual texts within photographic compositions. Welty's photographs often incorporate words or pictures, if not as frequently or as deliberately as those by Evans or Lange. Even if some of these visual and verbal intertexts were not developed consciously, Welty and the documentarians of the Depression South obviously did focus their photographs on words and/or images in many instances. One common motif is the language and imagery of segregation and racism, as the FSA photographers who worked in southern states produced many intertextual examples portraying these themes of social inequity. Despite Welty's insistence that, like her narratives, her pictures were not shaped by any conscious political program, she still produced powerful images of segregation in her photographs of Mississippi. In *Photographs*, a plate entitled simply "82. Jackson / 1930s," depicts a well-dressed black

man buying a movie ticket at the alleyway back door of a downtown theater. Welty's intertext here is a large sign balanced overhead that proclaims, "COLORED ENTRANCE," and ironically adds in smaller letters "to all performances." The play of late afternoon sun and shadow creates light and dark thematic imagery; particularly striking is the bright clothing of the black subject in contrast to the obscure figures of affluent white women who pass through this Mississippi scene oblivious to the racial dynamics that determine the course of their lives as much as that of the black moviegoer.

Such manifest examples of verbal texts within Welty's photographs establish their critical significance for interpreting her visual art, and they also suggest the importance of reading visual images, especially photographs, to gain a full comprehension of her writing in its intertextual modernist mode. Despite the developing interest in Welty's photography, most critics have approached instances of photographic tropes in her fiction tangentially, identifying only the more obvious examples, most often in terms of other matters and themes. A careful reading of Welty's entire canon discovers almost as many examples of photographs in her prose as of verbal texts in her pictures. As in the analysis of her photography, some of these references may appear inadvertent and even inconsequential, but the careful reader must remember that within written texts a photographic trope remains yet one more remove away from a photograph. As Henninger argues, literary photos call attention to themselves as mediations of reality, whereas actual photographs often disguise that fact (9). In other words, there can be no unintended photographic tropes in literary texts.

We might expect to find a substantial number of literary photographs in Welty's initial collection because its stories must have formed parts of "Black Saturday," which evolved during the very years when she was engaged most closely with photography. Such is not the case for many reasons, even though instances within the stories comprising *A Curtain of Green* do reiterate distinctions found in her own pictures, such as those relating to gender, race, and class.[8] These early stories also adumbrate Welty's thematic and symbolic uses of photographic tropes

in her later fiction, in terms of interrelated image motifs concerned with itinerant photographers, sentimental subjects, and romanticized photographs that were first suggested in her visual work. After all, Welty wandered far from her home to discover many of her subjects, and many of her pictures balance realism and sentimentality. These images become the central focus of her fictional canon, however, at least in terms of its photographic tropes that have more to do with a modernist concern for the mediation of individual perceptions than with the documentation of social or cultural realities.

One story in *A Curtain of Green,* "Why I Live at the P. O.," presents just such a complex take in terms of viewpoint, as its narrator/protagonist explains why she has quit her family home and moved into the back room of the tiny post office that she inhabits in China Grove, Mississippi. This estrangement began after an itinerant named Mr. Whitaker arrived, "taking 'Pose Yourself' photos," (*Stories* 57). In response to an interview question about the story, Welty explained Mr. Whitaker's occupation: "A man . . . came through little towns and set up a makeshift studio in somebody's parlor and let it be known that he would be taking pictures all day in this place, and a stream of people came. He had backdrops—sepia trees with a stool—then let them pose themselves. That was an itinerant livelihood during the Depression. Itinerants were welcome, bringing excitement like that, when towns were remote and nobody ever went anywhere" (*Photographs* xx). Welty's explanation proves illuminating for this story, in which the itinerant Mr. Whitaker functions as a mysterious stranger and as a missed candidate for marriage. These roles for the itinerant picture man are developed in the story "Kin" and in Welty's penultimate novel *Losing Battles.* It also suggests the differences between the writer's photographs and her narrative tropes, as Welty comments obliquely on the camera artist's mediating role in this aesthetic exchange. The romantic visions of these subjects are empowered by their self-posing within an artificial, sepia-toned dreamscape completely different from the harsher black and white reality then being recorded in documentary photography, including Welty's camera work created during the Depression decade.

Welty's second and third short story collections, *The Wide Net* (1943) and *The Golden Apples* (1949), reveal only a few fictive photographs, ones not from the 1930s for the most part. Welty's first full-scale novel, *Delta Wedding* (1946), though set in 1923, includes several interesting photographic tropes that recall the writer/photographer's work from the Depression years. Perhaps her finest work of fiction, *Delta Wedding* remains a pivotal text in Welty's canon, marking her development from shorter to longer narratives. Especially remarkable in terms of photographic tropes are the modernist tensions of visual and psychological imagery that contrasts sentimental wedding pictures and gruesome accident photos. Both sorts of pictures are taken by an itinerant photographer who has travelled southward by train from Memphis to take pictures of the Fairchild wedding for the metropolitan newspaper. As he arranges the entire family for a group portrait, he remarks insensitively about a photo plate already in his satchel: "Train victim. I got a girl killed on the IC railroad. My train did it. Ladies, she was flung off in the blackberry bushes" (*Novels* 306). His harsh remarks affect the Fairchild matriarch Ellen most, as his camera flash taking the wedding photo reveals to her "a vision of fate" (*Novels* 307). For Ellen has met this unfortunate waif earlier and was unable to turn her away from the dangerous journey to Memphis. As one posed photograph celebrates Ellen's daughter beginning a new life in marriage, another photo documents the awkwardly strewn corpse of a motherless girl, quite possibly on the way to motherhood herself. This contrast proves the darkest image of the novel's complex black and white patterns, the nexus of several important narrative strands in *Delta Wedding*.

Welty's fourth and last volume of short fiction, *The Bride of the Innisfallen* (1955), includes a trio of texts—the title story, as well as the final two, "Kin" and "Going to Naples"—involving more itinerant photographers and/or romanticized photographs. The two stories of European voyages are less central to my study here because of their later dates, their foreign subjects, and their slighter tropes, so I will turn next to the somewhat neglected story "Kin," an extensive vision of photographic figures and images set in Mississippi during the 1930s.[9] The story is

further complicated by its modernist point of view, narrative structure, and intertextuality. In particular, the photographic tropes here are contrasted with a pair of striking visual metaphors drawn from the central family's romanticized past—an itinerant artist's painting of her family's Mississippi matriarch from the nineteenth century and her dying twentieth-century patriarch's collection of stereopticon slides of scenes from around the world.

The protagonist of "Kin" is the newly engaged Dicey Hastings, who returns to small-town Mississippi from her new home in a northern city to plan her wedding. In the course of her visit, she is introduced to several relatives with whom she is at first "not that anxious to claim kin," though she finally comes to recognize her significant relations with these kindred spirits past and present in regard to her own future marriage, home, and family (*Stories* 650). On a warm April Sunday, Dicey and her more conventional cousin Kate are sent off on a ritual visit to their dying Uncle Felix at the family home place of Mingo, nine miles out in the country. The old man is actually their great-uncle, now in his eighties, who once was a drummer boy in the Civil War. When Dicey and Kate arrive at Mingo in late afternoon, they assume that he has died already and that the assembled crowd of country folk are "[v]iewing the body" (659).

Uncle Felix is being cared for by Sister Anne Frye, his dead wife's half-sister, who is a sort of poor cousin to their extended family and now an "old maid" (647). Sister Anne is also a comic figure who recalls the narrator of "Why I Live at the P. O." in her infatuation with an itinerant photographer. As she explains to the young cousins, Mr. Puryear, who, like Mr. Whitaker, is "of the Yankee persuasion," arrived in an "old-time Ford with a trunk on the back" and soon convinced her to let him use the family parlor for his studio on the very day the cousins were expected to visit at Mingo (662, 663). They soon suspect the self-centered and deluded motives of Sister Anne's invitation to "an itinerant. . . . almost but not quite the same thing as a Gypsy." Giving a romanticized description, their maiden aunt insists to them that "I flatter myself that I *don't get* lonesome, but I felt sorry for *him*" (663,

emphasis in text). For Dicey, the reconstructed parlor seems prepared as if "for a country wedding. I could almost hear a wavery baritone voice singing 'O Promise Me,'" as Sister Anne poses for her own free portrait, "[a] fan, black and covered with a shower of forget-me-nots, languidly across her bosom" (*Stories* 673, 675).

The younger woman suddenly realizes that "What would show in the picture was none of Mingo at all, but the itinerant backdrop—the same old thing, a scene that never was, a black and white and gray blur of unrolled, yanked-down moonlight," suggesting a sentimentalized vision of the Old South recreated by a Yankee photographer for his southern subjects (674). From earlier visits to the home place, Dicey also recalls that his painted backdrop covers a painting on the wall behind. It is a primitive portrait of her great-grandmother, "the romantic figure of a young lady seated on a fallen tree under brooding skies" (674). In a flash of ekphrastic insight, the young woman "*knew*, like a secret of the family" that the likeness of the frontier bride was in actuality a prepainted canvas to which an earlier itinerant portraitist "fitted" his sketch of her matriarchal ancestor, creating another counterfeit view of the South (675, emphasis in text). Dicey also knows that the bride in that picture is "her divided sister" in some sense. They both know "the wildness of the world behind the ladies' view" and reject its stereotyped vision of the cultural landscape and the place of women within it still common in Mississippi despite the passage of more than a century between their contrasted weddings (675).

Dicey's allusion to "the ladies' view" is more specific, however, for the initial stereopticon slide she remembers viewing with Uncle Felix as a little girl on her Sunday visits to Mingo was titled "The Ladies' View, Lakes of Killarney," an actual nineteenth-century prospect within another romanticized landscape (*Stories* 670). These seemingly magical pictures of exotic scenes from around the globe were in reality duplicated photographs printed side by side for viewing in the stereoscope, in which binocular vision produced three-dimensional effects.[10] As much as her own excitement, Dicey remembers her great-uncle's love for these "pictures of the world to see": "sand-pink cities, passionate

fountains . . . sleeping towers . . . statues [with] rainbow edges; volca-
noes; the Sphinx . . . and again the Lakes" (670, 671). By viewing her
great-uncle's silent contemplation of these images, Dicey had experi-
enced, for perhaps the first time, "That expectation—even alarm—that
the awareness of happiness can bring! Of any happiness. It need not
even be yours" (670). In Welty's wonderfully evocative story, the female
protagonist finds it difficult to assimilate all these complicated revela-
tions concerning her cultural forebears. Her new insights into family
relations, ones provided to this young bride-to-be by visual intertexts,
develop fresh perspective for her as she prepares to leave the culturally
limited, small-town Mississippi of her girlhood for the larger world
beyond, where she will be a modern married woman in an unnamed
northern city but still "kin" to her female forebears.

Welty's wrote more novels than stories after the mid-twentieth
century, and *The Ponder Heart* (1954), *Losing Battles* (1970), and *The
Optimist's Daughter* (1972) reveal few interesting photographic tropes.
However, one important example in *Losing Battles* recreates the 1930s by
way of a photographic intertext. Welty worked over a period of almost
twenty years to complete her only large-scale novel, and the book proves
a remarkable achievement in many regards. Everything in it seems
fully imagined, perhaps because its long narrative is set chronologically
during the Depression years when Welty traveled her native state for
the WPA. Geographically, her setting is the hill country of northeast
Mississippi, far from the heart of the state and Welty's Jackson home.
Although her richly detailed novel includes several photographic tropes,
the primary example is a heroic image developed over several pages, a
sort of modernist intertext that represents the larger narrative in all of
its complexity and complication. *Losing Battles* chronicles the history
of the Vaughn/Beecham/Renfro clan and their neighbors by way of the
events during and after what they believe is the ninetieth birthday of
the matriarch, Granny Vaughn, sometime during the later 1930s.

In the course of these celebrations, Granny's daughter Beulah Renfro
calls for her daughter Elvie to "Go bring out my wedding" (*Novels* 766).
Beulah is referring to her bridal picture taken a quarter of a century

earlier by an itinerant photographer or, as she says, "The man on the mule that happened along to take the picture . . . one of life's wayfarers, a picture-taker" (767). An epic example, "nearly two feet long, seven or eight inches high," it is the "only picture that ever was made of our whole family" in Beulah's memory (767). The family panorama is focused on the same front porch where they now view themselves twenty-five years later, as if this vision exposed itself gradually in the developing medium of passing time. The family is most aware of those still present in the photograph, though no longer with them in life. One is Sam Dale, the youngest Beecham brother, killed in the First World War, who can be discovered at both ends of the panorama, a feat achieved by running behind all the others during the picture's long exposure. In so doing, he is "putting his face smack and smack again into the face of oblivion," as if he were his own doppelganger (*Novels* 768). The sudden appearance of his stereoptical image is compounded by a blurred one, never noticed before this day, of Rachel Sojourner. She proves to be another strange and short-lived figure, as her names indicate, who is now revealed as the mother of Gloria Short. The secret of Gloria's parentage is revealed at the birthday celebration when Jack Renfro, the father of Gloria's little daughter Lady May, returns home on parole from the Parchman penal plantation far off in the Mississippi Delta. Both of these elements within this iconic family picture reveal shadowy aspects of photographic interpretation in its power to manipulate reality, as in Sam Dale's deceit a quarter of a century past, and in its ability to eventually reveal the truth, as in the present recovery of Rachel Sojourner.

A third lost soul newly discovered within the photograph is Julia Percival Mortimer, the intrepid teacher who fought throughout her life the losing battle of education at the local school and whose lonely death has just been reported. In this context, she is now remembered as a boarder with the Vaughns at the time of the wedding, who even then stood apart from the rest of the characters, "looking off from this porch here as from her own promontory to survey the world" (769) As Aunt Beck declares at last, "this picture's filling up with the dead," and she implies that the rest of them will continue to people it with similar

ghosts as time passes when she concludes, "After this year, let's not try taking it off its shelf any more" (769). Of course, this family dialogue recalls the formulations of Barthes, Sontag, and other critics about the power of the photograph to bridge past and present, as well as life and death, so that its viewers can read their relations with these final things in a new and a different manner through the language of vision.

More than any other photographic trope in her fiction, the Renfros' wedding photograph demonstrates how Welty created modernist intertextualities by acting herself as an itinerant of the literary imagination and exposing the depths of meaning beneath the surface of romanticized images from the southern past. This single instance proves significant because Welty's description of the panoramic photograph also provides a parallel reading of *Losing Battles*, her longest and most complex narrative. Published almost a quarter of a century earlier, *Delta Wedding* was brought into sharper focus by contrasting photographic tropes of bridal and funeral pictures that capture the tension between natural setting and cultural ceremony implied in its title. In the years between Welty's two best novels, photographic tropes are found most importantly in the rich selections gathered in *The Bride of the Innisfallen*—including the title story, "Going to Naples," and most especially "Kin"—all pieces written during the period of Welty's own greatest itinerancy. The photographic figures and verbal pictures in "A Worn Path," "Why I Live at the P.O.," and other narratives all support the significance of patterns of image and symbol within her entire literary canon. The linkage between the visual intertexts in her narratives and the verbal ones in her pictures take us back to her own photography and from there to the "kindred impulse" of creativity that informs Eudora Welty's narratives as being among the foremost texts of southern literature and perhaps even of American letters in the mid-twentieth century. Certainly, this judgment was expressed in reviews and essays by her professional colleague and personal friend, Robert Penn Warren. Warren was the subject of the previous chapter, of course, and Ralph Ellison, the subject of the following chapter, was another friend of Welty's who valued her work as highly.

SIX

Ralph Ellison, Photography, and
Invisible Man

The major African American writer Ralph Ellison lived from 1913 to 1994, and his great novel *Invisible Man* appeared in 1952, at the midpoint of the century and his life. The author and his novel still are recognized as significant in this new century, yet his career and canon remain contested even now. Ellison spent the latter half of his life laboring on a second epic fiction, though he never published that imposing if problematic effort. Its appearance as *Three Days Before the Shooting: The Unfinished Second Novel* in 2011 elicited renewed interest in Ellison. Scholarly editions of his other unpublished or uncollected writing, two substantial biographies, and an impressive number of recent studies from fresh critical viewpoints have yet to solve the many biographical and critical puzzles posed by Ellison's life and work.[1]

One of these new approaches becomes my focus here, as photography has been slighted to some extent by the Ellison criticism, along with other visual perspectives. Many aspects and instances of Ellison's visual imagery have been observed, though for the most part they are not considered consistently throughout *Invisible Man* or his other works, nor are they connected directly with his verbal recreation of visual art in the literary trope of ekphrasis. Ellison's personal interest in the folk culture of black America became professional when he worked on the WPA's Harlem projects (Jackson 182). These oral and musical aspects of black life prove central in much of the Ellison criticism, especially in his use of black artistic traditions found in tale-telling and sermons or in

blues and jazz. His cultural and critical essays on the African American legacies in oral and musical performance also determine much of the emphasis on these subjects in the Ellison criticism. Although these topics are significant to understanding his literary program, Ellison was interested by and often commented on the plastic and graphic arts in connection with culture and race—especially sculpture, painting, and photography. Ellison practiced all of these art forms himself, and he even considered them as professional possibilities before settling on letters.[2]

We can discover new answers to questions about Ellison as a man and as a writer within photography, fiction, and the cultural construction of racial identity within American, southern, and black literature during the middle decades of the twentieth century. These relations are manifold and demanding, and in Ellison's case they are focused by complex visual tropes involving literal sight and literary insight, imaged in light and dark or white and black, as well as in vision and blindness or visibility and invisibility. The writer's involvement with such visual imagery is most obviously developed in *Invisible Man*, where vision becomes his informing metaphor of race relations in segregated America. As we have seen, recent literary criticism has posited photographic images as crucial in modern American letters, including those cultural traditions important for the reading of Ellison, such as the varied relations of American realism and modernism during the mid-twentieth century, especially within southern and black literature. As Ellison's most striking visual images are developed in photography, a long-time personal and short-term professional interest for him, it proves central to my reading of his single major novel.

In several ways, *Invisible Man* recreates Ellison's own life during the 1930s, especially in the novel's chronological and spatial organization as the deepening Depression propels its unnamed protagonist northward from the segregated Deep South to a segregated Harlem. The narrator is not Ellison himself, of course, but a faintly autobiographical persona who embodies many of the writer's changing responses to his time and place as part of the evolution of an African American identity. One

aspect of this cultural and personal transformation is the Depression decade's interest in photography. Ellison's efforts as an amateur and a professional photographer during his early years in Harlem were an important part of his personal growth, but this development also reflected significant cultural changes during the years when he wrote *Invisible Man*. Ellison's interest in photography must have introduced him to the widely known and well-received work by white photo artists popular in the New York scene, such as Edward Steichen and Carl Van Vechten, and certainly to that of black photographers in Harlem, such as James Van Der Zee and Gordon Parks. *Invisible Man* also reflects the cultural constructs and dialectics during the Depression era that recent criticism has rediscovered in the best of the decade's writers and photographers. Morris Dickstein and other current scholars of the period have shown this central tension exemplified in literature, but it may be seen in the other arts, including Ellison's favorites—music, radio, and movies—and most of all in his visual pursuits in sculpture, painting, and photography.

Scholarly and critical work on African American photography and literature often discovers similar tensions between documentation and expression, which then are complicated by the consideration of racial identity and the construction of that identity in visual images. Blacks were slighted as both photographers and subjects even within a putatively liberal organization like the Farm Security Administration (FSA), as discussed in Nicholas Natanson's *The Black Image in the New Deal: The Politics of FSA Photography* (1996). In her *Harlem Crossroads: Black Writers and the Photograph in the Twentieth Century* (2007), Sara Blair views transitions between documentary realism and modernist subjectivity in both art forms, devoting much attention to Ellison and connecting him with contemporary photographers like Parks during the creation of *Invisible Man*. Miriam Thaggert's *Images of Black Modernism: Verbal and Visual Strategies of the Harlem Renaissance* (2010) balances the social and artistic aspects of photography and literature with direct consideration of visual efforts of Van Der Zee and others to create a cosmopolitan black identity within a new urban setting of Harlem.

Ellison was moved by his friend and mentor Richard Wright's realistic

prose and the documentary photographs of blacks from many sources presented in his photo book *12 Million Black Voices*. Because of his close relationship with Wright, Ellison took his mentor's photo book very seriously. Wright balanced his subjective narration of African American history against a documentary visual record of blacks both South and North, which was drawn primarily from the photography files of the several government agencies charged with documenting harsh Depression realities in order to justify the innovative policies of the New Deal. Almost all of these visual texts were created by white photographers, including Walker Evans, and their presentation was aided by Wright's coeditor Edwin Rosskam, a white bureaucrat with the FSA. Wright complemented the pictures they selected for *12 Million Black Voices* with his personalized account of black history and culture in America from slavery through the Depression. This saga was narrated not so much in his own voice, then well known and powerful as the author of the best-selling *Native Son* (1940), but as a collective narration that attempts to aggregate the voices of the twelve million African Americans reported in the 1940 census.[3]

Ellison was so impressed by *12 Million Black Voices* that he adapted a photo-textual approach in collaboration with Parks for a projected magazine article entitled "Harlem Is Nowhere," which became an important milestone in his literary evolution toward *Invisible Man*. In 1948, Ellison and Parks worked together for several months, scouring Harlem streets for visual images that would illuminate his verbal ones. This documentary project intended to combine nonfiction and photography immediately, as in a newspaper report, but Ellison's prose went unpublished until 1964 and Parks' photos were lost. Parks later had a long, productive career that included film, writing, and music as well as photography. Close in age and with similar backgrounds in segregated Kansas and Oklahoma, the two men soon became personal friends and professional collaborators. Ellison informed Wright that the photographer's contribution was "to capture those aspects of Harlem reality which are so clear to me" (Rampersad 221). Since these facets of the ghetto were not viewed in a simply documentary fashion by Ellison, his

visual goal must have been something like the tension between social documentation and subjective vision found in the best work of the FSA photographers. In fact, Parks had honed his photographic skills at the FSA; as one of its few black cameramen he created iconic images of Jim Crow conditions in the North as well as in the South.[4]

With much the same intention and intensity, the photographic tropes in *Invisible Man* balance realistic documentation and modernist subjectivity, which Ellison combined in order to record and recreate authentic black identity in a legally segregated America. All of Ellison's visual images in the novel are important to his purposes and worthy of careful consideration; however, my analysis focuses on his photographs of African Americans. Almost all of the photographs described in the novel are of human subjects, for the most part individuals rather than groups, and the great majority of these are pictures of black men. The photographic images of white Americans do provide meaningful contrasts, for example, in the pale faces and fair hair appearing in most commercial advertisements even in the heart of segregated Harlem. These pictures of whites prove significant as markers of segregation simply because they do not include blacks at all. Even more complex are photos of white subjects that imply a black agency that is not pictured, as in the newspaper photo of a bewildered white man roughed up by the protagonist after they collide on a darkened street.[5] As the narrator is quick to note, he is invisible to whites both in physical reality and in documentary re-creation, much as in the national culture during the Depression era. The portraits of black males provide the most meaningful photographic tropes found in *Invisible Man*, however, and they are the most important to Ellison's purposes in the novel.

Like many scholars and critics, I believe Ellison's *Invisible Man* remains a self-referential Bildungsroman, a narrative of the somewhat autobiographical protagonist/narrator's development into a self-realization and a racial identity much like those achieved by the author himself. Ellison often seems to explicate his own text; a notable instance is found in his protagonist's long recollection of a lecture by a literature professor at his southern college. This black intellectual proves to be another of

many surrogate fathers for the central character, one whom he recalls in the depths of personal and cultural depression in Harlem. Professor Woodridge instructs and exhorts his black students with the example of James Joyce's *Portrait of the Artist as a Young Man* (1916), a work that is one of Ellison's many models for his own novel of a developing artist. Most important is the focus that the black instructor, the black narrator, and the black author place on visual identity. "Stephen's problem, like ours, was not actually one of creating the uncreated conscience of his race," their teacher insists, "but of creating *the uncreated features of his face.* Our task is of making ourselves individuals. . . . We create the race by creating ourselves" (307, emphasis in text). Ellison recognizes that white culture constructs black identity in terms of visual and verbal markers, and the individual African American must define his own identity within this black/white continuum in much the same terms.

Following a pessimistic "Prologue," set some time after his protagonist has fled the racial battles of Harlem for an underground refuge, Ellison's narration follows in chronological order toward a more optimistic "Epilogue." Chapter 1 of *Invisible Man,* often anthologized separately under the title "Battle Royal" (in reference to its most striking action), introduces the photographic trope of visual identification as symbolic of the protagonist's developing racial consciousness. After the narrator is honored as the valedictorian of a southern town's black high school, he must humble himself before the local white patriarchy, first in a debasing free-for-all and next in a fawning speech cribbed from Booker T. Washington. Now at the cusp of manhood, the recent graduate is rewarded for his servility with a new leather briefcase and a scholarship to this southern state's black college. He then returns to his ghetto home to face the spirit of his grandfather, who counseled passive resistance rather than accommodation even on his deathbed: "I stood beneath his photograph with my briefcase in hand and smiled triumphantly into his stolid black peasant's face" (34). The narrator believes he is different in appearance and education, but he admits that his forebear's "was a face that fascinated me" (34). At some level the protagonist seems to know the photo is a mirror image of his own racial

heritage and thus of his identity as an African American. His focus, like a Barthean punctum, is the returned gaze of the dead grandfather. "The [picture's] eyes seemed to follow everywhere I went," as the narrator's haunted guilt feelings complicate this photographic document with a subjective, almost Gothic enigma (34). That same night his dead grandfather appears to him in a nightmare to translate his scholarship documents into a cultural imperative that becomes both the realistic racial theme and the subjective motif of Ellison's narrative: "Keep This Nigger-Boy Running" (35).

Ellison's protagonist is then paced through a series of picaresque adventures, southern and northern, that trace his development in *Invisible Man,* and photographs mark each stage of his enlightenment. Most of these pictures balance patterns of visual imagery at once realistic and subjective in terms of his racial self-identity. The narrator's black college is clearly modeled on Tuskegee Institute, where Ellison studied art, music, and literature during the early 1930s. Post–Civil War photographs of the institution's black and white founders are displayed in the campus museum, while more recent portraits of the school's present-day black leaders and white donors decorate its buildings. In the school's administrative offices, the narrator views "the framed photographs and reliefs of presidents and industrialists, men of power—fixed like trophies or heraldic emblems on the walls" (123). Thus, the documentary and memorial purposes of these pictures are subsumed by their subjective energy as symbolic markers of culturally constructed and fixed black/white binaries and hierarchies that create and inform the segregated institution from its inception.[6]

When Ellison's protagonist is summoned to the president's office to explain his misadventures while serving as guide for a white trustee on Founder's Day, ones that will cause his expulsion, he is made uncomfortable by the visual symbolism of that setting. In particular, the image of the legendary Founder honored earlier that day looms above the narrator—much as the photograph of his grandfather did earlier at home—as a symbol of his conflicted feelings about his racial heritage. Like the protagonist's forebear, the Founder was born into slavery, but

he made his accommodations with the New South that helped determine its racial binary. Across the president's oversized mahogany desk, above a case of gleaming trophies, the narrator observes, "a portrait of the Founder looked noncommittally down" on him and his problems (123). The black patriarch's impenetrable gaze recalls the invisible man's earlier reading of a campus memorial: "the bronze statue of the college Founder, the cold Father symbol," recalls the actual bronze sculpture of Booker T. Washington at Tuskegee lifting the veil of ignorance from a kneeling slave, though here the narrator wonders whether this is "a revelation or a more efficient blinding" (37).

Whatever his relation to the Founder might have become, Ellison's protagonist is clearly betrayed by his cynical successor, President Bledsoe. Represented "by pictures in the Negro press captioned 'EDUCATOR,' in type that exploded like a rifle shot," to extend him a white legitimacy by way of his subaltern status, Bledsoe's students see him "as our coal-black daddy of whom we were afraid" (108). The narrator later will defuse the power of these paternalistic images when he imagines this stock photo reprinted under outraged headlines exposing the educator's darker identity as a closet "chitterling" eater, a change revealing how the same image can be altered by cultural context (230). This educational functionary does engineer the protagonist's northern exile to cover up the contretemps involving the proper Bostonian trustee, who inadvertently visits a black juke joint and brothel while the narrator chauffeurs him around the campus and its environs on Founder's Day.[7]

In regard to his individual development, the northern exile of Ellison's protagonist soon proves as absurdly frustrating as his southern education. In addition to cultural tensions inherent in his abrupt transitions from a rural environment to an urban one, the narrator's search for suitable employment is sabotaged by negative letters (recalling his earlier scholarship letter) from the college's black president to its white trustees. The protagonist's trips between Harlem and Wall Street pursuing a job provide occasions for photographic tropes that involve contrasting black and white images that replicate ones seen earlier in the South. As his northern experience develops, however, these visual images

become more closely involved with the narrator himself. For example, he imagines himself becoming visible to the larger world in the greater scope of New York City by means of a photographic transformation. In his daydreams, he is literally transfigured by his future career among these powerful white men. He sees himself neatly dressed and nicely spoken: "I imagined myself making a speech and caught in striking poses by flashing cameras, snapped at the end of some period of dazzling eloquence" (145). As his life in Harlem continues to unfold, the protagonist's photograph will be taken in actuality, though not to the positive effects that he naively imagines early on in his personal migration.

Disappointment if not disaster ends the narrator's every attempt to find meaningful work. Notably, a surrealistic explosion injures him at the Liberty Paint factory, which represents the national enterprise in its "Right White" product line; the protagonist translates visual images into rhyming slang, "If you're white, you're right" (190). His injury requires electro-shock treatment in the company hospital, and his X-rays become a different sort of image, reversing the spectrum of black and white as in a photographic negative.[8] At last, the protagonist seems to find purpose when he gives a spontaneous speech to the angry crowd protesting the eviction of an older black couple by white deputies; this action earns him a place as a community organizer for the Brotherhood, Ellison's stand-in for the Communist Party. Unlike many of his literary colleagues during the 1930s, Ellison never actually joined the party, but he was sympathetic enough to feel sorrow and anger when it patronized its black members during this time.[9] The inspiration for his rhetoric is found in the old folks' possessions scattered on the white snow, a virtual history of black America by way of material culture, including symbolic pictures. This montage of images ranges from "a tintype of Abraham Lincoln" to "a picture of what looked like a white man in black-face" to a newspaper photo of "MARCUS GARVEY" (235).[10] The most important of them is their faded wedding photograph, and "seeing the sad, stiff dignity of the faces there," black agrarian ones much like his grandfather's, the narrator's own practice of ekphrasis moves him to find the words of defiant eloquence that sways the crowd (235).[11]

Although the integrated Brotherhood seems different than his seg-regated college, it ultimately proves to be another construction of the majority culture designed to keep the black minority in its "proper" place. The protagonist senses this duplicity from the start, but he re-fuses to recognize the deceptive constructs that surround him. For example, when he is introduced to the hierarchy of the organization at a cocktail party that recalls nothing more than the smoker from Chap-ter 1, the leaders' reservations are not about his race but his skin color. He hears a white woman enquire whether the new recruit "should be a little blacker" for effective leadership among the darker masses of Harlem (263). The answer to this question is suggested later when the protagonist is replaced by a darker Brother on a multiracial photo-graphic poster illustrating the organization's misleading motto: "After the Struggle: The Rainbow of America's Future." Ellison's narrator does receive a warmer welcome from some black Brothers, especially those forged in the crucible of the South. One is Brother Tarp, who had been condemned to a southern chain gang and who gives the new recruit a link from the fetters he escaped as a symbol of their common cause. The older Brother also mounts a framed picture on the younger man's office wall: "I sat now facing the portrait of Frederick Douglass, feeling a sudden piety, remembering but refusing to hear the echoes of my grandfather's voice" (328–29). Thus Ellison's photographic tropes continue tracing this psychological and social development, drawing closer to the narrator's new personal identity as both an individual and a representative African American in his own terms.[12]

The protagonist ponders this process of change before his first public appearance with the Brotherhood, sensing that this evening will be cru-cial in his journey of self-discovery. Like Douglass, he has a new name to match his new role, but he worries that he may become someone else as he prepares to make his maiden speech. "I seemed to view myself from the distance of the campus while yet sitting there on a bench in the old arena," he thinks, while sorting many images of manifold black selves, his own and those of others, including a newspaper photo taped to the locker room wall (289). This photographic trope again invokes

ekphrasis by way of its narrative extension of a tragic folk hero's difficult development, reflecting the protagonist's own growth as a black man.

> It was a shot, in fighting stance, of a former prizefight champion, a popular fighter who had lost his sight in the ring. It must have been right here in this arena, I thought. That had been years ago. The photograph was that of a man so dark and battered that he might have been of any nationality. Big and loose-muscled, he looked like a good man. I remembered my father's story of how he had been beaten blind in a crooked fight, of the scandal that had been suppressed, and how the fighter had died in a home for the blind. (289–90)

This visual element asserts the boxer's nonwhite otherness, but it reveals his universality as well, for his racial identification is subsumed in his human fate over the passage of time. The narrator remembers his father telling him the blinded fighter's sad history, so it becomes part of his personal development.[13] "Who would have thought I'd ever come here?" he muses, ironically "slouched on a bench," much like a fighter awaiting his call to the ring (291). This image is complicated by another one when the narrator tries to imagine the "unformed" person he sees in himself, "as when you see yourself in a photo exposed in adolescence: the expression empty, the grin without character" (291).

Visual images in general and photographic tropes in particular prove most crucial for exposing the protagonist's developing self-consciousness. The narrator can remember or imagine photos of himself across the span of his life, as when he recalls an adolescent snapshot or projects a future self on a slick magazine cover, but the first actual picture of him seen in the present moment of Ellison's narrative demonstrates his uneasy relationship with his new identity. After he becomes the Brotherhood's spokesman in Harlem, a downtown publication features him in an interview that upsets white and black Brothers for personal and political reasons. An older black leader confronts him over the piece, which includes "a portrait of me looking out from the magazine page" (346). The narrator then hastily explains to the lead-

ership committee that "the reporter asked a few questions and took a few pictures with a little camera" (348). The committee members quiz him closely about the text, but they seem more concerned about his picture, which paradoxically projects the protagonist as the face of the Brotherhood in Harlem, to the chagrin of its white leaders who did not want his light-skinned image on their deceptive recruiting poster.

In fact, the young black who replaces the narrator on the poster becomes a sort of a surrogate for him. Tod Clifton is an idealized figure in many ways, and the narrator describes his dark complexion contrasted with the white adhesive bandage covering a scrape from a recent street fight with Harlem's black nationalists (315). The young man naively accepts the assurances of racial equality implied in the Brotherhood's recruiting promises. However, Clifton allows himself to be destroyed by sorrow and rage when he realizes his deception, a fate not lost on Ellison's protagonist. The novel's visual expression of the other young leader's disillusionment is "*Sambo, the dancing doll,*" a dark tissue paper puppet hawked on street corners, until an argument with a white patrolman ends in Tod's death (373, emphasis in text). The Brotherhood, from which Clifton had resigned, is not above exploiting this tragedy for its political purposes, and the Brothers plan a memorial with the narrator as Clifton's eulogist. White placards with black borders are plastered across the ghetto, proclaiming "BROTHER TOD CLIFTON / OUR HOPE SHOT DOWN," and in visual symbolism, "a photograph of Clifton was . . . published" as a final documentation of the community's loss and a reminder of the photograph's power to transcend time and death (389). The narrator's eulogy is in a sense for his own younger, naïve, and idealistic self as well, rather like another in his album of successive photographic images. His harangue to the angry group at the eviction focused on a timeworn wedding portrait, beginning his involvement with the Brotherhood, whereas his funeral oration recreating the recent memorial photograph ends this stage in his personal growth. As a fullblown interracial battle ensues, the protagonist flees into his basement retreat, where his meditations in the concluding chapter recall the prologue and bring his narrative full circle to an epilogue that hints at

future progress beyond invisibility—his self-created identity becomes both the visual and psychological symbol of American cultural and racial complexity.

I trust that my reading of Ellison's novel demonstrates how the writer employs photographic tropes to reveal his title character engaging the images of himself and of others, black and white, in order to develop his individual identity as a fully realized person and his social situation as a black man in a segregated America. Black faces prove the most important for his purpose, whether his own at various stages of his life or those of other African American men who parallel these stages in his development ever more clearly: his grandfather, the Founder, President Bledsoe, the evicted black pensioner, the blinded boxer, Frederick Douglass, Marcus Garvey, Tod Clifton, and others. Like recent studies of *Invisible Man* and Ellison that take new and different viewpoints, my analysis of its photographic tropes means to open a unique perspective on the novel's power and complexity in a new century.

At the same time, it also becomes another way for us to approach Ellison's overall life and work, especially the posthumous *Three Days Before the Shooting: The Unfinished Second Novel*. Adam Bradley's *Ralph Ellison: In Progress* (2010) approaches Ellison's overall career and canon by way of the unpublished materials, effectively reversing chronology by working backward from the newest writing to the author's initial attempts at a novel to show both the achievements and the limitations of his vision. In *Ralph Ellison and the Genius of America* (2012), Timothy Parrish works through the career and canon in a more chronological order to make a convincing case for Ellison as a creative genius who was socially engaged throughout his entire career. Parrish emphasizes Ellison's friendship with Robert Penn Warren, and he views Warren as the most insightful critic of Ellison and his writing. If my own judgment of Ellison's place in our literary pantheon is not quite as positive as these two views, taken together they help refute Arnold Rampersad's unflattering biographical portrait of the writer and his negative assessment of the work. The importance of photography to Ellison's overall canon also suggests its utility as an introductory lens for viewing other texts by

other black, southern, and American writers of the twentieth century. This line of inquiry may be extended into our new century as well. For example, recent Poet Laureate Natasha Trethewey employs ekphrastic readings of real and imagined photographs in many selections from her poetry collections that recall the works of earlier southern writers considered here, both black and white, as will see in my seventh and concluding chapter that follows.

SEVEN

Photography and Southern Literature
in a New Century

American and southern literature from the transitional 1960s through the turn of our new century certainly recreated much of the experiment and excitement that obtained in the national and regional canons between the two world wars. Some of this energy derived from southerners who came into their own in the 1930s, especially Warren, Welty, and Ellison, among those major figures considered here. Although Agee died in 1955 and Faulkner in 1962, their posthumous popular and critical reputations extended their influence through their century and into ours. Welty and Ellison moved in new literary directions, seemingly impelled by the changing perceptions of gender and race in the 1960s, and both writers turned to nonfiction while working on long, complex, and summative novels. Warren's evolution proved even more complicated; a one-time Fugitive Agrarian, he revealed his changing racial attitudes in nonfiction concerning desegregation and civil rights during the 1960s, while in the 1970s he focused on lyric poetry and published several new volumes that won the Pulitzer Prize and other awards.

Many other southern writers of significance could be mentioned in connection with photography as well: men of letters such as Peter Taylor, Walker Percy, or William Styron; female fictionists such as Flannery O'Connor, Lee Smith, or Bobbie Ann Mason; and African American writers such as James Baldwin, Albert Murray, or Toni Morrison. Katherine Henninger's critical study ably considers the influence of photography on the writing of several other contemporary southern

women including Dorothy Allison, Ann Beattie, Josephine Humphreys, Jill McCorkle, Anne Tyler, and Alice Walker. The twentieth-first century has continued to witness remarkable new changes in the culture of the South, many of which are rooted in the 1930s, including aspects of the earlier era's literature and photography. My major example of the literary and graphic responses to these continuities and changes is the work of poet Natasha Trethewey, a southerner with a biracial background, who published her first collection in 2000. Yet her work proves intertextual with traditional southern poetry, especially that of Robert Penn Warren, and Trethewey also makes extended use of photographic images and tropes in ways that recall the earlier figures considered in my study.[1]

Winning the Pulitzer Prize in 2007 for her third poetry collection, *Native Guard*, made Trethewey a respected regional figure, but in 2012 she became known nationally with her initial appointment as poet laureate and the publication of her fourth collection, *Thrall*. Trethewey is much admired, as demonstrated by her reappointment to an uncommon second term in the laureateship. Most critics recognize that *Thrall* reiterates and expands the matters and forms discovered in her three earlier collections. In particular, she enlarges her psychological and poetic interests in child/parent relations as the subject matter of her poems in *Thrall*. Her mother was a black social worker, while her father was a white professor and poet. Whether autobiographical or imagined, family relations in Trethewey's poems are rife with racial tensions and laden with creative anxieties. Yet *Thrall* also extends Trethewey's poetic intertextualities, not just with literary works but with the drawings, paintings, and photographs she engages through the trope of ekphrasis. Trethewey's most recent collection includes much more traditional art than photography, though her overall canon reveals a persistent concern for photographs. Her frequent photographic images and tropes demonstrate Trethewey's contemporaneity in an artistic sense, yet her interests in photos as cultural documents also reveal an awareness of her heritage as a self-identified black writer of a changing South in our new century.[2]

Trethewey's complex relationships with southern traditions of literature and photography are encapsulated neatly in her dreamlike "Pastoral," the first of several poems focusing on her native region in the final section of her third volume *Native Guard* (2006). Although Trethewey found female role models in many women writers, the influence of her Canadian father's poetry on her work made it natural for her to seek literary father figures, black and white, within the literary legacies of the South. The opening lines of "Pastoral" establish her physical setting and define her psychological situation: "In the dream, I am with the Fugitive / Poets. We're gathered for a photograph" (*Native* 35). Trethewey uses the subjectivity of dreams and the documentation of photographs to frame her dilemma as her scene becomes a surrealistic version of actual portraits documenting the Fugitives' frequent gatherings and reunions. Ironically, the pastoral setting proves only "the photographer's backdrop," much as in Welty's "Kin," though here it is hiding "the skyline of Atlanta" and quieting "The drone / of bulldozers" (35). Trying to find her place among a group of poets so uniformly male and white makes her feel as if she is "in blackface," as they interrogate her: "*You don't hate the South?* they ask. *You don't hate it?*" (35, emphasis in text). Their questions are clearly rhetorical ones meant to elicit insistent denials on the model of Faulkner's Quentin Compson. She tries to ingratiate herself, citing her genealogy, both literal and literary: "*My father's white,* I tell them, *and rural*" (35). Among these patriarchal figures, only Warren seems to welcome her with a symbolic libation. "*Yes,* / I say to the glass of bourbon I'm offered" (35).

In interviews, Trethewey reveals that she values Warren not just as a poet but as a racially enlightened Southerner: "Robert Penn Warren means a lot to me because of his dynamic relationship with his South and his place in it. I admire the transformation he undergoes" (Glock). Therefore, "his work has meant a great deal to me. I'd like to think I'm in conversation and kind of extending a conversation with Warren" (Pettus). Twice poet laureate (the last southerner before Trethewey to have a second term) and twice Pulitzer Prize winner for poetry, Warren becomes a significant poetic precursor for Trethewey. His influence can be

felt from her first book, *Domestic Work* (2000), forward, and it becomes more marked as her canon unfolds. For example, Trethewey connects her literary hybrid, *Beyond Katrina: A Meditation on the Mississippi Gulf Coast* (2010), to Warren's much earlier study of Southern cultural change, *Segregation: The Inner Conflict of the South* (1956). She correctly identifies Warren's earlier text, which includes an interview with himself, as an intimate melding of the writer and the subject, calling *Segregation,* "a personal narrative—not a memoir, but somehow clearly an investigation of the self," much as *Beyond Katrina* would prove for her (Heath). Warren is just as concerned with parents and their progeny as is Trethewey, and his work often is as intertextual with literary and graphic models. For example, *Audubon: A Vision* (1969), his long poem about the early nineteenth-century artist, may have influenced Trethewey's *Bellocq's Ophelia* (2002), her second collection completely focused on pictures made by a New Orleans photographer. Most recently, as her epigraph for *Thrall*, Trethewey quotes Warren, "What is love? / One name for it is knowledge"; the question and answer concluding the penultimate section of *Audubon* that is entitled "Love and Knowledge."

Trethewey also connects *Beyond Katrina* with the work of James Agee and Walker Evans in *Let Us Now Praise Famous Men,* a comparison that proves appropriate in more senses than just its hybridity, as the writer includes in her text photographs from her family album and some she took herself (*Conversations* 119). Trethewey is versed not only in the practice, however, but in the theory of photography. One of the epigraphs for her own ekphrastic study *Bellocq's Ophelia* is from Susan Sontag: "Nevertheless, the camera's rendering of reality must always hide more than it discloses" (1). In several interviews, she expands on Sontag's formulation, explaining that the writer's ekphrastic task is seeing not just what is present in the photograph but more importantly what is not. As an example, she remarks the gender discrepancy of her own family album; it pictures more women than men, as the men often were absent. Trethewey frames the appearance of the males within the family album in terms similar to Sontag's; "[t]heir presence is felt most palpably because of their absence" (Rowell). Trethewey also

cites Barthes several times in interviews, connecting his terminology of the photograph's *studium* and *punctum* with Sontag's theorization of presence and absence (*Conversations* 37). Indeed, she often echoes the considerations of photography in relation to time and death as formulated by Barthes and Sontag. "I was interested in photography because of what is elegiac about it. As a child, I always found myself staring at photographs . . . what was most poignant for me then was that they were often of people who had died" (67). As for both theorists, for Trethewey the photograph could represent permanence as well as loss; "they were objects that helped hold on to something, the way language can" (68).

Photographic images and tropes appear throughout Trethewey's work, beginning with her initial published poems from the 1990s that were gathered in her first collection, *Domestic Work* (2000). The title suggests the volume's essential subjects, the demeaning labor performed by many African Americans and the arduous family relations that result from such employment. The volume is carefully organized to contextualize her individual poems within larger thematic orders, especially those based on photographs. An introductory section of five ekphrastic poems in Part I is based on pictures illustrating the darker aspects of the poet's familial and racial history. Part II, also titled "Domestic Work," is a chronological sequence of eleven poems, with the first entitled "Domestic Work, 1937"; all of these trace the work life of her maternal grandmother, much like a family album of snapshots. Part III is a grouping of ten poems considering Trethewey's black mother and white father, while the ten selections of Part IV return to her maternal family history. Eight of these two sections also employ photography in some manner, making *Domestic Work* second only to *Bellocq's Ophelia* among Trethewey's four collections in terms of the total number of photographic references.

Four of the five poems comprising Part I of *Domestic Work* are based on the photographs of Clifton Johnson, a white writer from Massachusetts who toured the South in search of local color at the turn of the twentieth century. These ekphrastic efforts are in some ways historical studies of the New South, as Johnson became a friend of Booker T.

Washington and other accommodating black leaders in this transitional era. Johnson's patronizing pictures reveal more than he intended to a careful reader of their visual language like Trethewey. Three of the photos are centered on black women as domestic or agricultural workers, while the fourth reveals black farmhands in Sunday clothes. Johnson's images were grounded in the pictorialism of his era, though they do prefigure the more documentary mode of the 1930s, especially Welty's early photographs of black life in Mississippi. Johnson's anonymous black women working in a kitchen or a garden circa 1900 may have reflected or even prefigured Trethewey's own family history, yet they were not part of it, nor did they directly influence the poet's own life. Trethewey turns next to her grandmother in Part II and to her mother and father who appear in the poems of Part III.

The one other ekphrastic poem in Part I, by way of contrast, is about Willie "Son" House, Trethewey's great-uncle, a black entrepreneur well known in her hometown during the mid-twentieth century. Trethewey deftly weaves his story into the history of her family and the Mississippi coast around Gulfport in *Beyond Katrina,* and she includes two photographs of him in the sheaf that illustrates that hybrid text. The first is a close-up portrait from the 1940s of an imposing black man (15), and the second is a longer view of him behind the bar of the Owl Club, a beer parlor that he owned in the 1950s (39). Although Trethewey does not credit the picture in *Domestic Work,* it seems to be the basis for her poem, "At the Owl Club, North Gulfport, Mississippi, 1950." Details of the photograph are seen in the poem: "the men / so casual," "tilted head and raised glass," "polished wood / and mirrors of the bar," even the beer cans, "Regal Quarts," lined up on shelves (4–5). Like the photograph, "Son Dixon's center of it all, / shouldering the cash register," for "This is where his work is," as he provides other black men "a moment's stay from work . . . [at] a colored man's club" (4). The black patriarch's more rewarding work includes buying the latest recordings of what then was called "race music" for the jukebox at his club, as in "Saturday Drive," a selection in Part IV that describes shopping trips to New Orleans with his niece, Trethewey's mother, for company (46).

Another image from Trethewey's family album centers Part IV of
Domestic Work in her ekphrastic study "Give and Take," in this case a
picture of her great-aunt. When Trethewey visits her now senile fore-
bear in the present, she remembers "the photograph you used to pull
out" (50). It shows the now aging relative as a young woman in "Chicago
1957, lab coat on, / you are bent over test tubes / adding substance to
substance" (50). Once again, Trethewey creates her own image outside
the photograph. "I imagine you before the flame / taking something out,
distilling / light from volatile darkness," much as the black woman had
done figuratively by leaving the South a half-century earlier to discover
a better work identity in a larger world. Now she has returned home to
age and die, ironically at an integrated nursing home still named "the
Dixie White House." As the title suggests, the old woman gives away
and takes back the pieces of her life, such as her aging photograph of
her younger self. For these ekphrastic poems and others just as fine,
Domestic Work won awards, including the Mississippi Institute of Arts
and Letters Book Prize and the Lillian Smith Award, both in 2001.

Trethewey's second collection, *Bellocq's Ophelia* (2002), confirmed
the early recognitions of her poetic talents and cultural insights. The
volume is focused on her ekphrastic responses to the New Orleans
photographer's turn of the twentieth-century portraits of sex workers
in the brothels of Storyville, then the designated quarter for vice in the
Crescent City. The Ophelia of Trethewey's title is her protagonist, a
biracial prostitute in a bawdy house exploiting black women for sexual
use by white men. Ophelia proves a poignant figure, one that Trethewey
imagines from a Bellocq photograph of a light-skinned nude (1912)
that also suggested John Everett Millais's portrait of the Shakespearean
character in his well-known painting (1852). Bellocq's and Millais's ar-
tistic legacies evoked the character and her tragic name, but Trethewey
enlarges their suggestions by placing her pale protagonist against the
dark background of American racial and sexual exploitation. Trethewey
also locates herself within similar cultural and psychological frames by
way of allusions to her own biracial heritage and her own literary given

name, making these references both within these poems and in remarks on them in interviews.[3]

Bellocq's Ophelia is presented in three numbered parts, yet two titled sequences of fourteen and ten poems, respectively, "Letters from Storyville" and "Storyville Diary," make up the majority of the book. As their titles suggest, these two dozen poems reveal Ophelia's subjective vision of her exploited situation in New Orleans through her written expressions first to a mentor and then to herself. Verbal texts often prove intertextual with visual ones within photographic tropes, and Ophelia discovers her emerging identity by means of Bellocq's photographic presence in her life. The two larger gatherings are complemented by five separate poems that serve as introductions, transitions, and conclusions. Two of the five are presented as verbal texts, "Letter Home," which comprises all of Part I, and "Countess P__'s Advice for New Girls," which opens Part II and introduces the "Letters from Storyville." Three ekphrastic poems based on actual photographs are seen from the poet's objective view rather than through Ophelia's subjectivity: "Bellocq's Ophelia," which prefaces Part I; "Photograph of a Bawd Drinking Raleigh Rye," which provides a transition between Part II and Part III; and, finally, "Vignette," which concludes the collection. These examples objectively confirm the psychological integrity of Ophelia's development as seen in her letters and diary.

Trethewey's opening selection, "Bellocq's Ophelia," provides a revealing introduction to her carefully organized collection. Subtitled "__ from a photograph, circa 1912," her title poem is an ekphrastic effort focused on a Bellocq portrait of a reclining nude.[4] Like all of Bellocq's subjects, his model remains anonymous; she is only a "nameless inmate of Storyville," as she is introduced in the poem (3). Trethewey invokes the name of Shakespeare's character because of the pictorial correspondences between Bellocq's photograph and Millais's Pre-Raphaelite vision of Ophelia drowned.[5] These visual connections recognized in "Bellocq's Ophelia" include the models' supine positions, pale complexions, and floral suggestions. These resemblances also reveal physical and psycho-

logical jeopardy as the young females are exposed and threatened by the gaze of male artists. In her opening stanza, Trethewey is concerned with Millais's model as much as with the literary creation she represents in the painting. She begins with Ophelia, who "dies faceup, // . . . flowers and reeds . . . / floating on the surface / around her," her open eyes and hands seeming to say "*Take me*" (3, emphasis in text). The poet is concerned for the model, for "The young woman who posed / lay in a bath for hours, shivering, / catching cold" (3).

Trethewey discovers both Shakespeare's Ophelia and Millais's model within Bellocq's image of "a woman posed on a wicker divan, her hair / spilling over" (3). Flowery patterns decorate the decor of this high-class house, and even faded spots on the aging photo "bloom like water lilies across her thigh" (3). The young prostitute seems to have been uncomfortable, too, with "her nipples offered up hard with cold" and her breasts, "her belly . . . / her pubis . . . her body / there for the taking" (3). Unlike Millais's Ophelia, Bellocq's subject is not so limited by the male artist's gaze. "Staring into the camera" through "her heavy-lidded eyes," her body may be "limp as dead Ophelia," but "her lips [are] poised to open, to speak" (3). In other words, this exploited young female prefigures the transition that Trethewey traces in her central character's movement toward her own agency.

This pattern of development extends throughout Trethewey's collection, supported by a variety of verbal and visual texts. Ophelia's quest is to use her verbal skills to secure a place in an office or a store, essentially "white work," which therefore eludes her. Physically, she is light skinned enough to "pass"; psychologically, she still identifies herself as a "*negress*" (*Bellocq's* 7, emphasis in text). The sounds of mule's shoes on cobblestone streets remind her of "who I am," a "mulatto," and the interrogating gaze of a white stranger confirms this identity for her (7). Ophelia instinctively identifies with "black work"—maids minding white children, laundresses balancing wash on their heads, field workers toting crops to sell. If the poem is a verbal text, then its visual images in black and white preview the ekphrastic poems that follow.

Bellocq's appearance introduces tropes of photography into this

series of verbal texts, but they have been prefigured by images of reflection and stillness, often drawn from the other arts. Ophelia describes "*Tableau Vivant,*" literally "living pictures," for example, or provocative poses struck by her and the other women on a cue from the Countess (*Bellocq's* 13). As Violet, she sees her doubled figure all about her: in the many mirrors of the parlor, in the faces of her cohorts, "fair as magnolias, pale as wax," and in her own naked "reflection in the bathwater," her "gooseflesh" recalling Millais's drowned Ophelia (18). Bellocq's art also reflects this earlier imagery; as the photographer "buys time only to look / through his lens," his newest subject "must sit for hours, / suffer the distant eye he trains on me" (20). Unlike the objectifying gaze of the clients, such as a peering man with a monocle, who view her as "spectacle and fetish," this silent subject must "face the camera, wait / for the photograph to show me who I am" (21).

One of the identities that Ophelia discovers within her pictures is that of an apprentice artist. In her letter of "September 1911," she reports that "I splurged, spent a little / of my savings on a Kodak," the pioneering affordable box camera (*Bellocq's* 17). Bellocq is her instructor in photography, of course, and he thus becomes another sort of mentor. Her photographic master takes her along on his professional assignments documenting the infrastructure and commerce of the bustling port city. Accustomed to posing and being viewed herself, Ophelia instinctively takes to framing and focusing other subjects before her. The exercise of her photographic art quickly reveals its nature not only to her but to the reader. Trethewey's Ophelia seems to have discovered her own identity at last, at least partially from engaging with the new visual art form, first as subject and then as artist under Bellocq's tutelage.

One of Trethewey's sonnets in Part III is entitled "Bellocq," and it reveals that he is known as "Papa Bellocq," among his models, making him a sort of surrogate white father to them all. This parental role is especially true with Ophelia when he takes her under his wing as his apprentice. In this sonnet and the four that follow it, Ophelia poses for Bellocq in a series of portraits that become increasingly revealing until, in "*August 1911,*" she ponders how "I pose nude for this photograph

awkward, / one arm folded behind my back" (42, emphasis in text). Con-
flicted feelings must haunt Ophelia's relationships with her several father
figures, however, as she realizes at some level their complicity in her
sexual exploitation. The last of these four poems is titled "Photography,"
as Ophelia begins to understand the art by studying a negative in which
"the whole world reverses" within a photographic trope that may be
extended to the black/white binary of racial identification as well (43).
In the final four sonnets of Part III, Ophelia is herself a photographer,
learning what the camera may disclose and what it may continue to
obscure. The last of the poems is titled "*(Self) Portrait*" and dated "*March
1912*"; in it Ophelia relates how she once forgot to remove the lens cap
so that she "saw only my own clear eye" reflected in the viewfinder as
a surrealistic punctum to this imagined shot (46, emphasis in text).

The final selection in Part III and in the volume, "Vignette," proves
to be another complex ekphrastic poem. Although the third and last of
three texts written from the poet's objective viewpoint, it also demon-
strates the way that Ophelia has developed an introspective clarity of
her own through photography. "Vignette," brings visual closure to the
volume by recreating the photograph we have identified as Trethewey's
Ophelia from the front cover, a sort of photographic epigraph. Her
concluding text bears its own verbal epigraph directly connecting the
actual image and the poetic one: "—*from a photograph by E. J. Bellocq,
circa 1912*" (47, emphasis in text). As always, Trethewey's title proves
suggestive, as "Vignette" has photographic and literary meanings; it can
be a visual text that loses focus toward its edges, as well as a brief verbal
text focused by a single image. Trethewey's "Vignette" also returns to
the more open poetic form of her other two ekphrastic studies, using
shorter lines but longer and looser gatherings of verse.

The first part describes Ophelia with the details to connect her
with the cover photograph, a portrait shot against a dark cloth: "She
wears / white, a rhinestone choker, fur, / her dark crown of hair—an
elegant image" (*Bellocq's* 47). To relax his subject, Bellocq chats with
her about "a circus coming to town" (47). In the second part his idle
chatter conjures up for Ophelia a single remembered image from a

sideshow. As a child, she had watched a contortionist "make himself small, fit / into cramped spaces, his lungs / barely expanding" (47). The recalled imagery reminds her of the sexual contortions of her professional role, of "her own shallow breath—/ her back straining the stays of a bustier, / the weight of a body pressing her down" (47). In her sympathy for another, "how he must have ached / each night in his tent," and in recognition of herself, Ophelia's "brow furrowed" in the pensive pose reflecting Bellocq's actual photograph (47–48). Trethewey thus makes a final challenge to her readers to recognize the possibilities that exist for Ophelia far beyond the fading edges of this tight space and this instant of frozen time: "Imagine her a moment later—after / The flash, blinded—stepping out / of the frame, wide-eyed, into her life" (48).

Domestic Work and *Bellocq's Ophelia* identified Natasha Trethewey as a poet to consider within the literary landscape of America as it entered the new century, and *Native Guard* established her as a writer to reckon with, especially after it won the Pulitzer Prize in 2007. As successful as Trethewey's two earlier collections are with readers and critics, *Native Guard* combines their different strengths into a single text that establishes a closer and more compelling connection between her personal story and American racial history. In several ways, Trethewey came to terms with her identity as a person and as a poet during the years that saw the appearance of these three books. *Domestic Work* traced Trethewey's family narrative by focusing on her maternal grandmother in its central gathering under the same title as the volume, while *Bellocq's Ophelia* probed the complications of race in America by capturing the self-portrait of her title character in its paired groupings of fictive letters and diary entries. In *Native Guard*, Trethewey combines these varied sources and efforts by recreating personal and family narratives in the first and last parts, while focusing directly on racial and regional history in the central section, which includes the title sequence of ten sonnets written as diaries and letters.

In contrast to *Domestic Work*, which was dedicated to her father and focused on her maternal grandmother, Trethewey inscribes *Native Guard*, "For my mother in memory," marking her as the central figure

of the book (iii). This dedication is echoed by her epigraph from poet Charles Wright that begins "Memory is a cemetery / I've visited once or twice," and both prefatory references suggest themes of loss and remembrance (v). In her set-off introductory selection, "Theories of Time and Space," Trethewey combines these theoretical concepts with regional geography and racial history by way of an arresting photographic trope. Part I consists of ten personal poems, for the most part concerned with the conflicted relations between the poet and her mother, including two that reference family snapshots. Trethewey then centers Part II around her sequence of ten sonnets under the title "Native Guard" in a memorial to the Louisiana Native Guards, the initial black regiment in the Union army. An introductory gathering for the second part of the volume, "Scenes from a Documentary History of Mississippi," is subdivided into four ekphrastic poems based on real or imagined photographs from the past of the Magnolia State. In Part III, Trethewey ranges widely across southern space and time, including her family saga and her personal history. This section begins with "Pastoral" (discussed earlier in this chapter), in which Trethewey poses for a group photograph, and contrasts this imagined scene with a real one captured in a childhood snapshot from the family album and described in the poem "Blond." The concluding piece of this section and the entire collection, "South," demonstrates how realities of geography and history shaped regional culture, in contrast to the theoretical speculation and ekphrastic imagery of "Theories of Time and Space."

The initial, discrete positioning of "Theories of Time and Space" within *Native Guard,* along with the poem's sweeping title, suggests that Trethewey intends it as a wide-ranging introduction to the collection. To accomplish this purpose, the poem works on both abstract and concrete levels that are reflected in contrasting elements of poetic form and finally conflated into a complex photographic trope. Trethewey involves her reader by the use of the second person. Her spare opening stanza, the first of ten, reads: "You can get there from here, though / there is no going home" (*Native* 1). Trethewey's generalizations here evoke larger considerations of where and when we all are

in space and time, while they also echo phrases of southern idiom and lines of southern literature. In her second stanza, "Everywhere you go will be somewhere / you've never been," she posits another philosophical proposition, but one she then grounds in a southern landscape. We "head south on Mississippi 49," the road to the Gulf and to Trethewey's childhood home. This movement in space is linked with the passage of time, "mile markers ticking off / another minute of your life," leading to the inevitable "dead end" in both realms.

Literal details of the docks and beaches by Gulfport give way to literary generalities once again. "Bring only / what you must carry—tome of memory, / its random blank pages" (*Native* 1). Her image of memory as a book suggests a verbal text, of course, yet a collection of memories also suggests a succession of photos such as a family album. Trethewey at last unites the levels of her poem in a photographic trope extending through the final two stanzas. "On the dock // where you board the boat for Ship Island, / someone will take your picture: // the photograph—who you were—/ will be waiting when you return" (1). Trethewey once again employs her theoretical understanding of photography in the service of her poetry. Like any other photo, the dockside snapshot may capture a moment; even so, it misses much more, not just in terms of time, or before and after, but of space as well, or the here and there that extends from the poem's first line well beyond the final photographic frame.

The poetic matters and forms, as well as the ekphrastic images and themes discovered in "Theories of Time and Space" reverberate through the collection that it prefaces. *Native Guard* becomes Trethewey's own "tome of memory," both in terms of personal recollections of her home place and of historical recognitions of Gulfport as a contested site of southern history. The poet also connects her family's snapshots with documentary photographs in several selections. For example, "Photograph: Ice Storm, 1971," also employs ekphrasis to a visual image, but in this effort a photographic trope evokes Trethewey's enduring sorrow over her mother's unhappy life. This ekphrastic exercise proves even more complex in recreating two different photographs. The poem's central focus is identified in the title, a picture from the family album

revealing the strange beauty effected on the southern landscape by an uncommon winter storm when Trethewey was still a small child. Thus, the image of a woman in the first tercet of the five comprising the poem would seem to reference her mother. "Why the rough edge of beauty? Why / The tired face of a woman, suffering, / Made luminous by the camera's eye?" (10).

In a recent interview, however, Trethewey identifies this image with Dorothea Lange's iconic migrant mother posed with her children, a Depression-era photograph from California that also recalls the southern documents of James Agee and Walker Evans (Magee 20). She goes on to remark that "there's something so strangely beautiful about her suffering face," perhaps the Madonna quality appreciated by many who have viewed Lange's striking image from the 1930s. Some of this luminous beauty is found in the title photograph, where "the landscape glistens beneath a glaze / of ice" in "the front yard a beautiful, strange place" (10). If a strange beauty is captured in the wintery visual imagery of the photograph, then a verbal text on the reverse side reveals a colder estrangement in Trethewey's final tercet: "why on the back has someone made a list / of our names, the date, the event: nothing / of what's inside—mother, stepfather's fist (10).

The section entitled "Scenes from a Documentary History of Mississippi" includes four exercises in ekphrasis, beginning with "1. King Cotton, 1907," a brilliant tour de force derived from a photographic postcard of then-president Theodore Roosevelt's visit to the King Cotton Festival at Natchez, Mississippi, in 1907. More interesting in photographic terms, however, the other three selections here all evoke documentary photography. All three poems also reveal Trethewey's concern for black children endangered by natural disasters, by cultural institutions, or by both. Trethewey's remarks about these three poems suggest that their bases are also real photos, though their actual origins remain elusive at this point. In one interview, Trethewey did say that she titled the second selection "2. Glyph, Aberdeen 1913" because the photographer was from Aberdeen, Mississippi, and the date was seen on the actual photo (Conversations 51). A "glyph" is an added mark giving an additional

meaning to a verbal text, so Trethewey perhaps implies that the written date adds chronological context to the visual text. In this example, the date reveals what she referred to as the historical moment in the first selection. Without this written date, the scene Trethewey describes well might be one captured decades later by an FSA photographer such as Lange or Evans. The image of a resting sharecropper holding his young boy that Trethewey recreates here suggests the iconic images of both photographic artists. The intimate relation between the male generations, "[t]he man, gaunt in his overalls, / cradles the child's thin arm," recalls Lange's tableaux of migrant families (*Native* 22). The harsh revelation of their impoverished existence evokes Evans's bleak images of paupers' burial grounds, when Trethewey images the boy's deformed and suffering body as "a mound / like dirt heaped on a grave" (22).

In another sense, perhaps, Trethewey's verbal text adds meaning to the photo she reinterprets, much like a glyph in this example, as well as in the two ekphrastic studies that follow, "*3. Flood*" and "*4. You Are Late.*" The catastrophe that titles the third selection is the Mississippi Flood of 1927, an unprecedented natural disaster, the effects of which were worsened by social and cultural failures that unduly affected the many blacks displaced by it. Trethewey recognizes these inequities in a photograph depicting a barge of black refugees borne on the swollen river and denied a comparatively safe landing on a levee by white National Guardsmen bearing arms. The poet incorporates the picture's verbal text into her recreation of the scene. "*One group of black refugees,* // the caption tells us, *was ordered / to sing* their passage onto land" (*Native* 23, emphases in text). The silent image reverberates with the sound of their voices, "like a chorus of prayer—their tongues / the tongues of dark bells," offered as if in testimony to their place among those to be saved from the cresting flood waters (23). Once again, endangered black youngsters are at the center of the visual and verbal texts, as "the camera finds them still," both in terms of their passivity within the scene and their moment frozen in time (23). Trethewey realizes this poignant imagery by a comparison with a contrasting photographic genre. "Posed / as if for a school-day portrait, / children lace fingers in their laps" (23). The

entire image becomes a literal and figurative "aperture," the opening through which light travels to record the photographic image, wherein "the angled light of 1927" reveals these black children as "refugees from history," ones "still waiting to disembark" (23).[6]

In the final selection of "Scenes from a Documentary History of Mississippi," Trethewey again suggests the dangers that loom in the passages of history for black children. In its title, *"4. You Are Late,"* the poem seems to echo the innocence and openness of children's lives and narratives. As in the opening example of these four historical scenes taken from photographs, a tightly structured poetic form implies the tension inherent in the image it recreates. Four quatrains rhyme the first and third, as well as the second and fourth of their generally iambic lines. This photograph, or "the subject of this shot," described in the poem, exposes a black child poised outside the *"Greenwood Public Library for Negroes"* at the instant of the camera's capture (*Native* 24). In the first stanza, her small figure casts a shadow like a sundial that marks the slow passage of time at summer noon in the Delta: "The sun is high and the child's shadow, / almost fully beneath her." Although "her goal [is] to read," and the child holds "a book / in her hand," she finds that "the library is closed."

Like the girl in the photograph, Trethewey and her readers view one sign declaring that sudden closing, perhaps in reaction to integration, while another shows "a finger pointing left" and implying the overall message of *"You Are Late."* This graphic image leads the child's, then the poet's, and then the readers' gaze "out of the frame" of the picture and the poem into the movement of time (24). In her final quatrain, Trethewey concludes, "this is history," perhaps the history of segregation with its entries lettered for "Whites" and "Negroes," or that of integration with its doors slowly opening to Mississippians white and black (24). Unlike in the first three selections in this group, Trethewey does not give the date of the photograph recreated, though it suggests the years of civil rights struggles. Her omission of a specific year may figure the painfully slow evolution of real integration, still not achieved by the time of the publication of *Native Guard* in 2006.

Only one of the thirty-two poems comprising Trethewey's 2012 col-
lection, *Thrall,* is focused by a photographic trope, "3. Help, 1968," the
third part in a gathering titled "The Americans" that includes a pair of
poems drawn from paintings. Although it is somewhat overshadowed
by the volume's ekphrastic considerations of other visual art forms, this
poem still makes an interesting comparison with photographic tropes in
the earlier volumes. The date in the title refers to the Trethewey family's
year in Canada when Natasha was two years old. A note indicates her
visual source, *"After a photograph from* The Americans *by Robert Frank,"*
a seminal photographic text published in 1958 (*Thrall* 35, emphasis in
text). Frank's photo book is clearly influenced by and intertextual with
Walker Evans's *American Photographs,* published in 1938 exactly two
decades before. In her ekphrastic study, Trethewey connects Frank's
portrait of a black woman carrying a white infant with her mother's
memories of her biracial child being mistaken for the white charge
of a black maid. Combining the vision of Frank's photograph and her
own visual imagination of her infancy, Trethewey creates a sort of
poetic double exposure. Her poem concludes with harsh images of her
mother, "like the woman in the photograph," become only "a prop, a
black backdrop, / the dark foil in this American story" (*Thrall* 36). Al-
though the infant's gender in Frank's photo is not evident, Trethewey
uses female references and thus identifies herself with that very white
figure in a stunning recognition of her own otherness even within her
own family.[7]

The Pulitzer Prize that Trethewey won for *Native Guard* established
her reputation as a poet, while *Thrall* confirmed it and led directly to her
extended term as our national poet laureate. *Thrall* is her finest effort
to date in the view of most critics, myself included, a collection that
enlarges the subjects, themes, and forms of her three earlier collections.
Like those volumes, *Thrall* is in essence a work of ekphrasis, but its
visual images and tropes are derived mostly from painting rather than
photography. The book's major sequence consists of a cluster of ekphras-
tic poems recreating familial portraits from eighteenth-century Latin
America, including the example colorfully reproduced on the book's

jacket. The poet explains, "*Casta* paintings illustrated the various mixed unions of colonial Mexico and the children of these unions whose names and taxonomies were recorded in *The Book of Castas*" (*Thrall* 81). *Thrall* exists as Trethewey's book of *castas,* for its two dozen poems consider the biracial children of all the Americas over time, including herself.

Reading *Thrall* as a picture album, as I have read Trethewey's work in this conclusion to my study, provides perspectives that can be applied to her other poetry collections—*Domestic Work, Bellocq's Ophelia,* and *Native Guard*—as well as too her hybrid volume *Beyond Katrina.* The most important aspect of this trope of the picture book, however, is found in Trethewey's ekphrastic readings of diverse visual sources, especially of family albums and documentary books. In this regard, Trethewey is influenced by her literary forebears, black and white, who have extended intertextualities with photography from the 1930s to the present. Although many other contemporary southern writers could be cited in support of this formulation, Trethewey makes the clearest example. In poetry and prose, her writing often achieves the language of vision, a literary and narrative insight based on the visual and spatial arts, especially that of photography, as we have seen here. In its many new accomplishments, Trethewey's work is still intertextual with and often influenced by that of other major figures in the literary and graphic arts that I have considered earlier—in particular, Robert Penn Warren. In turn, Warren links Trethewey with his literary colleagues and friends like Ralph Ellison, Eudora Welty, William Faulkner, James Agee, and ultimately with photographers such as my focal figure Walker Evans. My readings of their salient works as presented in the chapters here thus demonstrate how photography and southern literature have affected each other as intertextual languages and influential visions, creating personal insights and cultural meanings—visions of language perhaps—in the manifold convergences of documentary realism and subjective modernism during the 1930s and for long after into our new century.

NOTES

CHAPTER ONE

1. Recent scholarship on southern literature is so extensive that it is beyond my purposes to provide even a survey here. If I were to pick one source as a starting point, it would be Joseph M. Flora and Lucinda H. MacKethan, eds., *The Companion to Southern Literature* (Baton Rouge: Louisiana State UP, 2002). Although this volume is presented in encyclopedic rather than chronological format, it is well organized and indexed, so it is possible to trace the history of southern literature through a number of entries, all with brief bibliographies.

2. Stannard's informative essay is found in John Wood, ed., *America and the Daguerreotype* (Iowa City: U of Iowa P, 1991). Although not focused directly on the South, the book provides a thorough introduction to its subjects in eight essays, which are illustrated by more than a hundred figures and plates revealing the historical importance and lasting beauty of this early photographic format. There are many collections of daguerreotypes in print and online; the Daguerreian Society Web site is rich in images (www.daguerre.org).

3. For other examples of slave portraits, see Henninger (*Ordering* 60–61) and Dugan (27–35). Internet searches for any of these terms will discover many examples, as on the Library of Congress Web site (www.loc.gov/rr/print/list/082_slav2.html).

4. The literature of the Civil War is voluminous already, and it continued to expand during the sesquicentennial years. Several recent reconsiderations have reshaped my own thinking about the causes and the effects of the war. They include David W. Blight, *Race and Reunion: The Civil War in American Memory* (Cambridge MA: Harvard UP, 2001); Fitzhugh W. Brundage, *The Southern Past: A Clash of Race and Memory* (Cambridge MA: Harvard UP, 2005); and Drew Gilpin Faust, *This Republic of Suffering: Death and the American Civil War* (New York: Knopf, 2008). My war statistics are derived essentially from Faust, though they are similar to those cited by Blight, Brundage, and other scholars of the era.

5. Edmund Wilson's *Patriotic Gore: Studies in the Literature of the American Civil War* (New York: W. W. Norton, 1962) is generally considered the best overall source on the subject, while Lewis Simpson's *Mind and the American Civil War: A Meditation on Lost Causes* (Baton Rouge: Louisiana State UP, 1989) complements the efforts of northerner Wilson from a southern perspective. A recent study of southern letters during the war is Coleman Hutchinson's *Apples and Ashes: Literature, Nationalism, and the Confederate States of America* (Athens: U of Georgia P, 2012).

6. Important studies directly focused by photography in the epic struggle include William C. Davis, *Touched by Fire: A Photographic Portrait of the Civil War* (Boston: Little, Brown, 1985); Timothy Sweet, *Traces of War: Poetry, Photography, and the Crisis of the Union* (Baltimore: Johns Hopkins UP, 1990); Ross J. Kelbaugh, *Introduction to Civil War Photography* (Gettysburg, PA: Thomas Publications, 1991); and Webb Garrison, *Brady's Civil War* (London: Salamander, 2008). Davis, perhaps the leading scholar of Civil War photography, estimates that over a million photographic images were made in America from 1861 to 1865 (3). Online resources, including the Web sites of the Library of Congress, the National Archives and Records Administration, and the Center for Civil War Photography, offer many more examples of all photographic genres discussed here.

7. My terminology is influenced by Michael Perman's *The Road to Redemption: Southern Politics, 1869–1879* (Chapel Hill: U of North Carolina P, 1984), in which he traces varying southern movements of divergence and convergence within the reuniting nation. In my view, the best overall introduction to the South's final reconciliation with the nation is Edward L. Ayers's *The Promise of the New South: Life After Reconstruction* (New York: Oxford UP, 1992).

8. Both Miley's 1866 equestrian portrait of Robert E. Lee and the anonymous picture of the phallic memorial stone with its vestal virgins can be found in Dugan (58–59) as well as online at the Library of Congress and other Web sites.

9. For a more extensive overview of lynching photographs and postcards, as well as for further resources concerning these topics, see Henninger (*Ordering* 36–38). The best-known text is James Allen's *Without Sanctuary: Lynching Photography in America* (Santa Fe, NM: Twin Palms, 2000). It is supported and supplemented by an interest group and an ever-developing Web site (withoutsanctuary.org).

10. My two earlier studies of differing aspects of twentieth-century southern letters include more extensive discussion of and bibliography on the emergence of modern literature in the South. *Dixie Limited: Railroads, Culture, and the Southern Renaissance* (Lexington: UP of Kentucky, 2002) presents my formulations in some detail (1–9, 127–29), while *A Backward Glance: The Southern Renascence, the Autobiographical Epic, and the Classical Legacy* (Knoxville: U of Tennessee P, 2009), expands on them more recently (xii–xiv, 209–11). The careful reader will note that I have employed both spellings of the second term. These variations are conscious choices in regard to the different considerations of southern literature found in these two projects.

11. More extensive development of the technical and artistic changes outlined here may be found in Miles Orvell's compact but thorough, insightful, and readable historical survey, *American Photography* (New York: Oxford UP, 2003). A number of Web sites present many of the same images and ideas; a good example is that of the Public Broadcasting System (PBS) documentary series (www.pbs.org/ktca/americanphotography/).

12. As with books on the Civil War, works concerning the Great Depression of 1929–1939 are numerous, and they are increasing in response to the Great Recession of 2008. A still readable historical, social, and cultural summation from the era itself is Frederick Lewis Allen, *Since Yesterday: The 1930's in America* (New York: Harper & Row, 1940, 1972). On the economic, political, and social effects of the Depression in the region, see Roger Biles, *The South and the New Deal* (Lexington: UP of Kentucky, 1994). A useful comparison of the 1930s economic collapse with our recent fiscal crisis is found in Peter Temin, "The Great Recession and the Great Depression" (*Daedalus* 139 [2010]: 115–24).

13. On the documentary as genre, see William Stott, *Documentary Expression in 1930's America* (New York: Oxford UP, 1973, 1986). On the Farm Security Administration's photographic program, see F. Jack Hurley, *Portrait of a Decade: Roy Stryker and the Development of Documentary Photography in the Thirties* (Baton Rouge: Louisiana State UP, 1972, 1977).

14. For more details on Evans's literary connections outside the South with writers such as Hart Crane, Ernest Hemingway, and William Carlos Williams, among others, see my essay "The Language of Vision: Walker Evans and American Literature" (*South Carolina Review* 48 [2015]: 123–36).

15. The photo book was not just a southern phenomenon in the Depression era. Photo texts by other American writers from the period include John Steinbeck's *Their Blood Is Strong* (1938), Archibald MacLeish's *Land of the Free* (1938), and Sherwood Anderson's *Home Town* (1940), to name just a few notable examples.

16. Recent studies most influential on my formulations here include, in the order of their publication, Paul Hansom, ed., *Literary Modernism and Photography* (Westport, CT: Praeger, 2002); Joseph B. Entin, *Sensational Modernism: Experimental Fiction and Photography in Thirties America* (Chapel Hill: U of North Carolina P, 2007); Jeff Allred, *American Modernism and Depression Documentary* (New York: Oxford UP, 2009); and, in particular, Morris Dickstein, *Dancing in the Dark: A Cultural History of the Great Depression* (New York: Norton, 2009).

17. For a good example of this criticism, see chapter 5, "The Southern Past," in Peter Conn, *The American 1930s: A Literary History* (New York: Cambridge UP, 2009), esp. 162–64. Conn's thesis is that American literature of the 1930s was marked by its concern for continuities with the national past, despite its immediate engagement with economic and social crises of the present.

18. For a fine discussion of Faulkner's Civil War works in the context of the Depression South and a good survey of similar efforts by other southerners, see Ted Atkinson's

conclusion to *Faulkner and the Great Depression: Aesthetics, Ideology, and Cultural Politics* (Athens: U of Georgia P, 2006), 221–36.

19. Political analyst Kevin Phillips is credited generally with coining the term "Sun Belt" in his 1969 study of the nation's changing voting patterns, but like later students of the larger national culture, Phillips defined the geographical extent of this region as including the Southwest and southern California as well as the traditional South. At the same time, southern historians and social scientists often use the term, sometimes presented as "Sunbelt," as a synonym for the economic and social changes in the traditional South from World War II to the present. In my view, the "Sun Belt" provides a handy phrase for the literary historian while discussing the newer South of recent generations and its writing. For an overview, see Numan V. Bartley, *The New South, 1945–1980* (Baton Rouge: Louisiana State UP, 1995).

20. Once again, scholarship on the civil rights movement is vast, seemingly written from all possible disciplinary, theoretical, and political perspectives. Perhaps the best overall scholarly work is Manning Marable, *Race, Reform and Rebellion: The Second Reconstruction in Black America, 1945–1982* (Jackson: UP of Mississippi, 1984). A useful popular history of the era is Juan Williams, *Eyes on the Prize: America's Civil Rights Years, 1954–1965* (New York: Penguin, 1987).

21. On the national effects of other mass media, particularly movies and television, during the Civil Rights era, see Jack Temple Kirby, *Media-Made Dixie: The South in the American Imagination* (Athens: U of Georgia P, 2004).

22. Another important black photographer in the era is Ernest Withers from Tennessee. As a favorite photographer of Dr. King's, Withers's photo images seemed almost synonymous with the movement over the years, but recent investigations suggest that Withers was also a paid FBI informant reporting directly to J. Edgar Hoover on civil rights leaders. If these allegations prove true, Withers's case raises interesting questions about the effect of artistic biography on the consideration and evaluation of artists' work.

23. Like the photographic imagery of the Depression decade, Civil Rights–era photography is receiving renewed critical attention recently in several new books. In *Signs of the Times: The Visual Politics of Jim Crow* (Berkeley: U of California P, 2010), Elizabeth Abel pays close attention to photographic reproduction of segregation's symbols throughout the twentieth century, with an interesting focus on 1930s documentary. Leigh Raiford's *Imprisoned in a Luminous Glare: Photography and the African American Freedom Struggle* (Chapel Hill: U of North Carolina P, 2011) illustrates the centrality of photography to the achievement of black liberation across the twentieth century, including during the Civil Rights era. A more controversial study is *Seeing through Race: A Reinterpretation of Civil Rights Era Photography* (Berkeley: U of California P, 2011), in which Martin A. Berger asserts that iconic images like those of Birmingham's police dog attacks did enlist sympathy from whites but depicted blacks as powerless and thus dependent on the majority population for their ultimate liberation. All of these recent texts present

many examples of key photographs from the Civil Rights era, of course, and many more are available on electronic sites. The studies by Madden, Dugan, and Henninger also present useful analysis of Civil Rights–era photography, and the last two present some good selected images.

24. For a recent rethinking of this movement during the 1960s and 1970s, see Marc Weingarten, *The Gang That Wouldn't Write Straight: Wolfe, Thompson, Didion, and the New Journalism Revolution* (New York: Crown, 2006).

25. See note 10 above for references to my earlier formulations on the development of the Southern Renaissance. Other interesting considerations of these topics include Fred Hobson, "Of Canons and Culture Wars," in *The Future of Southern Letters*, ed. Jefferson Humphries and John Lowe (New York: Oxford UP 1996); Michael Kreyling, *Inventing Southern Literature* (Nashville: Vanderbilt UP, 2000), and Robert Brinkmeyer, "The Southern Literary Renaissance," in *A Companion to the Literature and Culture of the American South*, ed. Richard Gray and Owen Robinson (New York: Wiley-Blackwell, 2004).

CHAPTER TWO

An earlier version of this chapter appeared as "James Agee, Walker Evans, and the Dialectic of Documentary Representation in *Let Us Now Praise Famous Men*," *Southern Quarterly* 41 (2010): 81–99. It was republished in *The Past Is Not Dead: Essays from the Southern Quarterly* (Jackson: UP of Mississippi, 2012), 342–60.

1. Laurence Bergreen's *James Agee: A Life* (1984) remains the best biographical source, at least in the absence of a more definitive one. A similar situation obtains in regard to the surprisingly large number of critical and scholarly studies that have appeared in the half century since Agee's death. From my perspective, no fully authoritative reading of the writer's career or canon has emerged as yet, perhaps because the career was so different, the canon is so diverse, and both remain so conflicted. Significant readings include, in chronological order, Alan Spiegel, *James Agee and the Legend of Himself: A Critical Study* (Columbus: U of Missouri P, 1998); Michael A. Lofaro, ed., *Agee Agonistes: Essays on the Life, Legend, and Works of James Agee* (Knoxville: U of Tennessee P, 2007); and Hugh Davis, *The Making of James Agee* (Knoxville: U of Tennessee P, 2008).

2. Perhaps because both his career and canon were more of a piece, Evans has received better biographical, scholarly, and critical treatment than Agee. He is the subject of two excellent biographies: Belinda Rathbone, *Walker Evans: A Biography* (Boston: Houghton Mifflin, 1995), and James R. Mellow, *Walker Evans* (New York: Basic Books, 2001). Recent critical studies complement rather than displace earlier ones; ordered by date, they include John Szarkowski, *Walker Evans* (New York: Museum of Modern Art,

1971); William Stott, *Documentary Expression and Thirties America* (New York: Oxford UP, 1973); John T. Hill and Jerry L. Thompson, eds., *Walker Evans at Work* (New York: Harper and Row, 1982); Alan Trachtenberg, *Reading American Photography* (New York: Hill and Wang, 1989); Joel Eisinger, *Trace and Transformation: American Criticism of Photography in the Modernist Period* (Albuquerque: U of New Mexico P, 1999); and John T. Hill, *Walker Evans: Lyric Documentary* (Gottingen: Steidl, 2006). Also see my essay, "The Language of Vision: Walker Evans and American Literature."

3. In addition to the works referenced in the preceding notes, *Let Us Now Praise Famous Men* is the subject of many scholarly and critical studies. Several prove useful for historical, social, or cultural readings of the text, while others focus directly on its ideas, images, and art. Although my conclusions differ in several ways, interesting examples include, in chronological order, Carol Schloss, *In Visible Light: Photography and the American Writer* (New York: Oxford UP, 1987); T. V. Reed, "Unimagined Existence and the Fiction of the Real: Postmodernist Realism in *Let Us Now Praise Famous Men*," *Representations* 24 (1988): 156–76; Peter Cosgrove, "Snapshots of the Absolute: Mediamachia in *Let Us Now Praise Famous Men*," *American Literature* 67 (1995): 329–57; Janis Bergman-Carton and Evan Carton, "James Agee and Walker Evans: Tenants in the House of Art," *Raritan* 20 (2001): 1–20; Jonathan Raban, "Thinking About Documentary: Notes Toward a Lecture," *Michigan Quarterly Review* 44 (2005): 554–69. It should be noted here that some recent reactions to Agee, to Evans, and to *Let Us Now Praise Famous Men* are critical regarding their relations to class, race, and gender. I have listed a few of the more thoughtful examples above, but I find most of this criticism tendentious and ultimately pointless. Like most readers and critics of the book, I believe it is a masterpiece of southern literature and photography, to some extent because of its honesty in its consideration of itself.

4. Definitive editions of Agee's works have been reconsidered recently, but in the absence of a critical consensus about the definitive choice, I believe the most accessible and standardized is the Library of America edition. All references to *Let Us Now Praise Famous Men* are cited parenthetically in my text from this edition (New York: Library of America, 2005).

5. On the theoretical and critical implications of the photographer's depiction of his art work as "lyric documentary," a formulation that encompasses both genre and style as discussed above, see John T. Hill's introductory essay in his collection of Evans's photography and writing, as well as criticism of both, that takes its title from that phrase.

6. The *Fortune* article was long thought lost, but recently it was rediscovered and published as *Cotton Tenants: Three Families,* with photos by Evans (Brooklyn, NY: Melville House, 2013). This reestablished text is probably most interesting for the ways in which it demonstrates how *Let Us Now Praise Famous Men* evolved in every respect between 1936 and 1941. One of the most significant differences between article and book is the absence of any reference to Evans's photographs.

7. Evans's "James Agee in 1936" serves as the foreword to the 1960 edition of *Let Us Now Praise Famous Men,* and in it the photographer reveals his own literary talent through his analysis of his collaborator, including Agee's faith: "His Christianity . . . was a punctured and residual remnant but it was still a naked, root emotion. It was an ex-Church, or non-Church, matter, and it was hardly ever in evidence. . . . After a while, in a round-about way, you discovered that, to him, human beings were at least possibly immortal and literally sacred souls" (5).

8. Although in Book Two Agee does mention black tenant families, who formed the majority population of Hale County, African Americans remain peripheral figures in *Let Us Now Praise Famous Men.* Some recent critics have called Agee to task for this absence. Agee seems to know that his picture of the cotton belt is incomplete, and he also seems to excuse himself from documenting problems of race as well as class in a short sojourn. Although blacks also are absent from Evans's photographs that comprise Book One, much of his work in the South for the FSA, as well as before and after, focused on African Americans, particularly on black churches.

9. In addition to its importance in *Let Us Now Praise Famous Men,* ekphrasis continues to be significant in much of Agee's later writing—both his fiction, notably the posthumous *A Death in the Family* (1957), and his nonfiction, especially his voluminous film criticism. In particular, Agee's posthumously published "Foreword" to his friend Helen Levitt's photography collection, *A Way of Seeing* (1965), also proves important in terms of his ekphrastic theory and practice in describing her photographs of New York street scenes, which were influenced by the work of their mutual friend Evans. It is worth mentioning that in his later career Evans produced considerable journalistic and critical writing, most of it quite accomplished and much of it employing ekphrasis in the description of his own or other photographers' pictures. Again, see my essay "Walker Evans and American Literature."

10. The New York Metropolitan Museum of Art (NYMMOA) holds the largest part of Evans's canon. The museum's photographs are readily available online with their full data.

11. In his provocative study of the profusion of graphic images in modern culture, W. J. T. Mitchell gives us a close reading of Evans's matching portrait of Gudger's wife Anna Mae, though to different ends than mine. See his *Theory: Essays on Visual and Verbal Representation* (Chicago: U of Chicago P, 1995), 293–94.

12. Leyendecker mentored Norman Rockwell, and he is the only other American illustrator to prove so important to visual culture. Leyendecker's magazine covers and advertisements are found at the National Museum of American Illustration (www. americanillustration.org/artists/leyendecker_jc/leyendecker.html). On Leyendecker's connections with Fitzgerald, see Thomas Dilworth, "*The Great Gatsby* and the Arrow Collar Man," *F. Scott Fitzgerald Review* 7 (2009): 81–93.

13. For just one example, it appears very likely that both Agee and Evans had read *As I Lay Dying* (1930) before their Alabama sojourn in 1936, and it is not hard to surmise that Faulkner's realistic, respectful, and often humorous treatment of the Bundrens is

reflected in the visual and verbal images of the Burroughs, Tengle, and Fields families presented in *Let Us Now Praise Famous Men*.

CHAPTER THREE

1. Among many considerations of Faulkner and photography, I find the following criticism most useful for my readings here. In chronological order, see Judith Sensibar, "Faulkner's Real and Imaginary Photos of Desire, in *Faulkner and Popular Culture*, ed. Doreen Fowler and Ann Abadie (Jackson: UP of Mississippi, 1990): 110–41; James G. Watson, *William Faulkner: Self-Presentation and Performance* (Austin: U of Texas P, 2002); Katherine Henninger, "Faulkner, Photography, and a Regional Ethics of Form," in *Faulkner and Material Culture*, ed. Joseph R. Urgo and Ann Abadie (Jackson: UP of Mississippi, 2007): 121–38; as well as Judith Sensibar's *Faulkner and Love: The Women That Shaped His Art* (New Haven: Yale UP, 2009).

2. Given the many treatments of Faulkner in the 1930s, I cite only those that I found most useful for my reading of Faulkner and documentary photography. See Kevin Railey, *Natural Aristocracy: History, Ideology, and the Production of William Faulkner* (Tuscaloosa: U of Alabama P, 1999); Karl Zender, *Faulkner and the Politics of Reading* (Baton Rouge: Louisiana State UP, 2002); and Ted Atkinson, *Faulkner and the Great Depression: Aesthetics, Ideology, and Cultural Politics* (Athens: U of Georgia P, 2006).

3. In addition to those readings by Sensibar, Watson, and Henninger cited in note 1, I also take a different perspective on *Sanctuary*'s symbolic photos in my *Dixie Limited: Railroads, Culture, and the Southern Renaissance* (Lexington: UP of Kentucky, 2002): 14–16.

4. Novelist and critic David Madden provides an interesting if idiosyncratic reading of photographic tropes in the two versions of the novel. See his essay "Photographs in the 1929 Version of *Sanctuary*," in *Faulkner and Popular Culture*, ed. Doreen Fowler and Ann Abadie, (Jackson: UP of Mississippi, 1990): 93–109.

5. In particular, see Taylor Hagood, "Media, Ideology, and the Role of Literature in *Pylon*," *Faulkner Journal* 21 (2006): 107–21.

6. Textual questions about Faulkner's novels remain quite complicated; in the absence of definitive editions, I use the Library of America volumes of his *Complete Novels*.

7. For insightful discussions of *The Unvanquished* and some other Civil War novels of the 1930s, see Atkinson 231–36.

8. The best introduction to Faulkner's photographic portraits is Thomas Rankin, "The Ephemeral Instant: William Faulkner and the Photographic Image," in *Faulkner and the Artist*, ed. Donald M. Kartiganer and Ann Abadie (Jackson: UP of Mississippi, 1996): 294–317. For a more extensive, if often impressionistic, discussion of the portraits, see Lothar Honnighausen, *Faulkner: Masks and Metaphors* (Jackson: UP of Mississippi, 1997).

9. In chronological order, see Martin Dain, *Faulkner's Country: Yoknapatawpha* (New York: Random House, 1964); Jack Cofield, *William Faulkner: The Cofield Collection* (Oxford, MS: Yoknapatawpha Press, 1978); William Eggleston (with Willie Morris), *Faulkner's Mississippi* (Birmingham, AL: Oxmoor House, 1990); Alain Desvergnes (with Regis Durand), *Yoknapatawpha: The Land of William Faulkner* (Paris: Editions Marval, 1993); and George Stewart, *Yoknapatawpha: Images and Voices: A Photographic Study of Faulkner's Country* (Columbia: U of South Carolina P, 2009).

CHAPTER FOUR

An earlier version of this chapter appeared as "Robert Penn Warren and Photography," *rWp: An Annual of Robert Penn Warren Studies* 12 (2012): 1–15.

1. For a more extensive consideration of the complicated literary and critical relations between these two major southern writers, see my essay "Warren's Faulkner," *Mississippi Quarterly* 60 (2007): 351–67.

2. For a more extensive consideration of "The Patented Gate and the Mean Hamburger," see my *Robert Penn Warren: A Study of the Short Fiction* (New York: Macmillan, 1992), 40–45. My text also includes Warren's discussion of how he came to write the story, "On 'The Patented Gate and the Mean Hamburger'" (1966), 96–100.

3. Although much different from the novel and from each other in most regards, the two screen versions of *All the King's Men* (1949, 2006) are successful adaptations in some ways, and they remain interesting glosses on the novel. Both films also feature flashbulbs and news photos as significant visual motifs that punctuate the passage of events and the development of characters within their abbreviated narratives, though neither film includes the Cass Mastern narrative.

4. This long passage proves an interesting illustration of the differences between actual and fictive photographs that Katherine Henninger pointed to in her study of contemporary southern writing and photography. In this example, Warren creates both the photo of Cass Mastern and Jack Burden's failure at ekphrasis in its contemplation.

5. For an extended discussion of these materials, see my article "The Warren Family Gift of Audio-Visual Materials to the Robert Penn Warren Collection," *rWp: An Annual of Robert Penn Warren Studies* 6 (2006): 89–94. It features several photographs held in the Warren collections at Western Kentucky University.

6. See my *Robert Penn Warren After* Audubon: *The Work of Aging and the Quest for Transcendence in His Later Poetry* (Baton Rouge: Louisiana State UP, 2009) for the cover photograph, as well as for its more extensive discussion of Warren's later poems, introduced in this chapter as well as examined in several others.

CHAPTER FIVE

An earlier version of this chapter appeared as "Eudora Welty's Photography and Fiction in the 1930s and After," *South Carolina Review* 43 (2011): 32–43.

1. Probing the relationships between Welty's photography and fiction has become such an extensive subfield within the flourishing criticism of her work that I do not attempt a full listing of such studies here. Welty's centennial in 2009 saw the publication of *Eudora Welty as Photographer* by the University Press of Mississippi, a new collection of photos edited by Pearl McHaney, with focusing essays by McHaney, Sandra S. Phillips, and Deborah Willis, as well as an extensive bibliography.

2. In the absence of definitive editions of Welty's work, her critics recently have begun to use the Library of America volumes, as I do in this chapter: *Eudora Welty: Complete Novels* (New York: Library of America, 1998) and *Eudora Welty: Stories, Essays, and Memoir* (New York: Library of America, 1998).

3. On the importance of this somewhat neglected essay to Welty's conflicted literary responses to the changes of the Civil Rights years, see my article "'Something We Can Do About It?': Eudora Welty's Civil Rights Triptych," *South Atlantic Review* 75 (2010): 69–76.

4. In her chapter on the photographs in the State of Mississippi collections, Suzanne Marrs divides Welty's works by the progression of her cameras—a simple Kodak before 1935, a sophisticated Recomar in 1935–1936, and a compromise between the two in a Rolleiflex for the rest of the decade and beyond (*The Welty Collection: A Guide to the Eudora Welty Manuscripts and Documents at the Mississippi Department of Archives and History* [Jackson: UP of Mississippi, 1988], 77–78). I agree with Marrs that camera technology helped to shape Welty's photographs but not as much as her narrative language of vision did (79–81).

5. On FSA photography of women and blacks, see Andrea Fisher, *Let Us Now Praise Famous Women: Women Photographers for the US Government, 1935–1944* (London: Pandora, 1987), and Nicholas Natanson, *The Black Image in the New Deal: The Politics of FSA Photography* (Knoxville: U of Tennessee P, 1992).

6. Marrs convincingly connects descriptions of setting in "A Worn Path" with Welty's photographs of the Natchez Trace (83–84). In my view, larger elements of background in Welty's later pictures, such as landscapes or buildings, are rediscovered more often in her narratives, especially her nonfiction, than specific connections with characters or events, whether fictional or not.

7. Once long ago, I heard Welty remark that the *Odyssey* was not her model for Phoenix Jackson's retracing of her worn path, yet consistent intertextualities between her fiction and Homer's classic, particularly in her mythic story "Circe" (1955), make one wonder if she really was resisting the critical appropriation of her female creativity by what was then an essentially masculine literary and critical establishment in southern

letters. For a more extensive consideration of Welty's complex connections to classicism in general, see my chapter, "Eudora Welty: Fiction, Memoir, and Classical Myth," in *A Backward Glance: The Southern Renascence, the Autobiographical Epic, and the Classical Legacy* (Knoxville: U of Tennessee P, 2009), 153–78.

8. One reason may be that most of Welty's photographs are focused by black life, while black characters center only the four stories mentioned above out of the twenty-five published in her first two collections. This imbalance may have been one reason that *Black Saturday* went unpublished; although photo books were popular during the 1930s, in the great majority of them photographs functioned as illustrations of the text—as in most examples listed in Chapter One.

9. Such critical inattention probably obtains because of the story's place in Welty's least regarded collection, *The Bride of the Innisfallen*. Although the more comprehensive critical studies of Welty mention and applaud the story, few give it meaningful consideration. An exception is Danielle Pitavy-Soques, who concludes that "'Kin' deals with imposture," as well as with "what a fraud a family portrait is" ("A Blazing Butterfly: The Modernity of Eudora Welty," in Albert Devlin, ed., *Welty: A Life in Literature* [Jackson: UP of Mississippi, 1987], 133). Her observations work as well for *Delta Wedding* and *Losing Battles*, of course. Other articles on the story are interesting for their theoretical bases: Geraldine Chouard, "Vision and Division in 'Kin' by Eudora Welty," *Mississippi Quarterly* 55 (2002): 246–71; and Carey Wall, "Ritual Technique and Renewal in Eudora Welty's 'Kin,'" *Southern Quarterly* 40 (2002): 39–52.

10. In what is probably her most important theoretical statement on writing, "Place in Fiction" (1956), Welty compares this stereoscopic effect with literary fiction's fundamental artifice. Comparing the writer's view to a picture's "frame," she says that there are "two pictures at once in his frame, his and the world's," and that "his passion" is "to make the reader see only one of those pictures—the author's—under the pleasing illusion that it is the world's" (*The Eye of the Story: Selected Essays and Reviews* [New York: Vintage, 1979], 125). Welty's use of visual imagery is important here in terms of her photographic interests, as is the modernist emphasis on the preeminence of authorial vision. The passage is also remarkable for its correspondence with her sometime editor and long-time friend Robert Penn Warren's quite similar stereoptical image of the relation of past and present in the literary imagination mentioned in Chapter Four.

CHAPTER SIX

An earlier version of this chapter appeared as "Fiction, Photography, and the Cultural Construction of Racial Identity in Ralph Ellison's *Invisible Man*," *South Atlantic Review* 76 (2013): 3–17.

1. The Modern Library Edition of *Three Days Before the Shooting: The Unfinished Second Novel,* edited by John F. Callahan and Adam Bradley (New York: Random House, 2011), provides a generous selection and careful presentation of Ellison's various efforts toward a second novel, and it probably represents the best approach possible to these complex and complicated materials. The 2011 version both supplants and complements Callahan's earlier publication of the most nearly completed narrative he could edit from the many drafts as *Juneteenth* (New York: Random House, 2000). As Ellison's literary executor, Callahan also edited the writer's *Collected Essays* (New York: Random House, 1994) and his collected short fiction as *Flying Home and Other Stories* (New York: Random House, 1996). Even though all of these posthumous editions represent the best of the writer's work before and after *Invisible Man,* they also demonstrate that novel's centrality to and preeminence in Ellison's canon. Several of his later stories, especially "Flying Home" and "King of the Bingo Game," do point toward *Invisible Man*; the short fiction reveals few photo tropes, however, much as is the case with Welty's early stories. The uncompleted second novel also features some photographic tropes, but it is more concerned with film than photography.

2. The two major biographical sources are Lawrence P. Jackson's *Ralph Ellison: Emergence of Genius* (New York: John Wiley and Sons, 2002), which follows its subject from his birth in 1913 through the publication of *Invisible Man* in 1952, and Arnold Rampersad's *Ralph Ellison: A Biography* (New York: Alfred A. Knopf, 2007), which documents its subject through his life to his death in 1994. Both books should be consulted for a full picture of Ellison's life and work. Despite the inevitable overlapping of their materials, Jackson's and Rampersad's contrasting approaches to Ellison's life and work create substantial differences of interpretation and evaluation—essentially between Jackson's positive assessment of the early life and Rampersad's negative judgment of the later years.

3. For a thorough and sympathetic discussion of *12 Million Black Voices,* see novelist and critic David Bradley's introduction to the paperback reissue of the text by Basic Books in 1988. In his rereading of the work a generation after its initial publication, Bradley discovers "the theme of generational tension" that gave the book's "simplistic" sociological analysis "a psychological depth" and a personal "passion" (xviii–xix). Bradley does not develop the point, but it is important to recognize that Wright was an avid photographer himself and did some of the initial photographic work for *12 Million Black Voices.* Although Edwin Rosskam did not use Wright's pictures in the published text, the author went on to create another photo book that used his own prose and pictures to recount his 1949 visits to African nations then just emerging from colonial oppression.

4. Gordon Parks is a fascinating figure in his own right, though his full life, diverse efforts, and creative accomplishment also remain interesting as they anticipate, parallel, and illuminate Ellison's. Parks wrote often and well about his own career as a photographer, filmmaker, musician, and writer—perhaps one reason biographical and critical resources on him prove surprisingly sparse even now. If Parks's photography influenced *Invisible Man,* then Ellison's novel influenced the photographer's creative efforts in turn.

At the novel's publication in 1952, Parks created a short portfolio of Harlem images titled "Invisible Man" for *Life* magazine, where he had been hired as its first African American photographer. The pictures demonstrate a sense of Ellison's matter and style in his novel; they also range from the realistic to the symbolic. They are on the Gordon Parks Foundation Web page, www.gordonparksfoundation.org/archive/invisible-man-1952#1.

5. Ellison worked as a freelance photographer for New York publications, including the tabloids. For notable examples, see the Ellison chapter of Sarah Blair's general study, *Harlem Crossroads: Black Writers and the Photograph in the Twentieth Century* (Princeton, NJ: Princeton UP, 2007), which takes its title from the writer's business card during the late 1930s "Ralph Ellison, Photographer."

6. In her article, "The Visual Art of *Invisible Man*: Ellison's Portrait of Blackness" *American Literature* 81 (2009): 775–803, Lena M. Hill astutely traces the development of the writer's literary presentation of black consciousness under the influences of the visual and plastic arts, including photography, as well as their modes of presentation such as publications, exhibitions, and museums. Her perceptive analysis of the paired scenes that open my reading of the novel complement my selection and approach, although we reach differing conclusions concerning the social contexts and racial meanings of these images within the narrative.

7. The visual highlight of this long chapter is the most significant white photo in the novel, "the tinted miniature framed in engraved platinum" of the visiting trustee's long dead daughter, "a young woman of delicate, dreamy features," much like a Poe heroine (43). Her image strikes the narrator silent, and he is unsure if his appreciation of her almost otherworldly beauty might be read as sexual desire. In her discussion of *Invisible Man*, Sarah Blair connects this episode with the work of FSA photographers such as Walker Evans in mid-1930s Alabama while collaborating with James Agee. In my reading of the chapter, Ellison's somewhat bewildered narrator is the fulcrum balancing the white trustee's sentimentally subjective vision of the incestuous undertones within the scene with the black sharecropper Trueblood's harshly realistic reading of them. It also seems possible that Ellison's complicated parsing of genealogical configurations in terms of race and incest may be influenced by Faulkner's fictions, such as *Absalom, Absalom!* and *Go Down, Moses*.

8. The surrealism of the paint factory hospital action also becomes a focus for two studies that raise intriguing issues concerning in/visibility, visual art, and race. Maureen F. Curtin's "Materializing Invisibility as X-ray Technology: Skin Matters in Ralph Ellison's *Invisible Man*" (*Literature, Interpretation, Theory* 9 [1999]: 281–311) considers the expressionistic function of several medical images in the novel, such as X-ray photos. Other visual devices used in 1930s medicine, such as the reflector worn on an infirmary physician's forehead and a Brotherhood leader's errant glass eye, center a chapter on Ellison in Karen Jacobs's *The Eye's Mind: Literary Modernism and Visual Culture* (New York: Cornell UP, 2001).

9. Barbara Foley's *Wrestling with the Left: The Making of Ralph Ellison's* Invisible Man (Durham, NC: Duke UP, 2010) presents the fullest analysis of the author's complicated relations with leftist ideas and texts from the Depression to the Cold War. Foley finally concludes that Ellison's novel was limited by its denial of his earlier connections to the left. In my view, Ellison spends too much of his energies on the Brotherhood and, by extension, Communism in *Invisible Man.*

10. In an imaginative study, "Visuality and Black Masculinity in Ralph Ellison's *Invisible Man* and Romare Bearden's Photomontages" (*Callaloo* 26 [2003]: 813–35), Kimberly Lamm supports this reading of these black portraits in both theoretical terms and in specific photographic analogies. Perhaps the finest African American visual artist of the twentieth century, Bearden was a life-long friend to Ellison, who wrote important essays on Bearden's art, especially his later photomontages. It must be noted, however, that as chronology indicates, Lamm's connection of Bearden's later works with Ellison's first novel is by way of intertextuality rather than influence, though a strong case could be made for references to these visual texts in Ellison's never completed second novel.

11. Ellison's visual and verbal montage here may be influenced by *12 Million Black Voices* not only in general conception but in specific images presented by Wright's photo text. For example, a straight-on portrait of an aging black couple from Georgia, obviously respectable farm folk recently a bit ragged from wear, by white FSA photographer Jack Delano is complicated as a purely documentary view of contemporary conditions by the intertextual inclusion of their handsome wedding portraits mounted on the wall above them, suggesting their complicated journey in modern times and American spaces (29).

12. As his own photographs and those of others reveal, Ellison resembled the protagonist of *Invisible Man* in skin color, while his aloof personality and prideful intellectualism also made him seem too "white" for many blacks. Thus, Ellison's commitment to African American issues was questioned throughout his career, beginning with his personal refusal to support leftist causes in the 1930s and climaxing in the 1960s with his manifest disdain for the Black Power and Black Arts movements. Jackson treats the social positions that Ellison adopted during the Depression years rather positively in his biography, but Rampersad judges Ellison negatively in his biographical consideration of the author's public clashes with black militants during the 1960s and for long after.

13. The blinded boxer probably was suggested by Sam Langford, who lived from 1883 to 1956 and was called "The Greatest Fighter Nobody Knows" because he was denied challenges to white champions because of his race. After more than three hundred bouts, he retired in 1926 and later entered a Harlem home for the blind. He was interviewed for a magazine article that revived his reputation briefly in the late 1940s when Ellison was working on *Invisible Man.* It is possible that Ellison heard about Langford from his own father, as the description of this picture recalls one of the protagonist's dead father in the autobiographical story "Boy on a Train" from the late 1930s (*Flying Home* 15).

CHAPTER SEVEN

Parts of this chapter appeared as "'Love and Knowledge': Daughters and Fathers in Natasha Trethewey's *Thrall*," *Southern Quarterly* 50 (2013): 189–207. Like other articles in this special issue, mine is illustrated by photographs from the Trethewey family.

1. No definitive biographical study of Trethewey has appeared, though most interviews, reviews, and critical articles about her attempt to connect her life and work. At present, I believe the best biographical source may be the detailed chronology found in Joan Wylie Hall's edition of interviews, *Conversations with Natasha Trethewey* (Jackson: UP of Mississippi, 2013).

2. Joan Wylie Hall edited a special issue of the *Southern Quarterly* (50, no. 4 [2013]) devoted to Trethewey, which is the best gathering of materials on her work thus far. In addition to my essay "Love and Knowledge," it includes seven interesting articles; of particular importance in relation to photography and ekphrasis are Thadious M. Davis, "Enfoldments: Natasha Trethewey's Racial-Spatial Phototexting" (37–54), and Kimberly Wallace-Sanders, "'Your Eyes Returning My Own Gaze': Distortion and Photography as Meta-Narrative in Trethewey's Poetry" (173–88).

3. Two interesting readings of *Bellocq's Ophelia* as an ekphrastic volume are Annette Debo, "Ophelia Speaks: Resurrecting Still Lives in Natasha Trethewey's *Bellocq's Ophelia,*" *African American Review* 42 (2008): 201–14, and Debora Rindge and Anna Leahy, "'Become What You Must': Trethewey's Poems and Bellocq's Photographs," *English Language Notes (ELN)* 44 (2006): 291–305.

4. The photograph can be found in any of the several published collections of Bellocq's images. In fact, it was the cover illustration of the first and most influential of them; see Lee Friedlander and John Szarkowski, *E. J. Bellocq: Storyville Portraits—Photographs from the New Orleans Red-Light District, Circa 1912* (New York: Museum of Modern Art, 1970). This photograph, as well as others in the Bellocq collection, is available online at the Museum of Modern Art Web site (www.moma.org/collection).

5. Images of Millais's celebrated painting are available in many print and electronic sources. For a print example as well as a discussion of the picture, see Paul Barlow, *Time Present and Time Past: The Art of John Everett Millais* (London: Ashgate, 2005). The painting is at the Tate Britain Gallery, and an online image can be found at www.tate.org.uk/art/artworks/millais-ophelia-n01506.

6. The historical implications of Trethewey's open-ended final line suggest that "*Flood*" prefigures *Beyond Katrina* in its considerations of the 2005 disaster, whose victims, especially people of color, were often called refugees in news reports, as if they had fled from another country. The chronological and geographical settings of the 1927 Mississippi flood also recall Faulkner's "Old Man," and the poem complements that narrative's emphasis on white subjects.

7. Frank's striking photograph is titled simply by its time and place, "Charleston, South Carolina, 1955." It is available in the many reprintings of *The Americans,* as well as in several collections of Frank's photographs and of modern American photography. The best online sources include the New York Metropolitan Museum of Art Web site and the *Photo District News* Photo of the Day for November 6, 2009 (http://potd.pdnonline .com/2009/11/2594).

WORKS CITED

Agee, James. *Let Us Now Praise Famous Men, A Death in the Family, and Shorter Fiction*. New York: Library of America, 2005. Print.

———. *Letters of James Agee to Father Flye*. New York: Braziller, 1962. Print.

Barthes, Roland. *Camera Lucida*. New York: Hill and Wang, 1981. Print.

Bergreen, Laurence. *James Agee: A Life*. New York: Penguin, 1985. Print.

Blair, Sarah. *Harlem Crossroads: Black Writers and the Photograph in the Twentieth Century*. Princeton NJ: Princeton UP, 2007. Print.

Blotner, Joseph. *Faulkner: A Biography*. New York: Random House, 1984. Print.

Cutrer, Thomas J. *Parnassus on the Mississippi: The Southern Review and the Baton Rouge Literary Community, 1935–1942*. Baton Rouge: Louisiana State UP, 1984. Print.

Dickstein, Morris. *Dancing in the Dark: A Cultural History of the Great Depression*. New York: Norton, 2009. Print.

Dugan, Ellen, ed. *Picturing the South: 1860 to the Present*. Atlanta, GA: Chronicle Books, 1996. Print.

Ellison, Ralph. *Collected Essays*. Ed. John F. Callahan. New York: Random House, 1994. Print.

———. *Flying Home and Other Stories*. Ed. John F. Callahan. New York: Random House, 1996. Print.

———. *Invisible Man*. New York: New American Library, 1996. Print.

———. *Juneteenth*. New York: Random House, 2000. Print.

———. *Three Days Before the Shooting: The Unfinished Second Novel*. Ed. John F. Callahan and Adam Bradley. New York: Random House, 2011. Print.

Evans, Walker. *American Photographs*. New York: Museum of Modern Art, 1938. Print.

———. "Lyric Documentary." Lecture, March 11, 1964. Museum of Modern Art: New York, Walker Evans Archive. Print.

———. "Photography." In Louis Kronenberger, ed., *Quality: Its Image in the Arts.* New York: Atheneum, 1969. 169–71. Print.

Faulkner, William. *Collected Stories.* New York: Random House, 1949. Print.

———. *Complete Novels.* Vols. 2–4. New York: Library of America, 1995–2007. Print.

———. *"Interview with William Faulkner." The Paris Review Interviews.* Vol. 2. New York: Picador, 2007. 34–57. Print.

———. "Sepulture South: Gaslight." In Joseph Blotner, ed., *Uncollected Stories of William Faulkner.* New York: Random House, 1979. 449–55. Print.

Glock, Allison. "Natasha Trethewey: Poet in Chief." *Garden and Gun* October/November 2012. Web. June 2013.

Gray, Richard. "Inventing Communities, Imagining Places: Some Thoughts on Southern Self-Fashioning." In Suzanne W. Jones and Sharon Monteith, eds., *South to a New Place: Region, Literature, Culture.* Baton Rouge: Louisiana State UP, 2002. xii–xxiii. Print.

Hall, Joan Wylie. *Conversations with Natasha Trethewey.* Jackson: UP of Mississippi, 2014. Print.

Henninger, Katherine. "Faulkner, Photography, and a Regional Ethics of Form." In Joseph R. Urgo and Ann Abadie, eds., *Faulkner and Material Culture.* Jackson: UP of Mississippi, 2007. 121–38. Print.

———. *Ordering the Façade: Photography and Contemporary Southern Women's Writing.* Chapel Hill: U of North Carolina P, 2007. Print.

Jackson, Lawrence P. *Ralph Ellison: Emergence of Genius.* New York: John Wiley and Sons, 2002. Print.

Langford, Gerald. *Faulkner's Revision of Sanctuary.* Austin: U of Texas P, 1972. Print.

Madden, David. "The Cruel Radiance of What Is." *Southern Quarterly* 20.2 (1984): 5–43. Print.

Magee, Rosemary. "'The Larger Stage of These United States': Creativity Conversation with Natasha Trethewey." *Southern Quarterly* 50.4 (2013): 17–28. Print.

Marrs, Suzanne. *The Welty Collection: A Guide to the Eudora Welty Manuscripts and Documents at the Mississippi Department of Archives and History.* Jackson: UP of Mississippi, 1988. Print.

Mellow, James R. *Walker Evans: A Biography.* New York: Basic Books, 1999. Print.

Millichap, Joseph. *Robert Penn Warren: A Study of the Short Fiction.* New York: Macmillan, 1992. Print.

———. *Robert Penn Warren after* Audubon: *The Work of Aging and the Quest for Transcendence in His Later Poetry.* Baton Rouge: Louisiana State UP, 2009. Print.

———. "The Warren Family Gift of Audio-Visual Materials to the Robert Penn Warren Collection." *rWp: An Annual of Robert Penn Warren Studies* 6 (2006): 89–94. Print.

Mississippi: The WPA Guide to the Magnolia State. New York: Viking, 1938. Print.

Pettus, Emily Wagster. "Natasha Trethewey, U.S. Poet Laureate, Interview." *Huffington Post* 21 November 2012. Web. June 2013.

Pitavy-Soques, Danielle. "A Blazing Butterfly: The Modernity of Eudora Welty." In Albert Devlin, ed., *Welty: A Life in Literature.* Jackson: UP of Mississippi, 1987: 113–38. Print.

Raeburn, John. *A Staggering Revolution: A Cultural History of Thirties Photography.* Champaign: U of Illinois P, 2006. Print.

Rampersad, Arnold. *Ralph Ellison: A Biography.* New York: Alfred A. Knopf, 2007. Print.

Rathbone, Belinda. *Walker Evans: A Biography.* Boston: Houghton Mifflin, 1995. Print.

Rowell, Charles Henry. "Interview with Natasha Trethewey." *Callaloo* 27 (2008): 1021–35. Print.

Sensibar, Judith. *Faulkner and Love: The Women That Shaped His Art.* New Haven: Yale UP, 2009. Print.

———. "Faulkner's Real and Imaginary Photos of Desire." In Doreen Fowler and Ann Abadie, eds., *Faulkner and Popular Culture* (Jackson: UP of Mississippi, 1990): 110–41. Print.

Sontag, Susan. *On Photography.* New York: Farrar, Straus, and Giroux, 1977. Print.

Stannard, David E. "Sex, Death, and Daguerreotypes: Toward an Understanding of Image as Elegy." In John Wood, ed., *America and the Daguerreotype.* Iowa City: U of Iowa P, 1991. 73–108. Print.

Szarkowski, John, ed. *Walker Evans.* New York: Museum of Modern Art, 1971. Print.

Trethewey, Natasha. *Bellocq's Ophelia.* Minneapolis: Graywolf, 2002. Print.

———. *Beyond Katrina.* Athens: U of Georgia P, 2010. Print.

———. *Conversations with Natasha Trethewey.* Ed. Joan Wylie Hall. Jackson: UP of Mississippi, 2013. Print.

———. *Domestic Work.* Minneapolis: Graywolf, 2000. Print.

———. *Native Guard.* New York: Houghton Mifflin, 2006. Print.

———. *Thrall: Poems.* New York: Houghton Mifflin Harcourt, 2012. Print.

Warren, Robert Penn. *All the King's Men.* New York: Harcourt Brace, 1946. Print.

———. *At Heaven's Gate.* New York: New Directions, 1985. Print.

———. *The Circus in the Attic and Other Stories.* New York: Random House, 1947. Print.

———. *The Collected Poems of Robert Penn Warren.* Ed. John Burt. Baton Rouge: Louisiana State UP, 1998. Print.

———. *A Place to Come To.* New York: Random House, 1977. Print.

———. *Talking with Robert Penn Warren.* Ed. Floyd C. Watkins, John T. Hiers, and Mary Louise Weaks. Athens: U of Georgia P, 1990. Print.

———. "William Faulkner." In *New and Selected Essays.* New York: Random House, 1989. Print.

Watson, James G. *William Faulkner: Self-Presentation and Performance.* Austin: U of Texas P, 2002. Print.

Welty, Eudora. *Conversations with Eudora Welty.* Ed. Peggy Whitman Prenshaw. Jackson: UP of Mississippi, 1984. Print.

———. *Eudora Welty: Complete Novels.* New York: Library of America, 1998. Print.

———. *Eudora Welty: Stories, Essays, and Memoir.* New York: Library of America, 1998. Print.

———. *The Eye of the Story: Selected Essays and Reviews.* New York: Vintage, 1979. Print.

———. *Photographs.* Jackson: UP of Mississippi, 1989. Print.

INDEX

Note: page numbers followed by "n"
 indicate endnotes.

"1. A woman of the 'thirties/Hinds
 County/1935" (Welty), 90
"1. King Cotton, 1907" (Trethewey), 128
"2. Food, Shelter, and Clothing" (Agee), 38
"2. Glyph, Aberdeen 1913" (Trethewey),
 128–29
"3. Flood" (Trethewey), 129–30, 147n6
"3. Help, 1968" (Trethewey), 131
"4. You Are Late" (Trethewey), 130
12 Million Black Voices (Wright), 103,
 144n3, 146n11
"82. Jackson/1930s" (Welty), 91–92

Abel, Elizabeth, 136n23
Absalom, Absalom! (Faulkner), 12, 21,
 52–53, 55, 61
"Ad Astra" (Faulkner), 48, 69
African Americans and depictions of
 race: in antebellum era, 9–10; by
 black photographers, 25; Ellison's
 Invisible Man and, 101, 104, 105–12;
 Ellison's portraits of black males, 104;
 Faulkner and, 51, 61–62; by Genthe,
 14; Let Us Now Praise Famous Men

(Agee), 39, 139n8; lynchings, 14,
 134n9; Trethewey and, 120–21, 129–
 30; visual and psychological binaries
 of, 2; Welty and, 89–92
Agassiz, Louis, 9
Agee, James: Bergreen's James Agee: A
 Life, 137n1; Cotton Tenants, 138n6;
 Crane and, 30; A Death in the Family,
 139n9; Evans and, 7, 30–34; Evans's
 "James Agee in 1936," 139n7; Madden
 and, 3; Permit Me Voyage, 29; photog-
 raphy, interest in, 28; on photography,
 19; posthumous reputation of, 114;
 self-doubt of, 31; Trethewey and, 128,
 132; Walker and, 7; Warren and, 68.
 See also Let Us Now Praise Famous
 Men (Agee)
Allen, Frederick Lewis, 135n11
Allen, James, 134n9
Allison, Dorothy, 115
"All the Dead Pilots" (Faulkner), 48
All the King's Men (Warren), 75–77, 78,
 83, 141nn3–4
Altitudes and Extensions (Warren), 81–82
America and the Daguerreotype (Wood),
 133n2
American Photographs (Evans), 35–37, 131

"The Americans" (Trethewey), 131

The Americans (Frank), 131, 148n7

Anderson, Sherwood, 135n15

And Their Children After Them (Maharidge and Williamson), 32–33

Arbus, Diane, 79

As I Lay Dying (Faulkner), 48–49, 61, 139n13

Atget, Eugene, 14

At Heaven's Gate (Warren), 74–75

"At the Owl Club, North Gulfport, Mississippi, 1950" (Trethewey), 119

Audubon: A Vision (Warren), 117

"August 1911" (Trethewey), 123–24

Baldwin, James, 114

Band of Angels (Warren), 78

"Barn Burning" (Faulkner), 69

Barthes, Roland: Civil War photography and, 11; Stannard on, 9; on *studium* and *punctum* of the photograph, 5, 70, 118; on time, death, and memory, 4–5, 41, 47, 99; Trethewey and, 118; Warren and, 70, 76, 79. *See also* time, death, and memory

Bearden, Romare, 146n10

Beattie, Ann, 115

Bellocq, E. J., 14, 120, 124, 147n4

"Bellocq" (Trethewey), 123

Bellocq's Ophelia (Trethewey), 117–18, 120–25, 132

Berger, Martin A., 136n23

Bergreen, Laurence, 137n1

Beyond Katrina (Trethewey), 117, 119, 132, 147n6

"Black Saturday" (Welty), 84, 88, 89, 92, 143n8

Blair, Sara, 102, 145n7

"Blond" (Trethewey), 126

Bourke-White, Margaret: Agee on, 40; *You Have Seen Their Faces* (Caldwell and Bourke-White), 19, 40, 70

Bradley, Adam, 112

Bradley, David, 144n3

Brady, Mathew, 11–12, 40

The Bride of the Innisfallen (Welty), 94, 99, 143n9

The Bridge (Crane), 30

Brooks, Cleanth, 16

Bubley, Esther, 86

Burdine, Jane Rule, 26

Burroughs, Floyd, 42–43

Butler, Maud, 46

Cable, George Washington, 13–14

Caldwell, Erskine: Agee compared to, 19; photo books and, 33; *You Have Seen Their Faces* (Caldwell and Bourke-White), 19, 40, 70

Callahan, John F., 144n1

Camera Lucida (Barthes), 4–5

Cartier-Bresson, Henri, 40, 64

Chesnutt, Charles W., 13

Christenberry, William, 25–26

The Circus in the Attic and Other Stories (Warren), 70, 77–78

Civil Rights era, 23–25, 80, 137n23

Civil War, 10–12, 21

Clark, Eleanor, 68, 82

Cofield, Jack, 65

Collected Essays (Ellison), 144n1

Conn, Peter, 135n17

Cotton Tenants (Agee), 138n6

"Countess P__'s Advice for New Girls" (Trethewey), 121

Cowley, Malcolm, 56, 64

Crampton, Nancy, 82

Crane, Hart, 7, 30, 35

"The Cruel Radiance of What Is"
(Madden), 3
Cubism, 48
cultural representation dialectic. *See* documentary realist/subjective-reflective modernist dialectic
A Curtain of Green (Welty), 92–93
Curtin, Maureen F., 145n8

daguerreotypes, 8–10, 133n2
Dain, Martin, 65
Davis, William C., 134n6
death. *See* time, death, and memory
A Death in the Family (Agee), 139n9
Delano, Jack, 146n11
Delta Wedding (Welty), 94, 143n9
Depression. *See* Great Depression
Desvergnes, Alain, 65
Dickey, James, 22
Dickstein, Morris, 19–20, 91, 102
documentary realist/subjective-reflective modernist dialectic: Ellison and, 102, 104; Faulkner and, 20, 45–46, 47, 59, 62; Warren and, 20, 67; Welty and, 91
Domestic Work (Trethewey), 117, 118–20, 125, 132
Douglass, Frederick, 109
Dugan, Ellen, 3, 137n23

"Ebo Landing" (Weems), 7
Eggleston, William, 26, 65
ekphrasis: about, 6; Agee's *A Death in the Family* and, 139n9; Ellison and, 100, 108; Evans and, 139n9; Faulkner and, 52; Johnson and, 118–19; *Let Us Now Praise Famous Men* (Agee) and, 41–43; Trethewey and, 113, 115, 117, 119–20, 121, 127–32; Warren and, 80, 81, 141n4

Ellison, Ralph: biographical sources on, 144n2; *Collected Essays*, 144n1; critical assessments of, 112–13; Depression-era artistic tensions and, 20; documentation vs. expression and, 102–3; evolution of, 114; *Flying Home and Other Stories*, 144n1; as freelance photographer, 145n5; in Harlem, 20; "Harlem in Nowhere," 103–4; *Invisible Man* as semi-autobiographical, 101–2; "King of the Bingo Game," 144n1; photo books and, 19; photography, interest in, 102; racial identity and, 146n12; *Three Days Before the Shooting*, 100, 112, 144n1; Trethewey and, 132; Warren and, 82; Welty and, 99; WPA Harlem projects, 100–101; Wright's *12 Million Black Voices* and, 103. *See also Invisible Man*

Evans, Walker: Agee and, 7, 30–34; *American Photographs*, 35–37, 131; background, 7; biographical, scholarly, and critical treatment of, 137n2; Crane and, 30; Eggleston and, 65; ekphrasis and, 139n9; Faulkner and, 57, 65–66; "Faulkner's Mississippi," 65; FSA photographic program and, 18, 86, 145n7; influence of, 25–26; "James Agee in 1936," 139n7; on "language of vision," 7–8; lyric documentary style, 18, 25–26; Mayfield, KY, graveyard image, 65–66; Mississippi River flood (1927) and, 57; Trethewey and, 128, 129, 132; Warren and, 67, 68–69, 82; in Warren's *A Place to Come To*, 72; Welty and, 87; World War II and, 22; Wright and, 103. *See also Let Us Now Praise Famous Men* (Agee)

A Fable (Faulkner), 48, 64

family photography and albums: Agee
and Evans's *Let Us Now Praise Famous
Men* and, 34, 38, 43; Coldfield and,
12; Evans and, 36; Raeburn on, 17–18;
Trethewey and, 119–20, 127–28, 132;
Warren and, 74–75, 77, 79–82, 98–99;
Welty and, 85, 88, 89, 94, 98–99,
117–18, 120, 126–28, 131–32, 143n8

Farm Security Administration (FSA)
photographic program, 18; Delano
and, 146n11; Ellison's *Invisible Man*
and, 145n7; Evans and, 29, 145n7;
Evans's *American Photographs* and, 36;
Henninger's comparison of Faulkner
and, 57; Parks and, 104; Welty and,
86, 87–88, 91

Faulkner, William: *Absalom, Absalom!*,
12, 21, 52–53, 55, 61; "Ad Astra,"
48, 69; Agee compared to, 19; "All
the Dead Pilots," 48; *As I Lay Dying*,
48–49, 61, 139n13; aviation and,
47–48, 53–54; background, 46; "Barn
Burning," 69; Civil War and, 12, 21;
Cowley's *The Portable Faulkner*, 56,
64; ekphrasis and, 52; Evans and, 57,
65–66; *A Fable*, 48, 64; *Flags in the
Dust*, 46, 47–48, 49; *Go Down, Moses*,
55, 61–63; *The Hamlet*, 60–61; *If I
Forget Thee, Jerusalem*, 56; initial phase,
end of, 51–52; "The Leg," 46–47; *Let
Us Now Praise Famous Men* (Agee)
and, 43; *Light in August*, 50–51; *The
Mansion*, 60; modernist vs. docu-
mentary images and, 20; Nobel Prize
(1950), 64; "Old Man," 56–57, 147n6;
as photographic subject, 64–65;
photography, interest in, 43; political
position during Depression, 55; post-
humous reputation of, 114; post-WWII

work, 64; *Pylon*, 52–54; *The Reivers*,
64; Rowan Oak and Greenfield Farm
properties, 51–52, 55, 56, 62; *Sanctu-
ary*, 49–50, 53, 64, 140nn3–4; *Sartoris*,
46, 49; Sensibar's *Faulkner and Love*,
46; "Sepulture South: Gaslight," 65–
66; *The Sound and the Fury*, 48–49;
These Thirteen, 48, 69; *The Town*,
60; Trethewey and, 116, 132; *The
Unvanquished*, 21, 55–56, 61; Warren
and, 69–70; Welty on, 87; "The Wild
Palms," 56, 58–60; *The Wild Palms*, 55,
56, 58, 60; World War II and, 64

Faulkner and Love (Sensibar), 46

"Faulkner's Mississippi" (Evans), 65

fictive (literary) photographs, Henninger
on, 5–6, 141n4. *See also specific authors*

Fitzgerald, F. Scott, 42

Flags in the Dust (Faulkner), 46, 47–48, 49

Flora, Joseph M., 133n1

Flye, James Harold, 31

Flying Home and Other Stories (Ellison),
144n1

Foley, Barbara, 146n9

"Forever O'Clock" (Warren), 78–79

Fortune, 29, 138n6

Frank, Robert, 25, 79, 148n7

Friedlander, Lee, 14, 25

Frost, Robert, 35

gender binaries, Welty and, 89–90

Genthe, Arnold, 13–14

Go Down, Moses (Faulkner), 55, 61–63

"Going Naples" (Welty), 99

The Golden Apples (Welty), 94

Gone with the Wind (Mitchell), 20–21

The Grapes of Wrath (Steinbeck), 43

Gray, Richard, 1–2, 9, 16

Great Depression: FDR's second term
as midpoint of, 55; *Let Us Now Praise*

Famous Men (Agee) and, 28–29; Pearl
Harbor as end of, 64; photography
during, 17–21. *See also* documentary
realist/subjective-reflective modernist
dialectic
Gudger, George (Floyd Burroughs),
42–43

Hall, Joan Wylie, 147nn1–2
The Hamlet (Faulkner), 60–61
"Harlem in Nowhere" (Ellison), 103–4
Harlem projects (WPA), 100–101
Henninger, Katherine: on Civil Rights
era, 137n23; on Faulkner, 57; on fictive
photographs, 5–6, 43; on racist use of
photography, 9; on southern regional
photography, 3–4, 114–15; on Welty,
89, 92
Hill, John T., 138n5
Hill, Lena M., 145n6
Hine, Lewis, 14–15
history of photography and culture: an-
tebellum era and the daguerreotype,
8–10; Civil Rights era, 23–25; Civil
War and its aftermath, 10–12; Great
Depression, 17–21; language of vision
and, 7–8; Madden's three periods,
2–3; post-1960s period, 25–26; Re-
construction and Redemption period,
12–15; theoretical and historical
works, 3–7; World War I and 1920s,
15–17; World War II, 21–23
Homer, 6
Hudson, Bill, 25
Humphreys, Josephine, 115
Hurston, Zora Neale, 19, 33

"I Am Dreaming of a White Christmas"
(Warren), 79, 80
If I Forget Thee, Jerusalem (Faulkner), 56

intertextuality: Faulkner and, 57–58;
Let Us Now Praise Famous Men (Agee)
and, 28–29, 41; Trethewey and, 115,
132; Warren and, 70; Welty and, 99
Invisible Man (Ellison): Chapter 1
("Battle Royal"), 105; Parks and,
144n4; racial consciousness, individ-
ual development, and self-identity,
105–12; realistic documentation and
modernist subjectivity in, 104; as self-
referential Bildungsroman, 104–5; as
semi-autobiographical, 101–2; vision
as metaphor of race relations in, 101

Jackson, Lawrence P., 144n2, 146n12
James Agee: A Life (Bergreen), 137n1
Jarrell, Randall, 22
Johnson, Clifton, 118–19
Joyce, James, 105

Kasterine, Dmitri, 82–83
"Keela, the Outcast Indian Maiden"
(Welty), 91
"Kin" (Welty), 93, 94–97, 116, 143n9
King, Martin Luther, Jr., 23–24, 25
"King of the Bingo Game" (Ellison), 144n1
Kirstein, Lincoln, 35, 36–37
Krementz, Jill, 82
Kreyling, Michael, 16

Lamm, Kimberly, 146n10
Lange, Dorothea, 86, 128, 129
Langford, Sam, 146n13
"language of vision," xii, 7–8, 11–12
Lee, Robert E., 13, 80
Lee, Russell, 86
"The Leg" (Faulkner), 46–47
Leibovitz, Annie, 82
"Letter Home" (Trethewey), 121
"Letters from Storyville" (Trethewey), 121

Let Us Now Praise Famous Men (Agee):
African Americans as peripheral in,
39, 139n8; Agee's narrative organi-
zation, 37–41; Agee's "Three Tenant
Families" and, 37; Agee's untitled
poem dedicated to Evans, 33; agency
and responsibility, questions of,
32–33; artistic, personal, and profes-
sional tensions between Agee and
Evans and, 20, 30–34; "Clothing," 41;
"A Country Letter," 41; editions of, 34,
138n4; ekphrasis and, 41–43; Evans's
American Photographs and, 35–37;
Evans's spatial ordering, 34–35; Faulk-
ner's *As I Lay Dying* and, 139n13; influ-
ences and anticipations, 43; intertex-
tual references, 40–41; Madden and,
3; Maharidge and Williamson's *And
Their Children After Them* and, 32–33;
modernist documentary aesthetic
and, 35–36; "Near a Church," 39;
"Notes and Appendices," 40; pairing
of Evans and Agee on, 29–30; "Pream-
ble," 19, 31, 40; reception of, 19; schol-
arly and critical studies of, 138n3;
sexual tension among tenant farmers,
32; significance of, 28–29; subject
matter of, 29; Thoreau's *Walden* and,
38–39; Trethewey's *Beyond Katrina*
and, 117; Warren and, 68–69, 73, 78;
Welty and, 87
Levitt, Helen, 40, 139n9
Leyendecker, Joseph Christian, 42–43,
139n12
Light in August (Faulkner), 50–51
Lion, Jules, 8
literary (fictive) photographs, Henninger
on, 5–6, 141n4. *See also specific authors*
"A Little Girl, Twenty Months Old, Faces
the World" (Warren), 82

"Livvie" (Welty), 91
Lorentz, Pare, 57
Losing Battles (Welty), 93, 97–99, 143n9
Lost Cause imagery, 12–13
Luce, Henry, 29
lynchings, 14, 134n9
Lyons, Danny, 25

Macdonald, Dwight, 29
MacKethan, Lucinda H., 133n1
MacLeish, Archibald, 29, 68, 135n15
Madden, David, 2–3, 11, 33, 86, 137n23,
140n4
Maharidge, Dale, 32–33
Malle, Louis, 14
Mann, Sally, 26
Man Ray, 17
The Mansion (Faulkner), 60
Marrs, Suzanne, 142n4, 142n6
Marshall-Linnemeier, Lynn, 26
Martin, Louise, 25
Mason, Bobbie Ann, 114
McCorkle, Jill, 115
McCullers, Carson, 22
memorial photography, 13, 16. *See also*
time, death, and memory
Miley, Michael, 13
Millais, John Everett, 120, 121–22, 147n5
Mississippi River flood (1927), 56–57,
129
*Mississippi: The WPA Guide to the
Magnolia State*, 63
Mitchell, Margaret, 20–21
Mitchell, W. J. T., 139n11
modernism: Faulkner and, 48, 52; *Let
Us Now Praise Famous Men* (Agee)
and, 35–36, 44; naturalism vs., 20;
Welty and, 99. *See also* documentary
realist/subjective-reflective modernist
dialectic

Moore, Charles, 25
Moore, Marianne, 35
Morrison, Toni, 114
Murray, Albert, 114
"Must the Novelist Crusade?" (Welty), 87

Natanson, Nicholas, 102
Native Guard (Trethewey), 115, 116,
 125–30, 131, 132
naturalism, 13, 20, 35, 85
negative image, reversed, 2
New Journalism, 26
"News Photo" (Warren), 80
Night Rider (Warren), 73–74

O'Connor, Flannery, 22, 114
"Old Man" (Faulkner), 56–57, 147n6
"Old Photograph of the Future"
 (Warren), 81–82
One Writer's Beginnings (Welty), 85
On Photography (Sontag), 4
The Optimist's Daughter (Welty), 97
Ordering the Façade (Henninger), 3–4
Or Else: Poem/Poems 1968–1974 (Warren),
 78–81
Orvell, Miles, 135n11

Parks, Gordon, 25, 102, 103–4, 144n4
Parrish, Timothy, 112
"Pastoral" (Trethewey), 116, 126
"The Patented Gate and the Mean Ham-
 burger" (Warren), 70–71, 78
Percy, Walker, 114
Perman, Michael, 134n7
Permit Me Voyage (Agee), 29
Phillips, Kevin, 136n19
photo books: Great Depression and, 19;
 Let Us Now Praise Famous Men (Agee)
 and, 33; outside the South, 135n15;
 Warren and, 71

"Photograph: Ice Storm, 1971"
 (Trethewey), 127–28
"Photograph of A Bawd Drinking
 Raleigh Rye" (Trethewey), 121
Photographs (Welty), 89–90, 91–92
photography: Agee's interest in, 28;
 Barthes's *studium* and *punctum* of,
 5, 70, 118; Ellison's interest in, 102;
 Faulkner's interest in, 43; technical
 advances in, 9, 16, 22, 142n4; Warren's
 interest in, 67–68; Welty's interest in,
 84–85. *See also* history of photography
 and culture
"Photography" (Trethewey), 124
pictorialism, 35, 119
Picturing the South (Dugan), 3
Pitavy-Soques, Danielle, 143n9
"Place in Fiction" (Welty), 143n10
A Place to Come To (Warren), 71–73, 78
The Ponder Heart (Welty), 97
The Portable Faulkner (Cowley), 56, 64
Porter, Katherine Anne, 19
"*(Self) Portrait*" (Trethewey), 124
Portrait of the Artist as a Young Man
 (Joyce), 105
postmodernism, 26
postsouthernism, 22, 26
"Powerhouse" (Welty), 91
"Prime Leaf" (Warren), 69
Promises (Warren), 78
punctum (point) of the photograph:
 Barthes on, 5, 70, 118; Faulkner and,
 52; *Let Us Now Praise Famous Men*
 (Agee) and, 42
Pylon (Faulkner), 52–54

race. *See* African Americans and
 depictions of race
Raeburn, John, 17–18
Raiford, Leigh, 136n23

Ralph Ellison (Bradley), 112
Ralph Ellison (Jackson), 144n2
Ralph Ellison (Rampersad), 144n2
Ralph Ellison and the Genius of America
 (Parrish), 112
Rampersad, Arnold, 112, 144n2, 146n12
Rathbone, Belinda, 68
"Reading Late at Night, Thermometer
 Falling" (Warren), 80–81
realism: Civil War and, 10–11; Faulkner,
 New Deal art, and, 62; in late 19th
 century, 13; modern documentary
 aesthetic and, 35; Welty and, 85. *See
 also* documentary realist/subjective-
 reflective modernist dialectic
Reconstruction, 12–15
Redemption period, 12–15
The Reivers (Faulkner), 64
The River (Lorentz), 57
Rockwell, Norman, 139n12
Roosevelt, Eleanor, 37
Roosevelt, Franklin D., 17, 55
Roosevelt, Theodore, 128
Rosskam, Edwin, 103, 144n3
Rubin, Louis, 16

Sanctuary (Faulkner), 49–50, 53, 64,
 140nn3–4
Sartoris (Faulkner), 46, 49
"Scenes from a Documentary History of
 Mississippi" (Trethewey), 126, 128–30
*Segregation: The Inner Conflict of the
 South* (Warren), 80, 117
Sensibar, Judith, 46
"Sepulture South: Gaslight" (Faulkner),
 65–66
"Sermon with a Camera" (Williams), 36
Shahn, Ben, 86
Simpson, Lewis, 11, 134n5
Sleet, Moneta J., 25

Smith, Lee, 114
Sontag, Susan: Civil War photography
 and, 11; on time, death, and memory,
 4, 9, 41, 47, 99; Trethewey's *Bellocq's
 Ophelia* and, 117–18; Warren and, 79.
 See also time, death, and memory
The Sound and the Fury (Faulkner), 48–49
"South" (Trethewey), 126
*The Southern Companion to Southern Lit-
 erature* (Flora and MacKethan), 133n1
southern culture and photography, his-
 tory of. *See* history of photography
 and culture
Southern Renaissance (or Renascence),
 15–16, 17, 21–22
Spencer, Elizabeth, 22
A Staggering Revolution (Raeburn), 18
Stannard, David E., 9
Steichen, Edward, 16–17, 102
Steinbeck, John, 43, 135n15
Stewart, George, 65
Stieglitz, Alfred, 16–17, 35
The Story of Temple Drake (film), 53
"Storyville Diary" (Trethewey), 121
Strand, Paul, 17
Stryker, Roy, 18, 29
studium (study) of the photograph, 5,
 70, 118
Styron, William, 114
subjective modernism vs. documentary
 realism. *See* documentary realist/
 subjective-reflective modernist dia-
 lectic
Sun Belt, 23, 136n19
Szarkowski, John, 36, 82

Tate, Allen, 15–16
Taylor, Peter, 114
television as new medium, 24
Temin, Peter, 135n11

Thaggert, Miriam, 102
"Theories of Time and Space"
 (Trethewey), 126–27
These Thirteen (Faulkner), 48, 69
Thoreau, Henry David, 38–39
Thrall (Trethewey), 115, 131–32
Three Days Before the Shooting (Ellison),
 100, 112, 144n1
"Three Tenant Families" (Agee), 37. See
 also *Let Us Now Praise Famous Men*
 (Agee)
time, death, and memory: Faulkner and,
 47, 66; photography and, 4; photog-
 raphy as bridge and, 99; Warren and,
 81, 82
time, narrative sequences of, 6–7
Timrod, Henry, 13
The Town (Faulkner), 60
"tragic mulatto" figure in Faulkner, 51
Trethewey, Natasha: "1. King Cotton,
 1907," 128; "2. Glyph, Aberdeen 1913,"
 128–29; "3. Flood," 129–30, 147n6;
 "3. Help, 1968," 131; "4. You Are
 Late," 130; "The Americans," 131;
 "At the Owl Club, North Gulfport,
 Mississippi, 1950," 119; "August 1911,"
 123–24; awards and Pulitzer Prize,
 120, 125, 131; Bellocq, influence of,
 14; "Bellocq," 123; *Bellocq's Ophelia*,
 117–18, 120–25, 132; *Beyond Katrina*,
 117, 119, 132, 147n6; "Blond," 126;
 "Countess P___'s Advice for New
 Girls," 121; Depression-era artistic
 tensions and, 20; *Domestic Work*, 117,
 118–20, 125, 132; family relations and
 racial tensions in work of, 115; inter-
 texuality with other major writers,
 113, 132; laureateship, 115, 131; "Letter
 Home," 121; "Letters from Storyville,"
 121; *Native Guard*, 115, 116, 125–30,

131, 132; "Pastoral," 116, 126; "Pho-
 tograph: Ice Storm, 1971," 127–28;
 "Photograph of A Bawd Drinking
 Raleigh Rye," 121; "Photography," 124;
 "(Self) Portrait," 124; "Scenes from a
 Documentary History of Mississippi,"
 126, 128–30; "South," 126; "Storyville
 Diary," 121; "Theories of Time and
 Space," 126–27; *Thrall*, 115, 131–32;
 "Vignette," 121, 124–25; Warren and,
 115, 116–17, 132
Twain, Mark, 13
Tyler, Anne, 115

The Unvanquished (Faulkner), 21, 55–56, 61

Van Der Zee, James, 102
Van Vechten, Carl, 64, 102
"Vignette" (Trethewey), 121, 124–25
"The Visual Art of *Invisible Man*" (Hill),
 145n6

Walden (Thoreau), 38–39
Walker, Alice, 115
Walker, Marion Post, 86
Warren, Robert Penn: Agee and, 68;
 Agee compared to, 19; Agee's *Let Us
 Now Praise Famous Men* and, 68–69,
 73, 78; *All the King's Men*, 75–77, 78,
 83, 141nn3–4; *Altitudes and Exten-
 sions*, 81–82; *At Heaven's Gate*, 74–75;
 Audubon: A Vision, 117; *Band of Angels*,
 78; *The Circus in the Attic and Other
 Stories*, 70, 77–78; civil rights struggle
 and, 80; Ellison and, 112; Evans and,
 67, 68–69, 72, 82; evolution of, 114;
 family photography, 82; Faulkner and,
 69–70; Faulkner review, 64; "Forever
 O'Clock," 78–79; historical fiction,
 turn toward, 78; "I Am Dreaming

Warren, Robert Penn (*continued*)
of a White Christmas," 79, 80; *Let Us
Now Praise Famous Men* (Agee) and,
43; "A Little Girl, Twenty Months
Old, Faces the World," 82; "News
Photo," 80; *Night Rider,* 73–74; "Old
Photograph of the Future," 81–82; *Or
Else: Poem/Poems 1968–1974,* 78–81;
"The Patented Gate and the Mean
Hamburger," 70–71, 78; as photo-
graphic subject, 82–83; photography,
interest in, 67–68; *A Place to Come
To,* 71–73, 78; "Prime Leaf," 69;
Promises, 78; "Reading Late at Night,
Thermometer Falling," 80–81; *Segre-
gation: The Inner Conflict of the South,*
80, 117; subjective-documentary
dialectic and, 20; Trethewey and,
115, 116–17, 132; Welty and, 99,
143n10; *Who Speaks for the Negro?,*
80; *Wilderness,* 78; *World Enough
and Time,* 78
Washington, Booker T., 105, 107, 118–19
Weems, Carrie Mae, 7
Welty, Eudora: "1. A woman of the
'thirties/Hinds County/1935," 90;
"82. Jackson/1930s," 91–92; artistic
detachment and, 87; "Black Saturday,"
84, 88, 89, 92, 143n8; *The Bride of the
Innisfallen,* 94, 99, 143n9; cameras,
progression of, 142n4; centennial
of, 142n1; *A Curtain of Green,* 92–93;
Delta Wedding, 94, 143n9; Depression-
era artistic tensions and, 20; Evans
and, 87; evolution of, 114; family,
influence and encouragement of, 85;
FSA photography and, 86, 87–88,
91; gender, race, and class binaries
and, 89–92; "Going Naples," 99; *The

Golden Apples,* 94; Johnson's pictori-
alism and, 119; "Keela, the Outcast
Indian Maiden," 91; "Kin," 93, 94–97,
116, 143n9; *Let Us Now Praise Famous
Men* (Agee) and, 43; "Livvie," 91;
Losing Battles, 93, 97–99, 143n9;
Madden's periods of southern history
and, 86–87; "Must the Novelist
Crusade?," 87; *One Writer's Beginnings,*
85; *The Optimist's Daughter,* 97; photo
books and, 19; *Photographs,* 89–90,
91–92; photography, interest in,
84–85; "Place in Fiction," 143n10;
The Ponder Heart, 97; "Powerhouse,"
91; quantity and quality of photo-
graphic work, 88–89; Trethewey
and, 132; Warren, Ellison, and, 99,
143n10; "Why I Love at the P.O.," 93,
95, 99; *The Wide Net,* 94; "A Worn
Path," 90–91, 99, 142nn6–7; at
WPA, 86
West, Anthony, 65–66
Weston, Edward, 17
Who Speaks for the Negro? (Warren), 80
"Why I Love at the P.O." (Welty), 93, 95, 99
The Wide Net (Welty), 94
Wilderness (Warren), 78
"The Wild Palms" (Faulkner), 56, 58–60
The Wild Palms (Faulkner), 55, 56, 58, 60
Williams, William Carlos, 35–36, 37
Williamson, Michael, 32–33
Wilson, Edmund, 11, 134n5
Withers, Ernest, 136n22
Wolfe, Thomas, 43
Works Progress Administration (WPA),
100–101; Welty at, 86
World Enough and Time (Warren), 78
World War I photography, 15–17
World War II, 21–23, 64

"A Worn Path" (Welty), 90–91, 99,
 142nn6–7
Wright, Charles, 126
Wright, Richard: *12 Million Black Voices*,
 103, 144n3, 146n11; Ellison and, 102–3;
 photo books and, 19, 33

Yeager, Patricia, 16
You Have Seen Their Faces (Caldwell and
 Bourke-White), 19, 40

Zealy, J. T., 9